PENGUIN BOOKS

THE BRIDE AND THE BACHELORS

Calvin Tomkins was general editor in charge of art, music, and religion departments at *Newsweek* magazine. Since 1961 he has been a staff writer for *The New Yorker*. He is also the author of, among other books, *Living Well Is the Best Revenge*, and a novel, *Intermission*.

By Calvin Tomkins

THE BRIDE AND THE BACHELORS

FIVE MASTERS OF THE

AVANT GARDE · BY Calvin Tomkins

PENGUIN BOOKS

PENGUIN BOOKS
Published by the Penguin Group
Penguin Books USA Inc.,
375 Hudson Street, New York, New York 10014, U.S.A.
Penguin Books Ltd, 27 Wrights Lane, London W8 5TZ, England
Penguin Books Australia Ltd, Ringwood, Victoria, Australia
Penguin Books Canada Ltd, 10 Alcorn Avenue,
Toronto, Ontario, Canada M4V 3B2
Penguin Books (N.Z.) Ltd, 182–190 Wairau Road, Auckland 10, New Zealand

Penguin Books Ltd, Registered Offices:
Harmondsworth, Middlesex, England

First published in the United States of America by Viking Penguin Inc. 1965
Published in Great Britain by Weidenfeld & Nicolson 1965
Viking Compass Edition with a new Introduction and expanded text published 1968
Reprinted 1969, 1970, 1971, 1972, 1973, 1974 (twice), 1975
Published in Penguin Books 1976

20 19 18 17 16 15

ISBN 0 14 00.4313 6
Library of Congress catalog number: 65-14512

Printed in the United States of America
Set in Linotype Bodoni Book

Except for the Introduction, the text of this book appeared
originally, in somewhat different form, in *The New Yorker*.

To G.M. and S.W.M.

encore à cet astre . . .

CONTENTS

ILLUSTRATIONS

following page 150

Marcel Duchamp

The Bride Stripped Bare by Her Bachelors, Even (*Large Glass*)
Fresh Widow
Trois Stoppages-Etalon
A Propos de Jeune Sœur
Two readymades: *Bottle Rack* (replica) and *Bicycle Wheel* (replica)

John Cage

Rehearsing *Atlas Eclipticalis* with Bernstein, Tudor, and mechanical conductor
Sample pages from four Cage scores

Jean Tinguely

With his large "meta-matic" painting machine
Homage to New York: sketch; the most interested spectator; the
destruction phase begins

Robert Rauschenberg

In his New York studio
Odalisk
Bed
Monogram

Merce Cunningham

1967 performance of *Scramble*
Studio rehearsal with Sandra Neels and Barbara Lloyd
Studio rehearsal with Carolyn Brown and Gus Solomons, Jr.
Exploring *Scramble*'s new terrain
Walkaround Time (1968)

INTRODUCTION

Art has a way of undermining all aesthetic theories. This is particularly apparent today, when artists seem less and less inclined to work within established traditions and more and more drawn to explore the protean nature of art itself, to raise more questions than they solve, and generally to becloud the fantasy—sometimes delightful and sometimes not —of art history. In suggesting that there may be elements of a common design underlying the work of the five artists discussed in this book, it should be understood that I do not wish to entangle anyone in my design, least of all the subjects themselves.

Marcel Duchamp, John Cage, Jean Tinguely, Robert Rauschenberg, and Merce Cunningham do not constitute a movement or a school, nor do they even share a common point of view. Cage, the composer, and Cunningham, the

modern dancer and choreographer, have worked in close
collaboration for many years, and yet the intellectual rigor
with which Cage charts his aesthetic course is quite foreign
to Cunningham's more instinctive way of working. The ele-
ment of destruction that is central to Tinguely's approach
crops up only rarely in the other four. Although Duchamp's
infinitely subtle play of ideas has obvious reverberations in
the ideas of all the others, none of them has been directly
influenced by Duchamp (their discovery of him served
rather to reinforce ideas arrived at independently), and
none of them shows much of his ironical detachment. Grant-
ing each man his uniqueness, though, it seems to me that
there is a natural affinity in their basic attitudes toward
art, toward life, and toward what Rauschenberg has
called "the gap" between the two.

The most striking of these shared attitudes is a belief that
art is not half so interesting or so important a business as
daily life. The religion of art, with its agonies and ecstasies
so dear to popular fiction, strikes these artists as an absurdity
("Art as religion," Duchamp scoffs "—it's not even as good
as God"). Their attention is turned outward on the world
around them, not inward upon their own reactions to it. And
because they find the external world such a fascinating and
incredible place they are not satisfied to isolate little pieces
of it in the context of fixed, unchanging works of museum
art. What they have consistently tried to do is to break down
the barriers that exist between art and life, and not for
art's sake either. As Rauschenberg puts it, art for him is
not an end in itself but simply a "means to function
thoroughly and passionately in a world that has a lot more
to it than paint."

In the course of breaking down barriers they have also
discarded a number of traditional notions about the artist

and what he does. Duchamp got rid of a good many when he bought an iron bottle-drying rack in a hardware store, signed it, and called the result a "readymade" work of art. Cage, Cunningham, Tinguely, and Rauschenberg have shown a similar disrespect for the traditional definition of the artist as one who gives meaning and interpretation to reality by imposing upon it his own imaginative order. Each of them has tried in his own way to remove the traces of personal control and self-expression from his work, in the belief that the artist's own emotions, memories, and prejudices are just the sort of barriers that most obscure the view. Thus Cage looks upon his experimental music as an attempt to "let sounds be themselves," and Rauschenberg speaks of his work on a painting as a "collaboration" with materials.

It takes considerable ingenuity to get beyond one's own self-expressed taste. Not surprisingly, these five artists have employed certain methods in common. Chance, the most obvious substitute for personal control, has been the basis of Cage's experiments for twenty years, and it has figured more or less prominently in the work of the other four. The use of motion to approximate the constantly changing nature of life is explicit in Tinguely's mad sculptural machines and in much of Duchamp's early work, and implicit in the kaleidoscopic canvases of Rauschenberg and the music of Cage. In the case of Cunningham, whose medium *is* motion through space, it is interesting to note how he has opened and extended the whole concept of what constituted "dance" movements. Any movement, Cunningham maintains, can be part of a dance, and his choreography includes much ordinary walking, running, and standing still. Similarly, Cage's music has moved away from accepted "musical" tonality to include electronic feedback and the "found

sounds" of an urban environment, while the three plastic artists have made room in their work for snow shovels, street signs, broken scraps from the junkyard, and other mundane artifacts. If their use of these humble materials is nothing new in modern art, their attitude toward them is distinctive. This attitude is one of total acceptance of the commonplace for its own sake rather than for its ability to function as an image or a symbol in a work of art. They are not interested in turning the commonplace into art; they offer it intact, untransformed, a fragment of the life we live every day. And to the frequent accusations that what they do is not art, or is anti-art, they tend to reply with a rather unsettling question of their own: Why worry about art when life is what matters? "I can assure you," says Tinguely, "that once you get rid of the notion of art you acquire a great many wonderful new freedoms."

This is aesthetic heresy, of course, and the fact that it is carried out in a spirit that is not so much anti-art as anti-serious, and often highly comic, does not endear these artists to earnest critics and art historians. But the voice of the critic is unusually feeble and out of tune just now, and the heresy is already widespread. Artists in many countries have been moving away from the idea of interpretive, self-expressive art. Pop Art is one example of the trend, which has its echoes in music and literature as well. Pierre Boulez, generally considered the most significant of the younger European composers, has been quoted as saying that the motive behind all his work is "the search for anonymity." Karlheinz Stockhausen, another European, has staged musical-theatrical events that derive unmistakably from Cage. The theater of Ionesco and Pinter, the so-called "new novel" being written in France by Alain Robbe-Grillet and others, the "Happenings" movement, a good deal of contemporary

cinema, both underground and lately above-ground as well, and much of the choreography of young modern dance groups in America can also be seen as part of the general revolt against meaningful, reality-interpreting art in the Renaissance tradition. The revolt, moreover, incorporates a radically changed attitude on the part of the artist toward his audience. Instead of presuming to investigate reality and hand down his findings to the populace (or to the critics, who will tell the populace how to respond), the new artist-heretic invites the spectator to participate actively in the creative process—by interpreting the work of art however he pleases, or, even better, by simply experiencing it without interpretation. Art, in this sense, has left its pedestal and invaded the street, a spectacle that must necessarily dismay critics but one to which the public, and particularly that part of it under thirty, has responded with increasing delight. For the generation that responds to the Beatles and to the politics of participation, these artists seem utterly *relevant*—which means, of course, that they have remained miraculously in advance of events in the electronic era.

Although the new art of participation is world-wide, it seems to flourish most luxuriantly in America, and this suggests another point of affinity among the five artists discussed here. Duchamp was born in France, Tinguely in Switzerland, Cage in California, Rauschenberg in Texas, and Cunningham in Washington State, but all five have chosen to carry out their most significant work in New York City. There is some evidence that the climate of New York may now have become almost too favorable for heresies and radical experiments. The appearance of a large and militantly avant-garde audience, a shockproof public that accepts whatever is offered it in the name of art so long as it is certifiably new and *in*, has impressed Duchamp, among

others, that the long decline of Western art has reached its
nadir. It is all too easy for a young artist to succumb to the
asphyxiating embrace of this art-fashion audience. I find it
significant that none of the five artists in this book has suc-
cumbed. The most conspicuous example would be Rausch-
enberg, who, since his triumph at the 1964 Venice Biennale,
has passed from the status of *enfant terrible* to that of mod-
ern master. Rauschenberg's response to this sudden and
spectacular elevation has been more or less to withdraw from
painting; he now devotes most of his time to Experiments
in Art and Technology, a private foundation devoted to
bridging the "two cultures" gap between art and science—
another form of breaking down barriers. The temptation to
repeat a previous success, in any case, has been firmly re-
sisted. As Cage once said, in his extremist fashion, "When-
ever I've found that what I'm doing has become pleasing,
even to one person, I have redoubled my efforts to find the
next step."

Humor sustains these artists—humor, and the underlying
knowledge that what they are attempting, all this breaking
down of barriers between art and life, art and science, artist
and audience, is in the long run an impossible undertaking.
And here I should like to fall back, as so many have done,
on the iconography of Marcel Duchamp. For any artist
drawn in the direction of the "new reality" that lies some-
where between art and life, one of the key works of the
twentieth century is Duchamp's *Large Glass*, the unfin-
ished, shattered enigma in the Philadelphia Museum,
whose formal title is rendered in English as *The Bride
Stripped Bare by Her Bachelors, Even*. Committing upon
his title an act of symbolism that Duchamp would not ap-
prove, we might say that the wooing of this infinitely seduc-
tive Bride can never wholly succeed. The Bachelors may ex-

pend all their art in the attempt—and all their luck as well —and the Bride may even further their efforts with her own quickening desire to be possessed. But this bride, like life itself, can never truly be possessed, nor even stripped bare. Which may be why Duchamp, the master ironist, refrained from completing his *Large Glass*.

The courtship is what matters, and it seems reasonable to expect that we may see that continued, in one way or another, for some time to come.

Marcel Duchamp

One day in 1957, speaking as a "mere artist" before a learned seminar on contemporary aesthetics in Houston, Texas, Marcel Duchamp proposed a somewhat surprising definition of the spectator's role in that mysterious process known as the creative act. The artist, Duchamp said, is a "mediumistic being" who does not really know what he is doing or why he is doing it. It is the spectator who, through a kind of "inner osmosis," deciphers and interprets the work's inner qualifications, relates them to the external world, and thus completes the creative cycle. The spectator's contribution is consequently equal in importance to the artist's, and perhaps in the long run even greater, for, as Duchamp remarked in another context, "it is posterity that makes the masterpiece." Like so many of the ideas put forward by Duchamp, who has for years been the most enigmatic presence in contemporary art, this theory

tends to make a great many artists uncomfortable. Artists,
as a rule, do not like to think of themselves as mediumistic
beings who blindly perform only one part of the creative
act, and their attitude toward the spectator is not always
one of respectful collaboration. For Duchamp himself,
though, the theory has recently assumed a peculiar rele-
vance. Having engaged in no formal artistic activity since
1923, Duchamp has achieved, in his late seventies, the
unique position of being a member of the posterity that
is passing judgment on his own work—a process of de-
ciphering and interpretation that has been proceeding at a
pace little short of phenomenal.

The Duchamp boom went into high gear with a major
retrospective exhibition of his work at the Pasadena Art
Museum in the fall of 1963. The catalogue for this show
listed one hundred and fourteen items—drawings, graph-
ics, optical devices, photographs, and a large selection of
"readymades"—manufactured objects, such as snow
shovels and hat racks, that Duchamp has designated as
works of art by the mere act of signing them—as well as
nineteen paintings including the famous *Nude Descending
a Staircase* and a life-size replica of his climactic work on
glass, *The Bride Stripped Bare by Her Bachelors, Even.*
Admiration for the energy and persistence of Walter
Hopps, the Pasadena Museum's youthful director, in as-
sembling so much Duchamp material went hand in hand
with a general amazement in art circles that no one had
done so before—this being Duchamp's first major retro-
spective—and before long the international art market
could be heard clanking into action. In Milan the owner
of the Galleria Schwarz produced a limited series of
Duchamp readymades—exact replicas of the originals
made under Duchamp's benevolent "supervision" and

signed by the artist—and put them on exhibition in the spring of 1964. The Schwarz editions then toured Europe, preparatory to their being shown in New York, Tokyo, and other centers of vanguard taste. In New York a collection of one hundred and twenty Duchamp items acquired from various sources by Arne Ekstrom, the dealer, for Mrs. William Sisler went on exhibition at the Cordier and Ekstrom Gallery in January 1965, under the Duchampian title of "NOT SEEN and/or LESS SEEN of/by MARCEL DUCHAMP/RROSE SELAVY." This collection leans to very early drawings and paintings and includes, in addition to highly significant early paintings like *Network of Stoppages* and *A Propos de Petite Sœur*, some rather marginal "works" such as the camera used by Man Ray to film Duchamp's 1926 experimental movie *Anemic Cinema*— a clear indication, surely, of the power of aesthetic osmosis. Spurred by this show, which went on to several important United States museums, critical articles on Duchamp have appeared in a mounting flood in the international art journals, and the mass media, always alert to the birth or rebirth of a culture hero, have bombarded him with publicity. Duchamp accepted all this cheerfully enough, explaining that he had now entered his "sex maniac phase." He was ready, he said, "to rape and to be raped by everyone."

Duchamp's immense reputation is no new development, however. For more than half a century he has been a legendary figure, and his 1912 *Nude Descending a Staircase*, which baffled and outraged so many visitors to the 1913 Armory Show in New York, may very well be the most famous painting of the modern era. Both the *Nude* and *The Bride Stripped Bare by Her Bachelors, Even* (usually referred to simply as the *Large Glass*), together

with most of Duchamp's other major paintings, have been on view since 1954 at the Philadelphia Museum of Art, in the great collection of twentieth-century works donated to that institution by the late Walter C. Arensberg. But the majority of onlookers, whose adjustment to the paintings of Duchamp's contemporaries Picasso and Braque is by now well advanced, still tend to find Duchamp's work baffling and even outrageous, and a great many of these same onlookers were probably unaware until quite recently that Duchamp himself, a United States citizen since 1954 and a New York resident, off and on, for half a century, was still an active force on the art scene. Since 1923, the year Duchamp stopped work on his *Large Glass* and abandoned all formal artistic production, his reputation has been confined almost entirely within the art world, where he has nevertheless continued to exert a lively, paradoxical, and subversive influence.

The spectacular growth and spread of this influence within the art world since 1954 have coincided with certain new developments in American art, for which Duchamp's work, both formal and informal, is generally agreed to be a primary source and inspiration. The most obvious of these developments is Pop Art, or the "New Realism" as it is sometimes called, which takes as its subject matter the most banal objects and images from commercial culture and thus reflects, though often mistakenly, the iconoclastic mockery of Duchamp's readymades. Other examples would include the current fascination with motion in art, prophesied by Duchamp's *Nude* and his motor-driven optical devices; the new "hard edge" abstract painting, whose chromatic vibrations were anticipated by Duchamp's 1936 *Cœurs Volants* (*Fluttering Hearts*), a cover design for the magazine *Cahiers d'Art;* the experi-

ments with motion-picture photography (*Anemic Cinema*);
and even the recent rash of "Environments" and "Hap-
penings," a form of spectator involvement that Duchamp
practiced, less earnestly but somewhat more wittily than
the artists of the 1960s, in the installation of several Sur-
realist exhibitions in New York and Paris during the 1930s
and 1940s.

While it may sometimes appear that everything Du-
champ did or said in the past is being mined as source
material by a new generation, not many artists even today
share the intellectual attitude that motivated his countless
inventions. "I wanted to put painting once again at the
service of the mind," Duchamp once said. As early as 1910
he placed himself in opposition to what he considered the
dominant trend of painting in his time, which he traced
back to Courbet and described as "retinal" art—art whose
appeal is to the eye alone. Until the time of Courbet almost
all European painting was literary or religious, Duchamp
maintained. Courbet introduced the retinal emphasis, or
what Duchamp sometimes called the "olfactory" art of
painters who were in love with the smell of paint and had
no interest in re-creating ideas on canvas; and this retinal,
olfactory, anti-intellectual bias was accepted by the Im-
pressionists and subsequent schools. "All through the
last half of the nineteenth century in France there was an
expression, *bête comme un peintre*," Duchamp has said.
"And it was true; that kind of painter who just puts down
what he sees *is* stupid. In my case I was thinking a little
too much, maybe, but I don't care, that's what I thought."

Retinal painting, however, was only one of the trends
Duchamp rebelled against. From the start of his career in
France he could not resist mocking the high seriousness of
art and artists, who so often saw themselves as demigods

and were so conspicuously lacking in humor where their own art was concerned. Then, somewhat later, he became disgusted by the rising commercialism of the art scene— the "monetarization" of art that was a large factor in his withdrawal from painting in 1923. All three of these trends —retinal painting, high seriousness, and commercialism— have continued and still continue to dominate the art scene, as the visual orgies of Abstract Expressionism and the new collectors' status buying (tax deductible) clearly indicate. By the mid-1950s, though, the beginnings of a reaction against all three could be detected. Pop Art, whatever else one can say about it, is by no means primarily "retinal," nor does it function on the plane of high and humorless seriousness shared by such otherwise disparate movements as Cubism and Abstract Expressionism. A good deal of the new art both in this country and in Europe seems to make its appeal less to the eye than to the mind, and if the intellectual level of this appeal is rarely exalted, it is more often than not carried out in a spirit of mockery, iconoclasm, or sheer bumptiousness that is not far removed from the "hilarity" that Duchamp aimed at. It was Duchamp, after all, who suggested that art could be a form of play, a game between artist and onlooker. As far as commercialism is concerned, the astonishing prices paid for some of the Pop masterworks may be the most hilarious aspect of the reaction. When a collector pays ten thousand dollars for a work that is not only aesthetically but *physically* ephemeral—it almost inevitably will fall to pieces within a few years—there is some justification for thinking that the market itself has become absurd, and that the artist, who always appreciates a joke on the bourgeois, is actively hastening its collapse. Some artists, like the Swiss sculptor Jean Tinguely, have even gone so far as to create

works of art that destroy themselves before one's eyes, and
nobody is more in accord with these efforts than Duchamp.
"I'll tell you what's going to happen," Duchamp once said.
"The public will keep on buying more and more art, and
husbands will start bringing home little paintings to their
wives on their way from work, and we're all going to drown
in a sea of mediocrity. Maybe Tinguely and a few others
sense this and are trying to destroy art before it's too late."

It is hardly surprising that the newer developments in
art should have coincided with an increased awareness of
Duchamp among the younger artists. The publication in
1959 of Robert Lebel's comprehensive and lavishly illus-
trated book, *Sur Marcel Duchamp*, in French and English,
gave many of the rising generation their introduction to
Duchamp's work and ideas. In New York painters like
Robert Rauschenberg and Jasper Johns found in his ideas
confirmation of their own efforts to break away from the
prevailing climate of Abstract Expressionism and explore
new terrain. Young European artists like Tinguely and
Oyvind Fahlstrom, experimenting with movement, satire,
and the notion of art as a game, have unhesitatingly ac-
knowledged their debt to Duchamp. Scores of lesser figures
seized upon Duchamp's iconoclasm as an excuse to do as
little as possible, or in some cases nothing at all. Earnest
young scholars delved into the Duchamp *œuvre* and the
Duchamp legend, where they were able to find elaborate
networks of meaning in the readymades, and sometimes,
with miraculous ingenuity, in reported fragments of Du-
champ's casual conversation. Every move, every gesture,
every word from the master was seen to take its place in the
over-all pattern of the fabulous masterpiece that Du-
champ's life now came to be considered in these quarters.
If he chose to stay at the Green Hotel in Los Angles (as

he did in 1963 when he came out for the opening of the
Pasadena Museum show), this "fitted in" with the *Green
Box*, the title under which he had published his notes for
the creation of the *Large Glass*. Duchamp, it seemed,
could do nothing indifferently. The cult proliferated, but
the most ardent cultists, awed by their own image of a con-
tinuously self-creating masterpiece and also, perhaps, by
Duchamp's unfailing politeness (the French politeness,
which can be impenetrable), kept themselves at a respect-
ful distance from their idol. As one of them once remarked
humbly, "I just don't feel I have the right to take up his
time."

It is a curious experience to find at the center of this
adulation a man as serenely unself-conscious, as offhand
and offguard, as cordial, and as free of any taint of
mystification as Marcel Duchamp. He looks considerably
younger than most recent photographs taken of him. The
lean, indelibly French features show fewer lines and more
humor—particularly the intelligent gray eyes. Along with
his impenetrable French politeness, he has a quite contra-
dictory characteristic, a complete willingness to talk about
anything, on any level, and an interest in what is being
said that puts one completely at ease in his presence. Since
1954, when he married the charming and gracious Alexina
Sattler, who is known throughout the art world as Teeny,
his life has come to seem settled and conventional. The
walls of the Duchamps' pleasant, sunny apartment, in a
brownstone on Tenth Street just off Fifth Avenue, are hung
with a number of splendidly retinal paintings by Du-
champ's older contemporary, Henri Matisse, together with
more cerebral canvases by Yves Tanguy, Max Ernst, and
others of the Surrealist group with which Duchamp has long
maintained a friendly but characteristically detached rela-

tionship. Over the fireplace is Duchamp's own *Neuf Moules Malic*, an early study for *The Bride Stripped Bare by Her Bachelors, Even*; like almost every one of his works on glass, it has been broken, and the cracks have come to be regarded as parts of the composition. Three chess sets (one designed by Max Ernst, another by Man Ray) that are set up in different parts of the room remind the visitor of the part of the Duchamp legend that says he abandoned art in favor of chess. Sitting relaxed in an armchair, wearing a red-checked, soft wool shirt and flannel slacks, and smoking an inexpensive cigar, Duchamp himself gives somewhat the impression of a moderately well-to-do philosopher who is enjoying his retirement and who would be amazed to find that he is the idol of a growing cult. He does know it, of course, but his interest is that of an amused and tolerant spectator. Having been the object of one cult or another most of his life, he now views with serene detachment the cult of his own posterity.

"That business of my being influential is very much exaggerated," he once told a visitor. "Whatever there is in it is probably due to my Cartesian mind. I refused to accept anything, doubted everything. So, doubting everything, I had to find something that had not existed before, something I had not thought of before. Any idea that came to me, the thing would be to turn it around and try to see it with another set of senses. Anyway, it might be that now all these things I did, which did not come from anything before me, have become a source for these young people to start a new step entirely on their own—which I accept with pleasure. But all that has nothing to do with me, really." Duchamp paused to relight his cigar, which he had been rolling between his long, elegant fingers. "I'm not so interested in art per se," he continued after a

moment. "It's only one occupation, and it hasn't been my whole life, far from it. You see, I've decided that art is a habit-forming drug. That's all it is, for the artist, for the collector, for anybody connected with it. Art has absolutely no existence as veracity, as truth. People always speak of it with this great, religious reverence, but why should it be so revered? It's a drug, that's all. The more I go on, the more I'm convinced of it. The onlooker is as important as the artist. In spite of what the artist thinks he is doing, something stays on that is completely independent of what he intended, and that something is grabbed by society— if he's lucky. The artist himself doesn't count. Society just takes what it wants. The work of art is always based on these two poles of the maker and the onlooker, and the spark that comes from this bi-polar action gives birth to something, like electricity. But the artist shouldn't concern himself with this because it has nothing to do with him— it's the onlooker who has the last word. Fifty years later there will be another generation and another critical language, an entirely different approach. No, the thing to do is try to make a painting that will be alive in your own lifetime. No painting has an active life of more than thirty or forty years—that's another little idea of mine. I don't care if it's true, it helps me to make that distinction between living art and art history. After thirty or forty years the painting dies, loses its aura, its emanation, whatever you want to call it. And then it is either forgotten or else it enters into the purgatory of art history. But that's all just luck, a game between artist and onlooker, or a drug as I said before. I'm afraid I'm an agnostic in art. I just don't believe in it with all the mystical trimmings. As a drug it's probably very useful for a number of peo-

ple, very sedative, but as religion it's not even as good as God."

In "The Lighthouse of the Bride," an influential essay on Duchamp written in 1934, André Breton cited Edgar Allan Poe's celebrated insight that true artistic originality was generally achieved not by instinct or invention but by an absolute refusal to repeat what others had done before. "The unique position of Marcel Duchamp at the spearhead of all 'modern' movements for the last twenty-five years," Breton wrote, followed logically upon one's recognition "that never has a more profound originality appeared more clearly to derive from a being charged with a more determined intention of negation."

One of the oddest aspects of Duchamp's determined negations is the cool and seemingly effortless confidence with which, from the outset of his career, they have been carried out. As a child—"a very normal child," according to Duchamp—growing up in the affectionate surroundings of a large and respectable bourgeois family in Rouen, he was not even obliged to combat or reject the traditional parental ambitions. His father was a notary, but his maternal grandfather, Emile-Frédéric Nicolle, had been a highly talented engraver whose prints hung in the Duchamp home, and the choice of an artistic career was entirely understandable to Duchamp père. In fact, when four of his six children made that choice, he even agreed to support them while they were getting started—carefully noting down the precise sums he advanced them, which were later deducted from each one's inheritance. Gaston Duchamp, the eldest, came to Paris before the turn of the century and began painting under the name of Jacques Villon. He was soon joined by Raymond, the next in line, who gave up a career in medi-

cine to become a sculptor and took the name Raymond
Duchamp-Villon. Neither Marcel nor his younger sister
Suzanne found it necessary to reject the family name when
they came to Paris. But in this remarkable family of artists
it was Marcel's role to appropriate, and then decisively
reject, not only the traditions of the recent past, but the
discoveries that his contemporaries were making every day.
He was an Impressionist at fifteen, in the 1902 *L'Eglise de
Blainville*, which is his earliest surviving oil. The influence
of Cézanne showed clearly in the series of accomplished
family portraits and landscapes that followed. From 1907
to 1910 he was a Fauve, but in 1910 the bold and violent
colors of the Fauve school, then at its peak in Paris, gave
way in his canvases to the subdued palette and the flat,
broken planes of Cubism. Cubism proved revolutionary
enough for Jacques Villon and Raymond Duchamp-Villon,
whose studio in the Paris suburb of Puteaux had become
a focal point for the group of "reasonable" Cubists that
included Léger, Lhote, Delaunay, Gleizes, Metzinger, La
Fresnaye, and Le Fauconnier—reasonable in that they
were not yet willing to banish representation entirely from
their canvases as Picasso and Braque had done.

After a brief period of study at the Académie Julian in
1905 Duchamp exhibited with this group at the Salon des
Indépendants in Paris, and later at the Salon de la Section
d'Or. He supported himself during this period by drawing
cartoons for the illustrated papers of the day. Toward the
end of 1911, though, he started to work on a picture that
would prove to be too revolutionary even for his fellow
Cubists. It began as an illustration for a poem by Jules
Laforgue called *"Encore à cet astre,"* and the first drawing
(now in the Arensberg Collection in Philadelphia) shows
a fairly recognizable nude figure walking up a flight of

stairs. "That first study was almost naturalistic," Duchamp has said. "At least it showed some hunks of flesh. Right after that I started in to make a big painting of the same subject, but it was a long way from being naturalistic, and there were other changes too. In the sketch for Laforgue's poem I had had the nude *ascending*, but then I began to think that it would help my expression to have her descending. More majestic, you know—the way it's done in the music halls." Duchamp worked for a month on the painting, which he entitled *Nu Descendant un Escalier*, and in February of 1912 sent it off to the Salon des Indépendents show, at which the "reasonable" Cubists were exhibiting.

Nothing could better exemplify the art passions and politics of that era than the controversy set off by Duchamp's big *Nude*. A month before this, in January, the first exhibition of Futurist paintings had been held in Paris at the Bernheim-Jeune Gallery. The Italian Futurist movement had appropriated some of the discoveries of Cubism and applied them to its own ends, among which was the desire to express the "universal dynamism" of life through a "style of motion." The Puteaux Cubists (always a separate group from Picasso and Braque, who pursued their own course in isolation and with whom Duchamp had virtually no contact, then or later) looked with great disdain upon the Futurists, who in turn accused them of harboring an obstinate attachment to the past. But now it appeared to some of the Cubists, notably Gleizes and Metzinger, that the youthful Duchamp had sent in a picture that veered dangerously close to Futurism in its attempt to express movement. Duchamp himself had never seen a Futurist painting until he finished his *Nude*. Its composition had been suggested to him by Étienne Marey's chrono-photo-

graphs of moving figures which were then appearing in illustrated magazines. Although his desire to re-create ideas in painting had its echoes in Futurist theory, Duchamp's 1912 style was clearly Cubistic, showing little in common, for example, with a Futurist work like Balla's 1912 *Dynamism of a Dog on Leash*. But the fact remained that Cubism was static, and Duchamp's *Nude*, which he would later describe as "an expression of time and space through the abstract presentation of motion," was not. To Gleizes and Metzinger, the painting not only smacked of Futurism, it struck them as a mockery of Cubist theory. For a Cubist to paint a nude in the first place was questionable enough, but a nude *descending* . . . Was Duchamp making fun of everybody? Humor was clearly impermissible in the revolutionary climate of early Cubism, when a united front had to be maintained against the hostile public. A conference of the leading Cubists was called, and Duchamp's brothers were dispatched to ask Marcel to withdraw his picture, or at least to change the title, which was painted on the canvas itself.

"I said nothing to my brothers," Duchamp has recalled. "But I went immediately to the show and took the painting home in a taxi. It was really a turning point in my life, I can assure you. I saw that I would not be interested very much in groups after that."

For the next few months Duchamp's work gave little comfort to either the Cubists or the Futurists. His large oil *The King and Queen Surrounded by Swift Nudes*, together with other studies and sketches in which semi-abstract chess figures (the King and the Queen) were enveloped or pierced by what one critic called "whirling nudities," showed his continuing preoccupation not only with the idea of motion, but with the nude, a subject

shunned by every other advanced artist of the time. (The Futurists had denounced the nude in their 1910 manifesto as "nauseous and tedious" and called for its total suppression for ten years as a subject in painting.) Increasingly isolated from the violent cross currents in this era of aesthetic revolutions, Duchamp left Paris in July and spent the next two months in Munich. It was his first trip outside France, and from it came a series of works that took him out of the world of painting altogether. This astonishing series began with a drawing and a water color called *Virgin*, reached a climax with two Cubist oils, *The Passage from the Virgin to the Bride* and *Bride*, and closed with the first drawing for that complex and enigmatic work on glass that would occupy him for the next ten years, *The Bride Stripped Bare by Her Bachelors, Even*.

It is part of the Duchamp legend to suppose that *The Passage from the Virgin to the Bride*, painted in Munich, showed such a brilliant mastery of painting technique that it made Duchamp fear he was in danger of being "seduced by beauty," and thus influenced his withdrawal from painting. The picture, which hangs prominently in the Museum of Modern Art, is generally conceded to be his masterpiece as a painter, and its strange mingling of mechanical and visceral elements has had a profound effect on a number of other artists. Matta (Roberto Matta Echaurren), the Chilean Surrealist, has said that his discovery of this picture in the mid-1930s, reproduced in an issue of *Cahiers d'Art*, helped to bring about his own "passage" from architecture to painting and gave him his subject as well. "The Cubists concerned themselves with the object in space," Matta has said, "and the Futurists with objects in motion. But Duchamp's *Passage* attacked a whole new problem in art, and solved it—to paint the moment of change, change

itself. I have devoted myself to that same problem ever
since, and I've seen it become the preoccupation of our time
in science, in mathematics, in philosophy—the morphology
of form, relativity, it's all the same problem."

Matta, a close friend of Duchamp for many years, has
his own theory of why Duchamp abandoned painting so
soon after *Passage*. He believes that in this picture Du-
champ became involved with something so profound that
any further involvement, he saw, would limit the personal
freedom that he valued more than anything else, and that
he consequently made haste to disengage himself. Du-
champ's own explanation is somewhat different.

"From Munich on," Duchamp has said, "I had the idea
of the *Large Glass*. I was finished with Cubism and with
movement—at least movement mixed up with oil paint.
The whole trend of painting was something I didn't care to
continue. After ten years of painting I was bored with it—
in fact I was always bored with it when I did paint, ex-
cept at the very beginning when there was that feeling of
opening the eyes to something new. There was no essential
satisfaction for me in painting ever. And then of course I
just wanted to react against what the others were doing,
Matisse and the rest, all that work of the hand. In French
there is an old expression, *la patte*, meaning the artist's
touch, his personal style, his 'paw.' I wanted to get away
from *la patte* and from all that retinal painting. The paint-
ing around me was completely retinal. Forget about anec-
dote, forget about emotion in the subject—that was the
idea. Just concentrate on what comes in at the eye. The
only man in the past whom I really respected was Seurat,
who made his big paintings like a carpenter, like an artisan.
He didn't let his hand interfere with his mind. Anyway,

from 1912 on I decided to stop being a painter in the professional sense." Having assimilated and rejected the most advanced art of his own time, Duchamp, at the age of twenty-five, set out to find his own alternative.

When he came back to Paris in September, Duchamp made no effort to renew his old ties with the Cubists. The one painter he did continue to see quite often was Francis Picabia, whose iconoclastic spirit and fantastic imagination rivaled his own, and who was also in revolt against the lofty seriousness of the Cubist school. Different as the two men were in temperament—Picabia, who was well off, led an extravagant and sumptuous existence while Duchamp lived quietly, saw few people, and often spent two weeks or more closeted in his studio—they enjoyed each other's company, and their meetings invariably turned into pyrotechnical displays of verbal wit and clowning. They were often joined by Guillaume Apollinaire, the poet and first great champion of the new painting. In his book *The Cubist Painters*, published in 1913, Apollinaire wrote that Duchamp's role would be "to reconcile art and the people." Duchamp has always considered this a ridiculous statement that could just as well have been applied to anyone else. "Apollinaire wrote awfully foolish things about art," he told Francis Steegmuller in 1963, "but he was a charming man."

Picabia's wife, Gabrielle Buffet, described the Duchamp-Picabia-Apollinaire meetings as "forays of demoralization," in which they "pursued the disintegration of the concept of art," and she added that their fantastic verbal flights "seem to have contained all the germs of what later became Dada." Specifically, the sparks struck during these wild conversations may very well have ignited Apolli-

naire's "caligrammes" and conversation poems, Picabia's "machine-style" painting, and Duchamp's highly demoralizing readymades.

The readymades are the most baffling of Duchamp's creations. Thousands of words have been written in analysis and explanation of these curious artifacts without dispelling the general confusion, but André Breton's 1934 definition is probably the best: "Manufactured objects promoted to the dignity of objects of art through the choice of the artist." Unlike the Surrealist *objet trouvé*, which is a common object chosen for its accidental aesthetic value, the readymade has no aesthetic value whatsoever, according to Duchamp, and it therefore functions in one sense as a derisive comment on all art traditions and dogmas. Like most of Duchamp's work, though, the readymades tend to raise more questions than they answer, and their significance is endlessly debated. When the first one appeared in 1913, two years before Duchamp invented the term "readymade," he insists that there was no concept or intention of any kind involved. He simply took the front wheel of a bicycle and mounted it upside down on a kitchen stool in his studio, where a touch of the hand would set it spinning. "It just came about as a pleasure," he has recalled, "something to have in my room the way you have a fire, or a pencil sharpener, except that there was no usefulness. It was a pleasant gadget, pleasant for the movement it gave." The second readymade was more openly derisive. He bought in an art-supply store three copies of a cheap chromo-lithograph depicting an insipid winter landscape, added two dots of color, one red and one green (the colors of the bottles often placed in druggists' windows), and called the result *Pharmacy*. The idea had come to him one December evening as he was riding on the train from Paris

to visit his family in Rouen; looking out the window, he saw two lights in the distance across a snowy field, and something about them suggested the pharmacy image. Earnest disciples have seen a sardonic reference here to Suzanne Duchamp's first marriage to a pharmacist, but Duchamp has scoffed at this. *Pharmacy*, he has said, was "a distortion of the visual idea to execute an intellectual idea," something wrenched arbitrarily out of one context and placed in a new and unfamiliar one. This is perhaps the key notion behind the readymades, and it shows up even more clearly in the third example, the *Bottle Rack* of 1914. This time Duchamp bought a galvanized iron rack of the kind then in use for drying bottles—it had five tiers of projecting rods—and signed his name to it. By the mere act of signing, he removed the rack from its "useful" context and placed it (derisively) in the context of a "work of art." With the exception of one version of *Pharmacy* now in the Arensberg Collection, the originals of all these early readymades, which Duchamp turned out purely for his own amusement, have been lost or destroyed. They have all survived in the form of replicas, however, and the brisk sales of the brand-new Schwarz editions, coupled with recent statements by a number of younger artists and critics that the *Bicycle Wheel* and the *Bottle Rack* are among the most beautiful "sculptures" of the twentieth century, may serve to indicate just how successful Duchamp has been in his systematic disintegration of the concept of art and the codified values of formal Beauty.

While he cheerfully undermined several centuries of European art with his readymades, Duchamp continued to accumulate ideas, studies, and sketches for the work that he had outlined in Munich, and to which he had already given the title of *La Mariée mise à nu par ses céliba-*

taires, même (*The Bride Stripped Bare by Her Bachelors, Even*). It is entirely probable that only a mind that had rejected and laid waste all art, past and contemporary, could have conceived anything so original as this work. The *Large Glass* stands in relation to painting as *Finnegans Wake* does to literature, isolated and inimitable; it has been called everything from a masterpiece to a tremendous hoax, and to this day there are no standards by which it can be judged. Duchamp invented a new physics to explain its "laws," a new mathematics to fix the units of measurement of the new physics, and a condensed, poetic language to formulate its ideas, which he jotted down on scraps of paper as they occurred to him and stored away in a green cardboard box for future reference. The picture, if it can be called that, demonstrates among other things Duchamp's personal concept of the "fourth dimension," which was much discussed in scientific circles at that time; for Duchamp, the ideal fourth-dimensional situation was the act of love—in this case the erotic dance of unearthly machines that have taken on their own form of life. All this naturally required techniques of composition that were entirely original. Duchamp evolved these slowly, by trial and error, and in solitude.

Duchamp has traced the real origin of his *Large Glass* to a little painting he did in 1911, just a month before his *Nude*, as a present for Raymond Duchamp-Villon. Since the picture was to hang in his brother's kitchen, Duchamp decided to paint a coffee grinder. "But instead of making a figurative coffee grinder I used the mechanism as a description of what happens," he has explained. "You see the handle turning, the coffee after it is ground—all the possibilities of that machine." This use of machine imagery to illustrate a *process* was a determining factor in his de-

velopment from then on, although at the time he painted the *Coffee Mill* he had no idea what he was doing. When the machine, key symbol of the modern age, became the object of Duchamp's ironic imagination, a new kind of energy was released in art.

The first element of the *Large Glass* to take definite shape was the *Chocolate Grinder* of 1913, a precise rendering on canvas of the little machine that Duchamp had often seen in the window of a chocolate shop in Rouen. This painting, a study for the central organ of the "bachelor machine" in the *Glass*, was followed by another version in which the radial lines of the grinding drums, instead of being painted, were made by gluing and sewing white thread to the canvas—a mingling of paint and "non-art" materials that had not as yet received the name of collage. Neither of these canvases look "painted" in the usual sense, for the simple reason that Duchamp did not allow his hand to interfere with his mind. "The problem was to draw and still avoid the old-fashioned form of drawing," he has recalled. "Could one do it without falling into that groove? Mechanical drawing was the answer—a straight line drawn with a ruler instead of the hand, a line directed by the impersonality of the ruler. The young man was revolting against the old-fashioned tools, trying to add something that was never thought of by the fathers. Probably very naïve on my part. I didn't get completely free of that prison of tradition, but I tried to, consciously. I unlearned to draw. The point was to forget *with my hand*."

The young man was also bored with paint and canvas, though, and in the spring of 1913 he got the idea of making the main picture on glass. "The idea came from having used a piece of glass for a palette," Duchamp has explained, "and looking through at the colors from the other

side. That made me think of protecting the colors from
oxidation, so there wouldn't be any of that fading and
yellowing you get on canvas." He bought a large piece of
plate glass and began experimenting with it in his studio,
using paraffin to outline the shapes he wanted and then
etching them in with fluoridic acid. The fumes were so
bad that he had to give it up. "Then came the idea of
doing the designing part with lead wire—very fine wire that
you could stretch to make a perfect straight line. It was
very malleable, lovely to work with, and that pleased me."
The lead wires were glued down with clear varnish, and
the colors applied directly to the glass in the spaces out-
lined by the wires and then sealed with a protective coat
of lead foil. In this manner he made two preliminary
studies on glass—*Glider*, which resembles an old-fashioned
porch swing and is part of the "bachelor machine," and
Cemetery of Uniforms and Liveries, or *Moules Malic*.
These "malic" figures are actually the "molds" of the
Bachelors, in the sense that if hollow molds were made in
those shapes and lead poured in, the resulting cast would
in each case be a realistic likeness of a gendarme, priest,
soldier, or some other uniformed male figure.

While Duchamp slowly evolved his alternative to paint
and canvas in an obscure Paris studio, his earlier Cubist
works were achieving a *succès de scandale* in America.
The Armory Show hit New York like a cyclone in Febru-
ary 1913, and Duchamp's *Nude Descending a Staircase*
immediately established itself as the main storm center.
The immense furor over this painting, which was carica-
tured, attacked, and singled out as the epitome of Cubist
madness (Julian Street won a minor niche in art history by
calling it "an explosion in a shingle factory"; Theodore
Roosevelt compared it unfavorably to a Navajo rug), was

due in large part, Duchamp has always felt, to the title. The American public was as shocked as the Cubists had been by the idea of a nude descending, even though there was no recognizable nude to be seen. In art, nudes stand gracefully, or recline, or sit, but they do not come down stairs. Whatever the reason, the *Nude* attracted more attention than any other work in the show. People stood in line to see it, and an enterprising San Francisco dealer named F. C. Torrey bought it for three hundred and fifty dollars. Duchamp had sent three other paintings to the Armory Show—*Sad Young Man on a Train, Portrait of Chess Players,* and *The King and Queen Surrounded by Swift Nudes*—all of which were sold. The combined sales netted him about five hundred dollars, an unexpected windfall, but one that never once tempted him to resume painting Cubist pictures.

Duchamp had taken a job as a librarian in the Bibliothèque Sainte-Geneviève, which gave him just enough to live on. The job also removed him effectively from the competitive Paris art world, while affording plenty of time and solitude for his intellectual researches, and he considered it an ideal arrangement. Oddly enough, he has never been much drawn to books. Not only does he believe that when an artist becomes erudite he is in great danger of never finding anything of his own, but over the years he has come to the conclusion that words, spoken or written, are hopelessly inadequate as a means of communication. "As soon as we start putting our thoughts into words and sentences everything gets distorted," he has observed. "Language is just no damn good—I use it because I have to, but I don't put any trust in it. We never understand each other. Once I became interested in that group of philosophers in England, the ones who argue that all

32 The Bride & the Bachelors

language tends to become tautological and therefore mean-
ingless. I even tried to read that book of theirs on *The
Meaning of Meaning*. I couldn't read it, of course, couldn't
understand a word. But I agree with their idea that only a
sentence like 'the coffee is black' has any meaning—only
the fact directly perceived by the senses. The minute you
get beyond that, into abstractions, you're lost." The ap-
parent paradox in this attitude is that Duchamp, all his
life, has been fascinated by another sort of language in
which words break free of their accustomed meanings,
play tricks on themselves, and begin to operate in a new,
nonrational context. His love for puns, spoonerisms, and
nonsensical word play reflects his obsession with the
strange verbal power that he had found in certain French
poets such as Mallarmé and Rimbaud ("words get their
real meaning and place in poetry," he has said), and also
in the writings of Raymond Roussel, an eccentric novelist
and playwright whose fantastically improbable scenes were
always played in a flat, utterly banal manner. A per-
formance of Roussel's *Impressions d'Afrique*, which Apol-
linaire took Duchamp to see in Paris, had a considerable
influence on Duchamp's subsequent thinking about the
Large Glass. Duchamp has even said that the play was
responsible for the *Glass* and that Roussel "showed me the
way"—a somewhat overgenerous estimate, perhaps, in
view of the nature of both works. There is certainly nothing
very banal about the methods used to build up *La Mariée
mise à nu par ses célibataires, même*, the title of which
is a pretty fair example of the verbal play that Duchamp
enjoys.

It is hardly surprising that a mind that questioned
the power of language to express anything should be
equally unimpressed by the laws of science. Where

Cubist theory sought a basis in mathematics (as Jacques Villon's title "Section d'Or" for their group exhibitions indicates), Duchamp took the ironical view that "we don't know the half of it" and then proceeded to act on that assumption. Why, for example, should one accept as immutably valid the standard unit of measurement, the meter, which was then based on a bar of platinum kept under controlled temperature in the vault of the Bureau of Weights and Measures outside Paris? In a spirit of precise mockery, taking great pains over every detail, Duchamp made his own units of measurement based on the laws of chance. From a height of one meter, he dropped a thread one meter in length upon a canvas, fixed it with varnish in the shape it had assumed, and placed a sheet of glass over it for protection. This process was repeated twice. Three wooden "rulers" were then cut to conform to the curves of the dropped threads, and the mounted threads and rulers were then placed in an elegant wooden croquet box. These were the *Stoppages-Etalon*, or *Standard Stops*, an example of "canned chance" that figured prominently in the *Large Glass* and several other Duchamp works. The whole idea of chance, which was later to become the indispensable tool of a number of artists who saw it as a means to make their work conform more closely to the conditions of life, interested Duchamp in a rather unique way. He believes that chance is an expression of the subconscious personality. "Your chance is not the same as my chance," he has explained, "just as your throw of the dice will rarely be the same as mine." When Duchamp and his sisters Yvonne and Magdeleine amused themselves in 1913 by drawing the notes of the musical scale at random from a hat and then setting them down in the order drawn, the resulting composition, which they called *Musical Erratum*,

was in Duchamp's mind a lighthearted expression of their
own personal chance rather than a purely random creation.

In a similar vein Duchamp formulated the "amusing
physics" of the *Large Glass*, based on such concepts as
"oscillating density," "uncontrollable weight," and "eman-
cipated metal." It has been observed that Duchamp's
physics, amusing as it may be, really anticipates with
startling acumen the subsequent scientific theories of rela-
tivity and indeterminacy, but Duchamp himself has scoffed
at his supposed prescience. "It was just the idea that life
would be more interesting if you could stretch these things
a little," he has said. "After all, we have to accept those
so-called laws of science because it makes life more con-
venient, but that doesn't mean anything so far as *validity*
is concerned. Maybe it's all just an illusion. We are so
fond of ourselves, we think we are little gods of the earth—
I have my doubts about it, that's all. The word 'law' is
against my principles. Science is so evidently a closed
circuit, but every fifty years or so a new 'law' is discovered
that changes everything. I just didn't see why we should
have such reverence for science, and so I had to give an-
other sort of pseudo explanation. I'm a pseudo all in all,
that's my characteristic. I never could stand the seriousness
of life, but when the serious is tinted with humor it makes
a nicer color." The whole conception of the *Large Glass*,
Duchamp once suggested, could be seen as the sketch for
"a reality which would be possible by slightly stretching
the laws of physics and chemistry."

All Duchamp's ideas, notions, and experiments were re-
lated in one way or another to the *Large Glass*. Many of
them took the form of highly concentrated notes, which
he kept in the green cardboard box. The visual working
out of these ideas gradually took shape in a large sche-

matic drawing on one wall of his studio. "All this had to be planned and drawn as an architect would do it," he has explained. "I drew on the wall of my studio with a pencil the final shape, the exact shape of what the *Glass* would be, with all the measurements and the placement of all these things in perspective—old-fashioned perspective, at least for the Bachelor part. When an idea came to me I would immediately see if I could apply it to the rest of the conception. It all came to me idea after idea between 1913 and 1915, and all of the visual ideas were in that drawing on the wall of my studio. So that from 1915 on I was just copying."

The copying, however, was carried out in other surroundings. Duchamp, who had volunteered for his compulsory military service at the age of eighteen and served for one year, was now found to have a weak heart that rendered him unfit for military duty in the war. The patriotic fervor that gripped Paris made life uncomfortable for anyone not in uniform. Walter Pach, one of the organizers of the Armory Show, had visited France early in 1914 and urged Duchamp to come to America. The prospect appealed to him more and more. And so, in the spring of 1915, carrying a visitor's visa, a minimum of luggage, and a scale drawing for the *Large Glass*, Duchamp sailed on the *Rochambeau* for the United States.

"I remember we docked at about noon, on June fifteenth," Duchamp has recalled. "There had been a breeze until the moment we docked, and then suddenly I became aware of being terribly hot. I thought, my God, there must be a fire somewhere. It was dumfounding." He was equally astonished to find himself famous on arrival. The furor over *Nude Descending a Staircase* had not been forgotten, and Duchamp's reputation as a Frenchman in

New York was then, as his fellow countryman Henri-Pierre
Roché put it, equaled "only by Napoleon and Sarah Bern-
hardt." Reporters were on the pier to interview him, and
Duchamp, who spoke no English at this point, answered
through an interpreter a great many rude questions with
what one witness called "smiling composure." He was
rescued at last by Walter Pach, who took him directly to
the Arensbergs' apartment on West Sixty-seventh Street.

Walter Arensberg had already started to build his mag-
nificent collection of twentieth-century art, and he deeply
regretted that circumstances had kept him from visiting
the Armory Show until the last day, too late to buy any of
the four Duchamps there. He and his wife took to Duchamp
immediately and invited him to say in their apartment.
Duchamp stayed for a month, then rented a small studio in
the old Lincoln Arcade building on Broadway. "After a
year I felt very safe in New York," he once remarked. "It
was very different then from the way it is now, quieter and
less rat-racing. For a Frenchman, used to class distinctions,
you had the feeling of what a real democracy, a one-class
country, could be. People who could afford to have chauf-
feurs went to the theater by subway, things like that. Also,
there was a much better climate for someone who wanted
to keep aloof from movements, or theories, or people who
like to categorize you. It was much, much freer than in
Paris, and people left you alone more." In the 1920s
American expatriates would give almost the identical
reasons for preferring Paris.

The Arensbergs were the center of an extremely lively
group of artists and intellectuals, both American and
European. This circle, which included such painters as
Pach, Marsden Hartley, Joseph Stella, and Charles De-
muth, lost no time in lionizing Duchamp. Chronicles of this

period stressed his spontaneous and audacious high spirits, and also the "admirable beauty" of his person—the intelligent good looks of "a young Voltaire" that proved so irresistible to so many young women, whose favors he managed somehow to enjoy without involving himself either in monopolies or recriminations. Henri-Pierre Roché, a well-connected young Parisian who was in New York on a government mission at this time, has written a perceptive memoir in which he says that Duchamp gave the impression then of one who "enjoyed life and knew how it should be lived. His own example was to 'Do unto others as they would wish, but with imagination.' . . . He could have had his choice of heiresses, but he preferred to play chess and to live on the proceeds of the exclusive French lessons he gave for two dollars an hour. He was an enigma, contrary to all tradition, and he won everybody's heart."

The French lessons, like the librarian's job in Paris, gave Duchamp just enough money to be independent without tying himself down. "I gave two or three a day," he has recalled, "and I probably learned more English than my pupils learned French. I was not a good teacher—too impatient. But then I took only pupils who already knew some French, like the Stettheimer sisters, Florine Stettheimer, the painter, and Ettie, who wrote.* The sisters were inveterate celibates entirely dedicated to their mother. They were so funny, and so far out of what American life was like then. There was also a lawyer friend of John Quinn's, who would take a lesson and invite me out to dinner and the theater at the same time, a very pleasant way to give lessons. I could almost live on what I made

* Duchamp appears in several of Florine's paintings and is a leading character in Ettie's novel *Love Days*, which she wrote under the pseudonym "Henri Waste."

this way, because everything was so much cheaper then. You could live in New York on five dollars a day, and if you had ten dollars you were a king." Once, hoping to place his personal economy on a slightly firmer footing, Duchamp went into business with another displaced Frenchman named Léon Hartl, who had once worked in a dyeing establishment in Paris. They opened a small fabric dyeing shop downtown, on three thousand francs borrowed from Duchamp's father, and went quietly bankrupt in six months. A young Duchamp disciple has recently found that the dyeing business "fits in" with the Duchamp legend as a conscious play on words between *teindre* (to dye) and *peindre* (to paint), a discovery that Duchamp regards as entertaining proof that in this sort of scholarship anything goes.

Soon after his arrival in New York, Duchamp began work on the *Large Glass*. "I bought two big plate-glass panes and started at the top, with the Bride. I worked at least a year on that. Then in 1916 or 1917 I worked on the bottom part, the Bachelors. It took so long because I could never work more than two hours a day. You see, it interested me but not enough to be *eager* to finish it. I'm lazy, don't forget that. Besides, I didn't have any intention to show it or sell it at that time. I was just doing it, that was my life. And when I wanted to work on it I did, and other times I would go out and enjoy America. It was my first visit, remember, and I had to see America as much as I had to work on my *Glass*." When he had been in New York for about a year and a half Duchamp moved into a studio on Sixty-seventh Street that Arensberg had prepared for his use and for which Arensberg was paying. In return Duchamp promised him the *Large Glass*.

From time to time a new readymade appeared. Du-

champ's first "American" readymade was a snow shovel, which he bought in a hardware store on Columbus Avenue near his studio, signed, and entitled *In Advance of the Broken Arm*. This was followed by *Comb*, a metal comb of the type used for grooming dogs, with an inscription by Duchamp along the back edge reading, in French, "Three or four drops of height have nothing to do with savagery." "The idea was to write something that had nothing to do with dogs or combs," Duchamp has explained, none too helpfully. "Something as nonsensical as possible. It's not easy to be nonsensical, because nonsensical things so often turn out to make sense." *With Hidden Noise*, an "assisted" or "aided" readymade, consisted of a ball of twine compressed between two metal plates; Walter Arensberg, at his own suggestion, placed an object known only to him inside the ball of twine, and it makes a slight noise when the readymade is shaken. Arensberg, who died in 1954, never told anyone what he had put inside. When *With Hidden Noise* was being exhibited at the Pasadena Museum in 1963, Duchamp authorized Walter Hopps to pull back the twine and look inside, so Hopps has become the only one in on the secret. Duchamp has never wanted to know.

Duchamp also assisted somewhat at the creation of a readymade from an advertisement for Sapolin Enamel paint showing a little girl painting a bedstead. By juggling the letters slightly he made it read *Apolinère Enameled*, which became the title of the readymade. Duchamp also painted a reflection of the little girl's hair in a mirror to one side of the bed, and it has pleased him that hardly anyone ever has noticed this touch. Other, unassisted readymades dating from 1917 include the dust cover for an Underwood typewriter (*Traveler's Folding Item*), a hat rack (*Hat*

Rack), and a coat rack which he screwed to the floor of his studio, where visitors and sometimes Duchamp himself would trip over it (it was called *Trébuchet*, which comes from the French verb "to trip," and also refers to the chess term for giving up a pawn in order to trap, or trip up, one's opponent). Duchamp once instructed himself to "limit the number of readymades yearly," so as to avoid turning them into an artistic activity, and he either kept them in his studio or gave them away to friends. "I never intended to sell them," he said. "The readymades were a way of getting out of the exchangeability, the monetarization of the work of art, which was just beginning about then. In art, and only in art, the original work is sold, and it acquires a sort of aura that way. But with my readymades a replica will do just as well. I never even showed them until a few years ago, except for one exhibition at the Bourgeois Gallery in New York in 1916. I hung three of them from a coat rack in the entrance, and nobody noticed them—they thought it was just something someone had forgotten to take out. Which pleased me very much."

All these puzzling objects can be looked upon as part of Duchamp's tireless assault on the traditions of art and the artist—for him, the artist is just someone who signs things—and their shock value should not be underrated. The real shocker, though, was the readymade that Duchamp and Joseph Stella sent in anonymously to the hanging committee of the 1917 exhibition of the Society of Independent Artists, of which Duchamp was a founding member. This was the notorious *Fountain*, a porcelain urinal turned upside down and signed "R. Mutt." The hanging committee refused to exhibit this item, although the Society had supposedly pledged itself to show any work by any artist

who paid the six-dollar fee. Duchamp argued the case soon afterward in *The Blind Man*, an ephemeral little magazine financed by Arensberg and Roché and edited by Duchamp. "Whether Mr. Mutt with his own hands made the fountain or not has no importance," he wrote. "He CHOSE it. He took an ordinary article of life, placed it so that its useful significance disappeared under the new title and point of view—created a new thought for that object." As for the moral objections, Duchamp pointed out that similar fixtures were seen every day in plumbers' show windows and added succinctly, "The only works of art America has given are her plumbing and her bridges."

The spirit that animated Duchamp's readymades was by no means an isolated phenomenon at that time. Everything Duchamp had done since 1913, in fact—all his early work on the *Large Glass*, his "amusing physics" and playful mathematics, his disdain for paint and canvas—bore an obvious relation to the Dada movement that began in Zurich in 1916, and Duchamp himself has often been described as a proto-Dadaist who anticipated Dada's violent rejection of traditional European art and culture. Dada had many origins, of course, and at the outset its main preoccupations were not so much aesthetic as political, the expression of a profound disgust for the ideals of European thought and the rationalism of Europe's leaders, which had led straight to the senseless horrors of the First World War. In their demonstrations of organized insanity at the Cabaret Voltaire in Zurich, the Dadaists showered contempt on the supposed logic of a world gone mad.

The Dadaists were poets and artists, though, and when their movement spread throughout Europe after the war its aesthetic manifestations predominated. In these the spirit of Duchamp was often in evidence. "Art is not the most

precious manifestation of life," Tristan Tzara wrote in
1922. "Art has not the celestial and universal value that
people like to attribute to it. Life is far more interesting."
Richard Huelsenbeck, like Tzara one of the original
Cabaret Voltaire group, has said that Duchamp's ready-
mades summed up brilliantly the Dadaist belief that art
should be a piece of reality itself rather than an interpre-
tation of reality. Dadaism was not a new form of art like
Cubism," Huelsenbeck has said. "Its real origin was a
doubt in the interpretive function of art. We tried to bring
in life as much as possible—Schwitters with his little bits
of life raw, life assembling itself in the picture. Then we
went even further and denounced abstraction in art as
just another form of interpretation, a search for some
deeper meaning. Duchamp went even further with his
readymades, things for which he gave no interpretation
at all. One step beyond would have meant giving up art
altogether."

In 1917, Duchamp was not quite ready for this one step
beyond. Although he spent by far the greater part of his
time enjoying life in New York, he continued, a little bit
each day, the slow, meticulous process of building up the
Large Glass, every detail of which was carried out with the
most scrupulous craftsmanship. In 1918, as though in
mocking contradiction of his own previous farewell to
traditional art, he even executed one last painting on can-
vas. The painting was commissioned by Katherine Dreier,
the strong-willed heiress whose passion for modern art, in-
spired by a visit to the Armory Show, provided a suitable
cause for her crusader's zeal.

Designed to be hung in a particular space over the door-
way in Miss Dreier's house in Connecticut—it is now in
the Yale University Art Museum—the painting was about

ten feet long and two feet high, and, for Duchamp, surprisingly colorful. Duchamp made it a sort of inventory of his principal ideas up to that point. Contours of the *Stoppages-Etalon* are painted in at the bottom left, beneath an image of the *Bicycle Wheel* that was obtained by rubbing with a lead pencil over the shadow cast by a real bicycle wheel on the canvas. Rubbings of two other projected readymades, the hat rack and a greatly enlarged corkscrew, cast spectral shadows over the rest of the painting, in which a long row of overlapping paint samples recedes into a perspective distance and an actual bottle brush projects from a rent in the canvas; the rent is an illusion, painted in *trompe-l'œil,* but it is secured by three *real* safety pins. Near the center of the picture is a pointing hand executed by a professional signpainter whom Duchamp employed for this purpose and whose signature, "A. Klang," is visible just below. Duchamp refused to offer any explanation for the title of the painting, which is *Tu m'.* One popular guess made it a contraction of the French *"tu m'ennuies"* ("you bore me") and suggested that the sentiment might have referred to Miss Dreier; it could just as conceivably have referred to the painting itself. "I never liked that painting very much," Duchamp confided to a friend in 1964. "It was just something decorative; besides which it has all the characteristics of a résumé, never a very attractive form of activity. But other people liked it, and they are the boss as we say." In any case, this was to be his last painting.

It also marked the end of his first stay in the United States. Duchamp left New York in the summer of 1918 and spent the next nine months in Buenos Aires, where he completed a small work on glass called *To Be Looked at with One Eye, Close To, for Nearly an Hour.* A study for

one section of the *Large Glass,* it was made partly by
"scratching" a design in mercury applied to the back of
the glass. It is now owned by the Museum of Modern Art,
and, expectably, the glass has been broken.

The atmosphere of the Argentine capital depressed him
—"all those foreign colonies keeping to themselves"—and
may have been partly responsible for the "unhappy ready-
made" that he executed at long distance. In a letter to his
sister Suzanne in Paris, Duchamp sent directions for her
to hang a geometry textbook from the balcony of her
apartment, where the wind could turn its pages and sub-
ject the theorems to the daily test of sun and rain. Suzanne
followed his directions and painted a picture of the result.

While he was in Buenos Aires, Duchamp learned of the
death of his brother Raymond, a few weeks after the
Armistice, of injuries suffered as a soldier at the front.
He returned immediately to Paris. A great deal had
changed in his absence. Apollinaire was dead too, another
war victim. The creative fervor of the prewar period had
been dissipated by four years of bloodshed. The old
rivalries of Cubism, Futurism, and Fauvism were long
forgotten, and the new postwar energies had not yet
gathered force. In this vacuum the Dada movement ex-
ploded like a well-timed bomb. Tzara arrived from Zurich
toward the end of 1919 and spread the Dada gospel of
anti-logic. Dada, he proclaimed, meant "Freedom . . . a
roaring of tense colors, and interlacing of all opposites and
of all contradictions, grotesques, inconsistencies." The gos-
pel was enthusiastically taken up by a group of young
painters and poets that included Picabia, Jacques Rigaud,
Georges Ribemont-Desaignes, André Breton, Louis Aragon,
and Paul Eluard, who soon launched a series of public per-
formances and manifestations that often ended in riots.

The Paris Dada group immediately recognized Duchamp as a kind of patron saint, who was no less highly regarded because he chose to remain somewhat elusive. Duchamp has said that he did not have enough of the "ham actor" in him to take part in the Dada performances at the Salle Gaveau and elsewhere. Although he later overcame his reticence sufficiently to play the part of a nude Adam in the Picabia-Satie ballet *Relâche,* his natural resistance to joining groups of any kind kept him on the fringes of the Dada movement. But Duchamp was clearly a Dadaist when he paid for one hundred and fifteen dollars' worth of dental work in 1919 with a beautifully fabricated check drawn on "The Teeth's Loan and Trust Company, Consolidated," and his dentist, Daniel Tzanck, was equally a Dadaist when he accepted the forgery and later sold it back to Duchamp for a much larger sum. Nor could Dada's loudest sallies improve upon the quiet savagery of Duchamp's 1919 "corrected readymade," a photograph of the Mona Lisa with mustache and beard. As Duchamp explained, "The Gioconda was so universally known and admired, it was very tempting to use it for scandal. I tried to make that mustache very artistic. Also, I found that the poor girl, with a mustache and beard, became very masculine—which went very well with the homosexuality of Leonardo." The title he chose heaped a further indignity upon the world's most famous painting. Duchamp called his version *L.H.O.O.Q.,* letters meaningless in themselves but whose sound, pronounced phonetically in French, becomes *"Elle a chaud au cul."*

The Dada movement reached a violent climax in Paris about 1922 and then fizzled out, having given birth to its more durable successor, Surrealism. The original Dadaists became what they had fought so hard against—productive

artists, like Arp, Ernst, and Schwitters; poets, like Tzara
and Breton and Aragon. Huelsenbeck completed his medi-
cal studies and became a practicing psychiatrist in New
York. But Duchamp, who never joined the movement, has
remained a natural Dadaist all his life. "What is left of
Dada?" the French writer Georges Hugnet asked in a 1932
essay on the subject; ". . . above all the remarkable per-
sonality of Marcel Duchamp, whose moral austerity and
haughty detachment, whose experiments and profound
thought surpassed the limits of Dada."

On his return to New York in 1920 Duchamp managed
to combine serious activities with private jokes of an in-
creasingly Dadaistic character. He appears to have taken
quite seriously his position as director of the Société
Anonyme, Katherine Dreier's pioneering effort to educate
the public to modern art (nine years before the Museum
of Modern Art was founded for this purpose) with lec-
tures and exhibitions of her own growing collection, which
Duchamp was helping her to assemble. In his studio, where
he had resumed work on the *Large Glass*, he also turned
his attention again to the problem of movement. *Revolving
Glass (Appareil Rotatif, Optique de Precision)* dates from
this period. It is a construction of five rectangular glass
plates of graduated lengths, mounted on a single axle
turned by a powerful electric motor. The plates have black
and white lines painted at each end, and when they are
revolved at high speed these lines form an illusion of
continuous circles. The apparatus nearly decapitated Du-
champ's friend Man Ray, who had brought his camera
in to photograph it in operation, when a fan belt flew off
and sent glass scattering in all directions. Afterward,
Man Ray recalled in his autobiography, Duchamp "ordered

new panels and with the patience and obstinacy of a spider reweaving its web repainted and rebuilt the machine."

At about this time Duchamp decided to take on a second identity. It has greatly puzzled a number of people that he chose a female alter ego, "Rrose Selavy," and even had himself photographed by Man Ray in woman's clothes to signalize the event. Various psychological interpretations have been advanced, of course, although there is nothing in Duchamp's personality or career to suggest that his inclinations in this regard have ever been anything but orthodox. Duchamp's own explanation is characteristically free of logic. "I just wanted two identities, that's all," he said. "It was a sort of readymadeish action. I first wanted to get a Jewish name, but I didn't find one. Then the idea jumped at me, why not a female name? Marvelous! Much better than to change religion would be to change sex. Rose was the most corny name for a girl at that time in French, and Selavy, of course, was *C'est la vie.* The double *r* in Rrose came from a play on words in Picabia's painting *The Cacodylactic Eye,* which he wanted all his friends to sign; in signing it I used the word *arroser,* and that gave me the idea of keeping the two *r*'s in the name." Rrose took to coining elaborate puns and signing readymades; the first one was the 1920 *Fresh Widow,* a verbal and visual pun in the form of a carpenter's scale model of a window frame (french window) whose panes were neatly covered with black leather (freshly widowed). This was soon followed by what is probably Duchamp's most arresting readymade, the bird cage filled with what appear to be lumps of sugar but are in fact marble, into which a thermometer has been stuck. It is an open question whether any other marble or gilded monuments in the Philadelphia

Museum, where this object is enshrined, will outlive the
compelling illogicality of its title, which can only be seen
reflected in a mirror placed beneath the bird cage. The
title is *Why Not Sneeze?*

The *Large Glass*, meanwhile, was gradually assuming
the mysterious aura of a famous work that hardly anyone
had seen. Duchamp's efforts to finish it became more and
more sporadic. For six months the *Glass* lay untouched in
the studio, gathering a thick layer of dust which Duchamp
then proceeded to use as a pigment, gluing the dust down
with varnish to one part of the "bachelor machine" (the
"sieves") and then wiping the rest away. This gave him a
color that did not come from the tube. Man Ray recorded
the "dust breeding" in a 1920 photograph that resembles a
weird lunar landscape. To arrive at the shapes of the
"draught pistons" in the Bride's "Milky Way" (all these
terms are from Duchamp's own notes), he made use of the
wind; he suspended a square of gauze in an open window,
photographed it three times, and reproduced the wind-
blown shapes at the top of the *Glass*. The placement of the
Bachelors' nine "shots" (which never do reach the waiting
Bride) was effected by dipping matches in wet paint and
firing them from a toy cannon at the *Glass*. The forces of
gravity, wind, and "personalized chance" were thus sub-
stituted for the workings of his own conscious hand, always
in the spirit of hilarity that Duchamp once paraphrased
as that "necessary and sufficient twinkling of the eye," and
always with the same meticulous, painstaking attention to
detail that a scientist might apply to a controlled nuclear
experiment.

When the Arensbergs moved from New York to Los
Angeles in 1921 they sold the *Glass* to Katherine Dreier so
that Duchamp could continue working on it, and he did so,

with interruptions, for two more years. Then one day he stopped working. The *Glass* itself was far from being finished. A number of important elements had not even been suggested visually. The "electrical undressing" of the Bride, outlined in the notes, had not be carried out, and so in effect the willing Bride was *not* stripped bare at all. After ten years Duchamp was bored with it. "It was too long, and in the end you lose interest," he told Walter Hopps in 1963, "so I didn't feel the necessity to finish it. I felt that sometimes in the unfinished thing there's more, there's still more warmth that you don't get, that you don't change or you don't perfect or make any more perfect in the finished product." With the *Large Glass*, Duchamp also abandoned all formal artistic production.

The fact that in 1923 Duchamp ceased to produce anything like "art" has been treated, even by people who disapprove of Duchamp, as an event of some magnitude in the history of modern art, and the temptation to speculate about his reasons for this abandonment has been irresistible. According to Richard Huelsenbeck, Duchamp simply decided "that life was more interesting than aesthetics—that life had to be lived, not painted." To Matta, the decision was a retreat from deeper commitments. "Marcel has this bullet-proof system," Matta has explained. "He doesn't live anything; he makes beautiful gestures." The rising commercialism of the art market, which has put such pressure on the leading artists to produce and produce, repeat and repeat, has been singled out by other Duchamp disciples as the real reason for a renunciation inspired by disgust. "Duchamp is Picasso's bad conscience," the critic Nicolas Calas has wittily observed. A more hostile critic, Hilton Kramer, suggested

that "at a certain point in Duchamp's development as an artist, the experience and objects of modern life defeated his ability to cope with them." There may very well be elements of truth in each of these opinions, as in many of the others that have been advanced. Duchamp himself has always maintained that the famous decision was not a decision at all and that he could start painting again tomorrow if he thought he had something new to contribute.

For a long time after 1923 the main stream of his intellectual energy was concentrated on the game of chess. All six Duchamp children had been enthusiastic chess players while they were growing up, and the game figured prominently in many of Duchamp's early paintings. Duchamp has dated the real beginning of his "violent career" as a chess player from his 1918 trip to Buenos Aires, where he joined a local chess club and took to staying up late at night to study the game. Back in New York after the war, as a member of the Marshall Chess Club that used to meet over the Pepper Pot restaurant near Washington Square, he started to play serious competitive chess and found himself winning more games than he lost. "After that the ambition set in," he has recalled. "When you reach that point you want to go on and become champion of the world, or champion of something. Of course I never did. But I tried. For twenty years I took it quite seriously, played in tournaments here and in France, even entered those correspondence tournaments where you play against twelve people who send you their moves by postcard that you must reply to within forty-eight hours— one tournament takes a year and a half to finish, and during that time you don't do anything but wait for that damn postcard and prepare your answer. By 1940 I under-

stood completely that it was hopeless, that there was no more use in trying."

The American chess master Edward Lasker, one of the great international champions of recent times and the author of many books on chess, has expressed the opinion that if there had been official rankings of United States chess players in the 1920s and 1930s Duchamp would certainly have ranked within the top twenty-five. "He was a very strong player," Lasker has said. "Of course, he never had the experience of playing regularly against professional masters, which is absolutely essential if you are going to become a champion. That's why the Russians are so good—in Russia promising young players get discovered in the Pioneer youth clubs and take lessons from masters. But Duchamp was a master among amateurs, and a marvelous opponent. He would always take risks in order to play a beautiful game, rather than be cautious and brutal to win." Duchamp himself has taught a number of his friends the game, and through his connections in the art world he has raised considerable sums of money for the American Chess Foundation, which sends the top United States players to compete abroad. He seems, on the whole, to have been a good deal more serious about chess than he ever was about art, and he has made no secret of his opinion that as an activity of the mind chess is much purer than art, because it is in no danger of being corrupted by money.

There may also have been a deeper motive. According to Julien Levy, the art dealer, who has been a close friend of Duchamp's for many years and an occasional chess partner since Duchamp taught him the game, "Marcel wanted to show that an artist's mind, if it wasn't corrupted

by money or success, could equal the best in any field. He
thought that with its sensitivity to images and sensations,
the artist's mind could do as well as the scientific mind with
its mathematical memory. He came damn close, too. But
of course the memory boys were tougher, and they had
trained for it from an early age. Marcel started too late
in life."

Although chess claimed a great deal of the energy
that Duchamp had formerly devoted to his *Large Glass*,
the usual statement that he abandoned art for chess is
misleading. In fact, one of the essential facts about Du-
champ is that while he has successfully avoided playing
the role of artist since 1923, he has never left the art world.
Soon after leaving his *Glass* in its state of definitive "in-
completion," Duchamp returned to Paris, where he re-
mained for the next three years. During that time he acted
as an unofficial agent for Arensberg, buying paintings and
receiving a ten-per-cent commission on each purchase.
Duchamp insists that Arensberg, like Katherine Dreier,
was an extremely strong-minded collector who did not
depend on anyone's advice. "He would write and ask me
to get a painting by Max Ernst, or someone else, and I
would send back photographs, and often he would decide
on the basis of the photographs. I didn't influence his de-
cisions." It is probably true that Duchamp's influence on
these two collectors was not a direct one. But as Julien Levy
has explained it, "When you're a disciple of Marcel's, it's
enough for him to say one day that he likes Max Ernst's
work, and a month later you find yourself wanting to buy
paintings by Ernst. That's how it must have been with
Arensberg, who was certainly a disciple."

Once Duchamp had stopped producing art, in fact, he
found himself hard put to avoid the pedestal on which

a growing host of admirers and disciples wished to place him. The Surrealist group in Paris treated him with even greater respect and awe than the Dadaists had, and André Breton, Surrealism's high priest, clearly regarded him as the greatest artist of the epoch. Although Duchamp took an active part from time to time in the Surrealists' activities, he never became involved in the personal feuds and rivalries that periodically decimated its ranks. His smiling, ironical detachment was never resented. There was so little self-interest in his irony that he made no enemies, not even among the legions of young women who continued to fall ecstatically in love with him, drawn by what one of his old friends has described as "an ethereal person who was also earthy, and devastatingly handsome." Disciples were not really his style in any case—particularly female disciples. Duchamp's longest and most devoted attachment, until his present marriage, was to an attractive American war widow in Paris named Mary Reynolds, who obviously adored him but just as obviously was his equal in the relationship. Their liaison, which lasted until Mrs. Reynolds' death in 1950, was thought by their friends to be happier than most marriages. It was certainly happier than Duchamp's first marriage, in 1927, to the daughter of a well-known French automobile tycoon. Since Duchamp never has discussed his private life, no one has ever been able to explain this curious affair as anything more than a Dadaistic joke on his part (albeit a rather cruel one). Man Ray has written that Duchamp spent most of the one week they lived together studying chess problems, and that his bride, in desperate retaliation, got up one night when he was asleep and glued the chess pieces to the board. They were divorced three months later.

The death of both his parents, in 1925, had brought Du-

champ a modest inheritance that was sufficient for his
material needs. Duchamp's economic theory was to break
even: having too much money made one a slave to the
goods money could buy, while having too little was maso-
chistic, therefore equally stupid; the only way to be free
was to break even, plus about ten per cent. Duchamp came
close to this ideal in 1924, when he worked out a system
of playing roulette that assured him of winning, as he put
it, an amount equal to the wages of a clerk who worked in
an office for as many hours as the gambler worked in the
casino. He floated a loan to finance the testing out of his
system at Monte Carlo and issued handsome "bonds"
bearing Man Ray's photograph of a faunlike Duchamp
with his hair soaped up into a pair of horns. The certifi-
cates, signed by Rrose Selavy as chairman of the board,
are now worth a good deal of money. In several weeks
of play at the roulette tables in Monte Carlo, Duchamp
broke even.

Following the debacle of his marriage, he returned to his
one-room apartment on the Rue Larrey in Paris—an apart-
ment that entered the Duchamp legend by way of a door,
which he designed and had made by a carpenter, that
served to close either the bathroom or the main entrance
alternately, and could therefore be open and shut at the
same time. In those pleasantly ambiguous surroundings,
Duchamp resumed his quiet existence. He was not really
working on anything except chess at this point. Since re-
turning to Paris in 1923 he had carried out another set of
motion experiments that resulted in his *Rotary Demi-
sphere*, a second and more complex optical machine whose
undulating spiral images Duchamp and Man Ray recorded
in their 1926 experimental film, *Anemic Cinema*. Now and
then he produced one of the anagrammatic puns (*Anemic*

Cinema, for example) or elaborate spoonerisms that goaded words into new areas of non-meaning; a good many of these were somewhat erotic (*"Faut-il mettre la moelle de l'epée dans la poil de l'aimée?"*), and some were truly magisterial, like the legend on the face of the *Rotary Demisphere*, which read *Rrose Selavy et moi esquivons les ecchymoses des Esquimaux aux mots exquis."* These verbal readymades often appeared in Surrealist magazines, and a slim volume of them was published in 1939. Duchamp also made several trips to New York, twice to organize exhibitions of Brancusi's sculptures, whose importance he was one of the first to recognize, and once to buy back from the estate of the lawyer and collector John Quinn some of his own early work, which he wanted Walter Arensberg to have. For the most part, though, Duchamp played chess. He played in international tournaments throughout Europe, winning his share of matches and achieving many beautiful games, without quite managing to beat the toughest of the "memory boys." In 1932 he published a treatise on chess that only a chess master could understand. His sole contribution to art in that year was to coin the word "mobile" for Alexander Calder's first moving sculptures—objects, Duchamp said admiringly, that "carry within them their own pleasures, which are quite different from the pleasures of scratching oneself."

Even within the art world, Duchamp's reputation had faded to near invisibility by the early 1930s. The publication in 1934 of his complete notes for the *Large Glass*, loosely gathered together in a limited edition called the *Green Box*, was therefore something of an event in art circles. As Duchamp said later, the *Large Glass* itself was not just an object to be looked at, but a "wedding of mental and visual elements" in which "the ideas . . . are more im-

portant than the actual visual realization." The notes, he said, "are concerned with what happens without being seen. My first idea was that after the *Glass* was finished I would have the notes made into a book, rather like a Sears and Roebuck catalogue, to go with it. I never did that, of course." His alternative solution in 1934 was to reproduce the notes exactly as they had been written—on the same size scraps of paper, using the same inks, duplicating even the underlinings and deletions—and to publish them just as they appeared in the original cardboard box, jumbled together in no special order so as to avoid the temptation of overly logical interpretations. The *Green Box* of 1934 was thus the first public revelation of a whole new aspect of Duchamp's major work, an aspect that Duchamp considered at least equal in importance to the visual part already known.

Deciphering the notes proved to be a major undertaking, couched as they were in a language of Duchampian playfulness and complexity, but there were admirers willing to make the attempt. The most successful of these was André Breton, whose brilliant essay *"Le Phare de la Mariée"* ("The Lighthouse of the Bride"), published in the October 1934 issue of the Surrealist journal *Minotaure*, laid the groundwork for a new approach to the *Large Glass*. Following the clues in the *Green Box*, Breton provided a step-by-step interpretation of how the Bride was almost (but not quite) stripped bare by her Bachelors, even, and reflected poetically on Duchamp's "fabulous hunt through virgin territory, at the frontiers of eroticism, of philosophical speculation, of the spirit of sporting competition, of the most recent data of science, of lyricism, and of humor." In its perfect balance of rational and non-rational concepts, he concluded, the *Large Glass* ranked among the most sig-

nificant works of the twentieth century, a magical light-
house whose purpose was "to guide future ships on a
civilization which is ending."

Duchamp has accepted Breton's exegesis as he has ac-
cepted all others, without cavil or correction. To him, these
industrious colonizations are just as valid as his own voy-
ages of discovery. He has smiled indulgently at the psy-
chiatric interpretations which prove that the *Glass*'s creator
was a schizophrenic, although he has been known to protest
upon occasion that the *Glass* "is not my autobiography, nor
is it even self-expression." One gathers, though, that Du-
champ does not really believe that his great work requires
or lends itself to rational explanation. As he once remarked
to his friend George Heard Hamilton, in reference to the
Glass, "There is no solution because there is no problem."

Through an irony that was truly Duchampian, when
Breton's essay appeared the lighthouse itself had been
wrecked. In 1926 the *Large Glass* was included in a
Société Anonyme exhibition at the Brooklyn Museum. For
its return trip to Katherine Dreier's home, the upper and
lower glass panels were separated and placed, one on top
of the other, in a packing case, which was then loaded on
the back of an old truck. The packing case remained closed
for several years. When it was finally opened the *Large
Glass* lay in a heap of shattered fragments.

"I didn't feel anything much when I heard the news,"
Duchamp has recalled. "I had to console poor Katherine
Dreier, for one thing. But then I'm fatalistic, I never cry at
unpleasant things." He repaired it in 1936, reassembling
the splintered fragments and securing them between two
sheets of heavier plate glass clamped together by a metal
frame. Observers soon noted an extraordinary coincidence:
the cracks in the glass, which ran the same way in both

sections because of the manner in which they had been
packed, bore a striking resemblance to the contours of
Duchamp's personal units of measurement, the *Stoppages-
Etalon*. This led a few soothsayers to conclude that Du-
champ had planned the whole thing, by way of extra-
sensory perception. The cracks have come to seem an
integral part of the composition, but Duchamp has main-
tained that the form they took was mere coincidence.

The two-month effort of repairing the *Glass* was not an
unpleasant chore for Duchamp, who had for some time
shown a paternal interest in the final disposition of his
work. Whenever he heard that a painting or an object of
his was coming on the market (often these were items that
he had given away to friends), he made every effort to see
that it went to the right person—usually Walter Arensberg.
Julien Levy has told of a time during the 1930s when he
was having a struggle keeping his New York gallery open,
and needed two thousand dollars to pay his back rent: "I
only had one or two pictures worth that amount, and one
of them was Duchamp's 1913 painting, *Bride*, which I'd
acquired about four months previously. I don't know how
Marcel's wireless operated, but he called me up just about
that time and said he understood I needed some money
and that he had arranged for Arensberg to buy the *Bride*
for two thousand dollars. He said, 'I would like him to
have it now.' So that's what happened."

Several dealers would have paid handsomely for a new
painting by Duchamp at this point. His reputation was
rising again, partly as a result of Alfred Barr's important
exhibition of "Fantastic Art, Dada, Surrealism" at the
Museum of Modern Art in 1936, in which eleven works
by Duchamp were featured. The art dealer Knoedler once
appealed to Man Ray to tell Duchamp that there was ten

thousand dollars a year at his disposal if he would return to painting—"all he had to do was paint one picture a year." When Duchamp heard about the offer "he smiled and said he had accomplished what he had set out to do and did not care to repeat himself." Occasionally, when asked, he would design a cover or layout for a magazine, and these seemingly casual efforts never failed to show some striking originality. His cover for a 1936 issue of *Cahiers d'Art* was a design of superimposed red and blue hearts (*Cœurs Volants*) in which the juxtaposition of the two colors set up chromatic vibrations that created the illusion of depth—a discovery that anticipated by thirty years the "optical" art of Morris Louis, Kenneth Noland, and a number of others. The year before, he had spent several months turning out "rotoreliefs," round cardboard disks that fitted on a phonograph turntable and whose printed abstract designs, when revolved at 33 r.p.m., produced the illusion of recognizable objects in three dimensions. Duchamp exhibited his rotoreliefs at the annual gadget show in Paris, the Concours Lépine, hoping perhaps to fulfill Apollinaire's prophecy that he would reconcile art and the people; the people would not be reconciled, and in a month not a single disk was sold. But nothing could induce the apostate to return to painting.

In 1938, with the shadow of another war falling over Europe, Duchamp began quite literally to pack his aesthetic bags. He designed an ingenious leather-covered box, about the size of an attaché case, whose sides opened out to form a sort of personal museum for small-scale reproductions of sixty-eight of his works—paintings and ready-mades. Duchamp had three hundred copies of each item made up in Paris, by commercial printers and hardware-supply houses, and then turned over the job of assembling

them in the individual boxes to a succession of needy friends. By 1964 the project was still unfinished; the *"boîtes-en-valise,"* as they were called, were being assembled, at the rate of thirty a year, by Duchamp's own step-daughter by his present marriage. From the first, he priced them only slightly higher than they cost to make. He insists that the enterprise was mainly a business ("small business, I assure you"), but he adds that for him it was far easier than doing a new painting, and "more fun to make a grouping that is expressive of one's life." The boxes also serve to make certain the survival of his ideas, which have always been more important to him than the original works that incorporate them.

When the war came Duchamp once again found sanctuary in New York. By posing as a cheese buyer for a Paris firm he was able to make repeated trips through Occupied France to Marseilles, and on each trip he carried out a bundle of his reproductions in miniature. When he had them all safely in Marseilles he made his way to Lisbon and from there to New York, arriving late in 1942 with his reproductions and very little else.

Among the group of European artists and intellectuals uprooted by the war and set down in New York, Duchamp alone seemed to feel completely at home—Max Ernst described him as "perfectly contented." He lived in a studio over a commercial building on West Fourteenth Street, and he had no telephone. People who wanted to get in touch with him did so by postcard or telegram. According to Sidney Janis, the art dealer, Duchamp lived on twenty-five dollars a week. Few people were ever invited to his studio (which he still maintains and where he still spends a few hours a day when he is in New York). William Copley, the painter and collector, was taken up to it once by

Duchamp, and he remembers it vividly: "It was a medium-sized room. There was a table with a chess board, one chair, and a kind of packing crate on the other side to sit on, and I guess a bed of some kind in the corner. There was a pile of tobacco ashes on the table, where he used to clean his pipe. There were two nails in the wall, with a piece of string hanging down from one. And that was *all*." No one had the slightest idea what he did in these spartan surroundings. It was said that he gave French lessons, that he spent all day studying chess problems, that he was working in secret on a new masterpiece. Duchamp provided no enlightenment. When reporters tried to pin him down he would say only that he was a *"respirateur,"* a breather, and that his economic arrangements were his own affair. Occasionally, through his many contacts in the art world, he would be instrumental in procuring a particular painting for some collector, and it was generally believed that the modest commissions he received gave him all he needed to live on.

Odd tales were told about him. It was said, for example, that a young professor had come to interview Duchamp in his studio, and found him playing chess with a nude woman; that they had finished their game while the professor nervously waited, after which the young woman dressed and departed and Duchamp, without a word of explanation, turned his attention to the visitor. Like a good many of the tales told about Duchamp, this one was wholly imaginary, although perhaps spiritually true.

Much of Duchamp's extraordinary influence can be traced to the complete trust that important dealers and collectors, following the lead of Arensberg and Katherine Dreier, placed in his judgment during this period. Peggy Guggenheim, whose "Art of This Century" gallery on West

Fifty-seventh Street was showing the work of the European
refugee artists as well as new American painters like
Jackson Pollock, Clyfford Still, and Mark Rothko, has said
frankly that Duchamp taught her everything she knew
about painting, that he was responsible "for my whole life
in the modern art world." Sidney Janis regularly sought
his advice on new artists. "He had that inner confidence
that I've observed in only one other painter, Mondrian,"
Janis has said. "Both Marcel and Mondrian liked things
that were very different from what they themselves had
done. They didn't have to protect their own point of view
all the time, as so many painters feel obliged to do. Even
Picasso, when he first looked at a painting of Pollock's,
said it was 'nothing.' But Marcel was never dogmatic."
Duchamp has preferred to minimize his own influence:
"It was partly my age. Don't forget, I'm ten years older
than most of the young people!"

The paradox of his position is splendidly ironic. Often
described as the supreme anti-artist of all time, he has
consistently helped to promote the careers of other artists
and to further the development of modern art. As several
of his friends have remarked, Duchamp always says yes.
He believes that it is easier to do what people ask of you,
because afterward you are free; to say no, he has found,
leads to endless complications.

The Surrealists, who liked to show their work in a
properly surrealist atmosphere, periodically enlisted Du-
champ to help organize their exhibitions. For the 1938 In-
ternational Exposition of Surrealism in Paris, he turned
the main room of the Galerie Beaux Arts into a subter-
ranean cave by hanging twelve hundred coal sacks from
the ceiling and covering the floor with a thick carpet of
dead leaves. In 1942 a Surrealist exhibition was organized

in New York for the benefit of French children and war prisoners. Duchamp's setting for this show was a vast web of string, several miles in all, running from floor to ceiling and thoroughly entangling both the paintings and the spectators. The string may have been thought to symbolize the difficulty of approaching this kind of art, but, according to Duchamp, "these ideas never had rational explanations." The 1947 International Exposition at the Galerie Maeght, in Paris, for which Duchamp acted as "benevolent technician" although he remained in New York, had a Duchamp-designed catalogue on the cover of which was a woman's breast in sponge rubber, with a notice beneath reading "Please Touch."

During the 1940s and 1950s, Duchamp seemed to do little or nothing to promote his own reputation, but this was hardly necessary. Others did it for him—at least in America, which he had chosen to make his permanent home. In 1945 a whole issue of the New York Surrealist journal *View* was devoted to Duchamp, his influence, and his legend. His work kept appearing in group exhibitions, and in 1954 a major part of it went on permanent display with the Arensberg Collection in the Philadelphia Museum, which had also received the *Large Glass* as a gift from Katherine Dreier. The rest of Miss Dreier's collection was divided, after her death in 1952, between the Yale University Art Gallery and the Museum of Modern Art. Duchamp, as her executor, made the distribution.

Robert Lebel's definitive study in 1959, together with the 1958 volume of Duchamp's collected puns and other writings edited by Michel Sanouillet (published in French under the suitably punning title of *Marchand du Sel*), and the 1960 version of the *Green Box*, translated into English by George Heard Hamilton and put into book form by

Richard Hamilton, a young British artist, made his work
and ideas readily available for the first time to a whole new
generation. And the big 1963 retrospective show at the
Pasadena Museum effectively canonized him as one of the
old masters of twentieth-century art. The effect of all this
on the contemporary art market can be imagined. In the
early 1960s William Copley paid an astute New York
dealer ten thousand dollars for a 1921 Duchamp ready-
made called *La Bagarre d'Austerlitz* (it is a carpenter's
sample window, something like the one in *Fresh Widow*,
but the panes are glass instead of leather). On his way
home with it he stopped in to see another, equally astute
dealer, who suggested that the *Bagarre* might be worth
double that amount to him. Copley wasn't interested.

For a number of Duchamp's close friends, the really
tantalizing question is Duchamp's own role in this process.
Has he really been indifferent toward fame or did he
subtly engineer the whole thing? No one really knows
the answer. Pierre de Massot, one of the early Dadaists
and a friend of Duchamp for forty years, has said that
"ever since 1920 he has been preparing his pedestal—he
always knew just what he was doing." Huelsenbeck, who
has known him almost as long, believes that there has
never been a trace of ambitiousness in Duchamp's charac-
ter. "He never wanted to be anybody," says this Dadaist-
turned-psychiatrist, "and he became one of the great per-
sonalities of our time." When Sidney Janis was planning
a retrospective Dada exhibition at his gallery in 1953, he
insisted that Duchamp help with the organization. As
Janis has told it, two other former Dadaists soon began
to take over the preparations, to the point of moving Du-
champ's works out of the front room where Janis had
placed them so as to make space for others they considered

more representative. "Marcel's attitude was to let them do it. He had no objection at all to being put in the back room. I wouldn't have that, and I finally had to lay down the law to the other two and tell them it was my show. Well, now, did Duchamp *know* I was going to do that? Or didn't he really care? Arshile Gorky used to say that Duchamp planned everything that way, counting on others to fight his battles for him. I just don't know—and no one else does either."

Now and then the Duchamp legend has given rise to a muttering of protest in some quarters. During a 1963 public seminar on Pop Art at the Museum of Modern Art, a conservative critic launched a fairly vitriolic attack on Duchamp from the platform, calling him "the most over-rated figure in modern art." When Duchamp was asked during the intermission how he felt about this diatribe, his only comment was that it had been "perhaps insufficiently lighthearted." But in New York, where his reputation has always been much greater than in Paris, Duchamp seems to have had no real enemies in the art world—a unique fact in itself and a tribute to his own lightness of heart. Even the Abstract Expressionists, whose intensely "retinal" painting is about as far as possible from the Duchamp concept of art as a mental act, seem to go along with Willem de Kooning's celebrated remark that " Duchamp is a one-man movement, but a movement for each person and open to everybody."

Since about 1954, the year he became a United States citizen and married Teeny Sattler, friends have detected a subtle mellowing of Duchamp's nature. His irony has tended to be a little less cuttingly bacheloric, a little more what Duchamp once defined as the "irony of indifference." "If you can ironize with no affective result, with no de-

structiveness or laughter either—in other words, with in-
difference—then you have a chance for another vista,"
Duchamp has said. "It's not very clear, I know, but then
I'm not writing a book on the science of irony." He ap-
pears to take great pleasure both in his marriage and in the
douceur of his new life, which is now arranged so that
he and Teeny spend their summers in Paris and Cada-
qués, on the Costa Brava. Although he retains many of his
old ties in France, he is nevertheless quite satisfied to live
most of the year in New York, which he still considers a
better climate for an artist. "In Europe," he maintains,
"the young always act as the grandsons of some great man
—Victor Hugo, or Shakespeare, or someone like that.
Even the Cubists liked to say they were grandsons of
Poussin. They can't help it. And so when they come to
produce something of their own the tradition is inde-
structible. They're up against all those centuries and all
those miserable frescoes which no one can even see any
more—we love them for their cracks. That doesn't exist
here. You don't give a damn about Shakespeare, do you?
You're not his grandsons at all. So it's a good terrain for
new developments. There's more freedom here, less rem-
nants of the past among young artists. They can skip all
that tradition, more or less, and go more quickly to the
real. Also, people leave you alone here. In my case, any-
way, I've found in America a little better acceptance of
my right to breathe. Of course, any place you stay in
long enough becomes boring. Heaven especially, I im-
agine."

Whatever mellowing there may have been in Duchamp's
personality, none has been detected in his attitude toward
the art of his time, or toward art in general. In fact, the
three small sculptures that Duchamp turned out in the

1950s—*Objet-Dard, Female Fig Leaf,* and *Coin de Chasteté* (the last a wedding gift to his wife in 1954)— are as erotically disturbing as anything he has done in the past, and a good deal more shocking than the latest triumphs of the Pop generation. Nor has Duchamp's benevolence toward some of the younger American artists altered his belief that almost all of the art produced in this century has been of relatively little importance. "I'm afraid that our dear century will not be very much remembered," he has said. "In the first place, the means employed today are very perishable. They use bad pigments, and they do everything so quickly. Quick art, that's been the characteristic of the whole century from the Cubists on. The speed that's being used in space, in communications, is also being used in art. But things of great importance in art have to be slowly produced. And then, of course, there is the terrific commercialization. So many artists, so many one-man shows, so many dealers and collectors and critics who are just lice on the back of the artists. Some of them are my friends, but I still have no respect for the profession of dealer or critic. And with commercialization has come the integration of the artist into society, for the first time in a hundred years. In my time we artists were pariahs, we knew it and we enjoyed it. But today the artist is integrated, and so he has to be paid, and so he has to keep producing for the market. It's a vicious circle. And artists are such supreme egos! It's disgusting. No, the only solution for the great man of tomorrow in art is to go underground. He may be recognized after his death, if he's lucky. Not having to deal with the money society on its own terms, he won't have to be integrated into it and he won't become contaminated, as all the others are." Asked whether going underground was

not, in a sense, what he had done, Duchamp gave a wry
laugh. "Maybe in the beginning," he said. "But I'm not
underground now, am I? People ask me so many questions.
It's probably my doom, too."

It is many years since Duchamp thought of himself as
an artist, though, and he values his freedom far too much
to return to the "doom" of habit-forming drugs. In spite
of his gathering fame, he has remained a free man—free
of all cults and movements, and free especially of his own
past work, in which he takes a cool, objective interest.
"These things are like his children who have gone out into
the world and become different people," Richard Hamilton
has observed. "He's interested in them, but detached—they
really have nothing to do with him any more."

In any event, while posterity goes about its job of having
the last word and completing the creative act that he un-
wittingly began, Duchamp continues in his quiet way to
undermine aesthetic pretensions and knock over the icons
wherever he finds them, even the icons of his own cult.
During the official opening of the Pasadena show, for ex-
ample, he spent one whole morning signing replicas of his
work—readymades, prints, exhibition posters, and the like.
He signed and signed, smiling all the while and looking,
according to Richard Hamilton, rather pleased with him-
self. When the job was finished Duchamp touched Hamil-
ton's arm and said softly, "You know, I like signing all
those things—it *devalues* them."

John Cage

One afternoon in the fall of 1962 the American composer John Cage and the pianist David Tudor, who were nearing the end of a six-week concert tour of Japan, attended a special service in their honor at the Grand Shinto Shrine of Ise, near the seacoast about seventy miles south of Nagoya. The service had been ordered and paid for by their official host, Mr. Sofu Teshigahara, a well-to-do Japanese art patron and master of the art of flower arrangement, and it included the music and dances of the ancient ritual of *gagaku*. The purpose of the ceremony, as requested by Mr. Teshigahara and expressed in the prayers of the officiating priests, was to bring blessings upon the avant-garde activities of Mr. Cage and Mr. Tudor, and to cause the sun to shine favorably upon the flowering of all such avant-garde activities throughout the world.

Whether by coincidence or design, the international

avant-garde does seem to have been more active than usual
since then, causing lively disturbances and astounding the
bourgeois in many countries. Nowhere, however, has it
been more active than in the United States, and no Ameri-
can has caused so many disturbances or astonishments as
John Cage. Although it could be argued that Cage has
been doing this sort of thing since the 1940s and on a
scale so far unapproached by any of his musical col-
leagues, the 1963 and 1964 music seasons in New York
seemed at times to be characterized by a wholly unpre-
cedented blossoming of Cage-directed activities, including
the first performance of Cage's work by the New York Phil-
harmonic. The reaction of the Philharmonic subscription
audiences to Cage's musical ideas indicated that Mr.
Teshigahara's Shinto blessing was wearing a bit thin, but
Cage had no time to brood about that. Shortly afterward,
he left New York for a six-months world tour with the
Merce Cunningham Dance Company, during which he and
Cunningham brought their avant-garde music and dance
ideas to the attention of new and far more receptive audi-
ences in Europe, Scandinavia, and the Far East.

The attitude of most New York subscription audiences,
and most New York musicians for that matter, toward
works by Cage is almost invariably hostile. Cage regrets
this but is not in the least daunted by it. In the first place,
most regular concertgoers in this country are inclined to
be hostile to *all* music composed in the twentieth century
(excepting jazz and its derivatives), and they find them-
selves confirmed in their opinion by the fact that our
major orchestras rarely perform such works. Although
recordings and FM radio broadcasts, together with a few
enterprising concerts put on by small groups in New York
and elsewhere, are beginning to acquaint a predominantly

youthful audience with the musical works composed since the 1940s, it is still accurate to say that a very large section of the American music public—unlike the public for the visual arts—has been effectively insulated from the developments in musical composition that have sprung from the two great revolutions in twentieth-century music: Schönberg's abandonment of conventional tonality, and the post–World War II development of magnetic tape that ushered in the era of electronic music. In this atmosphere, it is hardly surprising that the general public shows particular hostility to the work of John Cage. His music is certainly less familiar—less recognizable, that is, by nineteenth-century standards—than any other music being written in the 1960s, and ears tuned to nineteenth-century traditions usually do not hear it as music at all. However one chooses to define what Cage does, though, it can hardly be denied that his work and his ideas have exerted, and continue to exert, an extraordinary influence on the work of contemporary composers throughout the world.

The most cursory survey of Cage's career—in his fifties, his vigor and originality show no signs of flagging —suggests the profusion of his musical ideas. In his twenties Cage developed new forms of percussion music, following the work of Edgard Varèse but altogether unique in tone, many of which served as scores for the leading modern dance groups of the day. His invention of the "prepared piano," a system of muting the strings that transformed an ordinary grand piano into a kind of percussion orchestra, won him awards from the Guggenheim Foundation and also from the National Academy of Arts and Letters, which cited him for "extending the boundaries of musical art." In his thirties he started to employ techniques of composition by chance methods which anticipated

and directly influenced the European and American composers of what is now called "aleatory," or chance, music, and which Igor Stravinsky has described (in some dismay) as the music of the 1960s. Cage was experimenting with electronic sounds ten years before the advent of magnetic tape, and when tape became available to composers he was one of the first to sense its possibilities; his *Imaginary Landscape No. 5,* a collage of recorded sounds, is the earliest piece of tape music to be produced in this country. The fecundity of his ideas has impressed itself upon a whole new generation of composers and painters to such an extent that the music critic Peter Yates, looking back over this record in 1963, concluded that "John Cage would appear to be the most influential living composer today—whatever opinion you or I may hold about his music." Although the current crop of avant-garde leaders in Europe and the United States tend to deny that they are influenced by Cage, and some spend a great deal of time explaining just how their work differs from his, the question of influence is of minimal interest to Cage himself. Now that aleatory music is all the rage, he has moved on, as usual, into new fields of electronic sound and audio-visual activities. His extraordinary ability, even in this era of rampant avant-gardism, to stay several jumps ahead of his followers has long been one of his more noteworthy characteristics, and there is simply no telling what astonishments he may provide in the years to come.

Cage would be very happy if his work were received more sympathetically, or at least more objectively, by audiences, critics, and musicians. He prefers to live "in a climate of agreement," as he puts it, and his own approach to life and experience is so openhearted, his sense of humor so abundant, and his personality so winning that

he is rarely subjected in private life to the hostility that his work arouses in public. And yet Cage is far too intelligent to expect any general acceptance of his music or his ideas in the foreseeable future, for what he is proposing is, essentially, the complete, revolutionary overthrow of the most basic assumptions of Western art since the Renaissance. The power of art to communicate ideas and emotions, to organize life into meaningful patterns, and to realize universal truths through the self-expressed individuality of the artist are only three of the assumptions that Cage challenges. In place of a self-expressive art created by the imagination, tastes, and desires of the individual artist, Cage proposes an art born of chance and indeterminacy, in which every effort is made to extinguish the artist's own personality; instead of the accumulation of masterpieces, he urges a perpetual process of artistic discovery in our daily life.

Again and again in *Silence,* the published collection of his lectures and writings up to 1961, Cage asked himself the question: What is the purpose of writing music (or engaging in any other artistic activity)?, and answered with a restatement of his basic creed. The purpose, he wrote in 1957, is "purposeless play"; and he added: "This play, however, is an affirmation of life—not an attempt to bring order out of chaos nor to suggest improvements in creation, but simply to wake up to the very life we're living, which is so excellent once one gets one's mind and one's desires out of its way and lets it act of its own accord."

Cage is by no means alone in pursuing an art that goes beyond individual self-expression. A number of painters, writers, and composers in various countries have been moving in roughly the same direction, and many of

them have used chance methods as a means to that end. None of them, however, has been willing to go as far as Cage does. Composers like Pierre Boulez and Karlheinz Stockhausen have employed methods of chance and indeterminacy in their writing, but generally without giving up control of their use. Cage, on the other hand, favors abandoning all vestiges of control and turning the whole composition over to chance. All his efforts are directed to the difficult process of getting rid of his own tastes, imagination, memory, and ideas, so that he will then be able to "let sounds be themselves." To many of his old friends, this is pure heresy. The sculptor Richard Lippold, who has known Cage for many years, says he now finds it difficult to talk with him at all. According to Lippold, "John has the most brilliant intellect of any man I've ever met, and for years he's been trying to do away with it. Once he said to me, 'Richard, you have a beautiful mind, but it's time you threw it away.' To me, that's like saying, Richard, you make beautiful sculpture, why not cut off your hands?" Even Earle Brown, a composer who has worked in close association with Cage, has parted company with him aesthetically over the issue of eliminating all control. "There's no real freedom in John's approach," Brown has said. "I think that a really indeterminate situation is one where the self can enter in, too. I feel you should be able to toss coins, and then decide to use a beautiful F sharp if you want to—be willing to chuck the system in other words. John won't do that."

To all such complaints and criticisms, Cage's answer is basically the same. He believes that the world is changing more rapidly and more drastically than most people realize. A great many of the traditional attitudes of Western thought will soon be obsolete, he feels, and a great

many of the older traditions of Oriental thought are be-
coming increasingly relevant to life in the West. Cage
insists that the true function of art in our time is to open
up the minds and hearts of contemporary men and women
to the immensity of these changes, in order that they may
be able "to wake up to the very life" they are living in the
modern world. But—and this is crucial to Cage's argument
—only by getting completely out of the imprisoning circle
of his own wishes and desires can the artist be free to enter
into the miraculous new field of human awareness that is
opening up, and thereby help others to enter in as well.
Thus, even in Cage's view, art turns out to have a purpose
after all, and a very important purpose at that. The "pur-
poseless play" of the artist, which is really an imitation of
nature in her newly perceived manner of operation (in-
determinate, chancy, without design), should serve ideally
to lead his audience into the promised land of a totally
new form of experience in which, as Cage picturesquely
describes it, "everyone is in the best seat." Art and life,
for Cage, are no longer separate entities as they have been
in the past, but very nearly identical; and Cage's whole
career can in fact be seen as a long campaign to break
down all demarcation between the two.

A moderately tall man whose close-cropped dark hair
and broad smile make him appear considerably younger
than his years, Cage gives the impression of one who
finds his own life a continually delightful and surprising
affair. He is a Californian by birth, and this, some people
feel, explains a lot. "They try anything in California—and
Cage is like that," Aaron Copland has written. "He is really
interested in the experimental attitude, not in creating
great eternal masterpieces, but in amusing himself on the
highest level with new notions concerning music." It has

also been viewed as significant that he is the son of a well-known inventor and electrical engineer. In 1912, the year Cage was born in Los Angeles, his father, John Milton Cage, established a world's record for staying under water in a submarine of his own design—thirteen hours, with thirteen people on board, on Friday the thirteenth. The submarine was propelled by a gasoline engine that left a trail of bubbles on the surface, and was therefore of no interest to the Navy; Cage *père* had not been thinking in military terms when he built it. Although Cage showed an early and marked disinclination toward anything connected with engineering, he has agreed (with Copland) that the experimental attitude is what really interests him, and he has always been pleased to be thought of as an experimenter with sounds and an inventor in the field of music.

John Milton Cage's inventions never quite led to the long-expected pot of gold, and the family fortunes were somewhat up and down. The Cages moved about a good bit. John, Jr., their only child, attended schools in Ann Arbor, Detroit, Santa Monica, and Los Angeles, getting straight A's in all of them. An extraordinarily gifted, happy youngster, he took to music early and with complete enthusiasm. His mother has a vivid recollection of him standing in the aisle, totally absorbed, during the entire two hours of a symphony concert to which she had brought him in some trepidation—he was five at the time. Although his parents tried at first to discourage his musical interests (two of Mrs. Cage's sisters and one of her brothers were musicians, "and the general feeling," Cage has said, "was that it wasn't a good thing to be"), they capitulated gracefully to the boy's already remarkable powers of persuasion and bought him a baby grand piano, which he remembers

playing on while the movers were carrying it into the house.
Cage started taking piano lessons when he was in the fourth
grade, first from a local teacher whose sign he had spotted
near their own house in Santa Monica, then from his
Aunt Phoebe, and later from Fannie Charles Dillon, a
composer who used to listen to bird calls, write down the
notes, and use these as her melodies.

"I wasn't very gifted on the piano," Cage has said.
"I disliked the technical exercises and all the physical
aspects, and I remember having a kind of sinking feeling
every time Aunt Phoebe or Miss Dillon played for me,
because the music they played was fantastically difficult
and I knew I would never be able to play that well. But
Aunt Phoebe taught me sight reading, and that seemed to
open the door to the whole field of music." He haunted
the Los Angeles Public Library's extensive music collec-
tion, taking home scores and exploring the literature—
within certain limitations. Aunt Phoebe did not approve of
Bach or Beethoven, and she never once mentioned Mozart.
Cage's explorations were therefore confined to the minor
figures of the nineteenth century. "I became so devoted to
Grieg," he has said, "that for a while I played nothing else.
I even imagined devoting my life to the performance of
his works alone, for they did not seem to me to be too
difficult, and I loved them."

This ambition was eventually supplanted by the desire
to become a minister, as his grandfather had been, of the
Methodist Episcopal Church, but his ecclesiastical leanings
did not survive his exposure to a wider intellectual climate
at Pomona College in Claremont, California. College had
a strange effect on Cage. Having been graduated from Los
Angeles High School with the highest scholastic average
in the school's history (he was class valedictorian, and

won first prize in the Southern California Oratorical Contest), he entered Pomona at the age of sixteen and soon slumped to the level of a B or C student. He has described how this came about: "One day the history lecturer gave us an assignment, which was to go to the library and read a certain number of pages in a book. The idea of everybody reading the exact same information just revolted me. I decided to make an experiment. I went to the library and read other things that had nothing to do with the assignment, and approached the exam with that sort of preparation. I got an A. I deduced that if I could do something so perverse and get away with it, the whole system must be wrong and I wouldn't pay any attention to it from then on. I'd discovered Gertrude Stein about that time, and I took to answering exams in her style. I got an A on the first and failed the second. After that I just lost interest in the whole thing." He was writing poetry then and had begun to think he would be a writer. At the end of his sophomore year, he persuaded his parents that a trip to Europe would be more useful than two more years of college, and in the spring of 1930, having been promised a modest allowance from them, he hitchhiked to Galveston and sailed for France.

Paris enchanted but rather overwhelmed the seventeen-year-old Cage. Trying to find some means of making contact with the city and its past, he decided to make an exhaustive study, in the architectural library of the Bibliothèque Mazarin, of fifteenth-century stone balustrades. This somewhat confining enterprise was brought to an abrupt end by the arrival in Paris of one of his former professors at Pomona, José Pijoan, a flamboyant scholar, who asked Cage what he was doing and, when informed, "lifted his foot and gave me a violent kick in the pants." Pijoan sent

him to see a young modern architect in Paris named Gold-
finger, and Cage spent the next few months in Goldfinger's
office, drawing Greek columns. One day, he heard Gold-
finger tell a friend, "To be an architect, one must devote
one's life solely to architecture." Cage went up to his
employer and explained that he could not follow this ad-
vice, because there were too many other things he was
interested in. He left the firm soon afterward.

Cage became keenly interested in modern painting in
Paris, to the point of trying it himself, but he still knew
next to nothing about modern music, or, for that matter,
about Bach or Mozart. He did know a little about Bee-
thoven, though, and one evening, at the home of the Baronne
d'Estournelles, to whom he had been introduced by a
Pomona classmate, he was asked to play a Beethoven
sonata on the piano. Cage explained that he could not play
the first movement because he lacked sufficient technique
but would be happy to play the andante. His hostess said
this was all wrong but to go ahead anyway. When he had
finished, La Baronne, who had great influence in musical
circles, praised his touch and said she would give him an
introduction to M. Lazare Lévy, at that time the leading
piano teacher at the Paris Conservatoire. "Lazare Lévy
was extremely surprised that I had no knowledge of Bach
or Mozart," Cage has recalled. "He accepted me as a
pupil, but I took only two lessons. I could see that his
teaching would lead to technical accomplishment, but I
wasn't really interested in that. Meanwhile he sent me
to a Bach festival, where I finally discovered Bach—you can
imagine how delighted I was over that! On my own, I
went to a concert of modern music by the pianist John Kirk-
patrick, who really got me interested in modern music. He
played Stravinsky, Scriabin, and some other things. I went

right out and bought myself a collection of modern music,
with short pieces by Hindemith and Stravinsky, and I also
bought the Bach *Inventions* and the Scriabin *Preludes*, and
then I began spending a lot of time playing as much of this
music as I could on the piano."

At this point in his career, however, Cage was not ready
to devote himself exclusively to any of the arts. Suddenly
restless after six months in Paris, he left on an impulse
for Capri, and then spent the next year wandering rather
aimlessly from place to place—Biskra, Majorca, Madrid,
Berlin. He wrote poetry and painted pictures, and in
Majorca, where he had access to a piano, he tried for the
first time to compose music. These early pieces, which were
very brief, he worked out according to an elaborate mathe-
matical system that he felt was an attempt to approximate
the structural order in Bach. The attempt was not successful,
and none of the pieces survives. "My attitude then," Cage
has said, "was that one could do all these things—writing,
painting, even dancing—without technical training. It
didn't occur to me that one had to study composition. The
trouble was that the music I wrote sounded extremely dis-
pleasing to my own ear when I played it."

Cage came home in the fall of 1931, after eighteen
months in Europe. He drove across the country in a Model
T Ford and moved into his parents' home in the Pacific
Palisades, where he continued his writing, painting, and
composing. Soon afterward, another reversal of the family
fortunes obliged his parents to give up their house and
move into an apartment in Los Angeles. Cage took a job
as gardener in a Santa Monica auto court. To help make
ends meet, he set himself up locally as a lecturer on
modern painting and music, selling tickets to housewives
in door-to-door fashion (ten lectures for two and a half

dollars) and explaining, with typical candor, that he did not know very much about these subjects but was enthusiastic about them and would each week inform himself on the subject of that week's lecture. Surprisingly enough, considering that this was the depth of the Depression, enough housewives turned out for each lecture—from twenty to thirty each time—to make the venture mildly profitable.

"But then the day came," Cage has recalled, "when I foresaw that I'd have to give a lecture on Arnold Schönberg. I didn't know anything about him, and his music was far too difficult for me to play. It was really a disastrous situation." Cage did know that an American pianist named Richard Bühlig had been the first person to play Schönberg's *Opus 11*, a crucial work in the history of modern music and a landmark on the road to atonal, twelve-tone composition. Cage had telephoned Bühlig the preceding year in Los Angeles—after deciding quite irrationally that Bühlig must live there and finding that he did—and asked if he could come and hear him play Schönberg's music. "Certainly not," Bühlig had said and hung up. Now Cage decided to go to see him and explain his current predicament. He did so, waiting for twelve hours outside the man's house and accosting him when he came in. Although Bühlig flatly refused to play for Cage's lecture audience, he invited Cage inside, agreed to look at Cage's music, and eventually took him on as a pupil.

"Bühlig was a wonderful, cultivated man, and he taught me a great deal," Cage has said. "The first thing he said, after seeing my music, was that I had to learn something about structure." Cage's work up to that time had been of two kinds—very brief pieces derived from complex mathematical systems, and settings of written texts by Aeschylus, Gertrude Stein, and other favorite authors,

which he would improvise at the piano and then try to
write down quickly before they got away. Bühlig showed
him that these were not really composed at all, since they
lacked any sort of structural relationship, and he directed
Cage to Ebenezer Prout's standard books on harmony and
musical form. Bühlig also impressed on him the im-
portance of time. "One day, when I arrived at his house
half an hour early he slammed the door in my face and
told me to come back at the proper time. I had some library
books with me which I decided to return, and thus I ar-
rived at his house a half hour late. He was simply furious.
He lectured me for two hours on the importance of time—
how it was essential to music and must always be carefully
observed by anyone devoted to the art." As a result of his
work with Bühlig, Cage developed a method of com-
position that employed two twenty-five-tone (two-octave)
ranges, one low and one high, with a middle octave shared
by both; no single tone in the shared range was to be re-
peated until at least eleven others had intervened, and no
tone in the non-shared range could be repeated until all
twenty-five had been used. The method was rigid, com-
plex, but structured, and it was not unlike the method used
by Schönberg himself. (In Schönberg's method of "serial"
composition the twelve tones within each octave are re-
arranged by the composer to form a theme, or "tone-row";
the composition is then built by using the tones horizon-
tally, as melody, or vertically, in chords, but only in the
order established by the original tone-row, and all twelve
tones must be used before any one can be repeated.) A few
of Cage's pieces from this period have been preserved, and
one of them, called *Six Short Inventions,* was on the pro-
gram of Cage's twenty-fifth anniversary retrospective con-
cert at Town Hall in 1958.

With Bühlig's encouragement, Cage sent several of his new twenty-five-tone pieces to Henry Cowell in San Francisco. Cowell, himself a composer of dash and originality —he was the first to experiment with "tone clusters" produced by striking the piano keys with the entire forearm— was at that time putting on concerts of new music, publishing a great deal of experimental work in his *New Music Quarterly,* and serving as a walking repository of names, addresses, and information about everyone doing original work in the music field. He agreed to have a Cage *Sonata for Clarinet* performed at one of his concerts. Cage hitchhiked to San Francisco for the great event. When he got there, on the afternoon of the performance, he found that the clarinetist had not even seen the piece before that day, and, after taking one look, had decided it was too difficult to play. Cage ended up playing it himself, on the piano, but he was deeply offended, and the incident had a bearing on his subsequent decision not to rely on conventional musicians.

Through his lectures and his association with Bühlig, Cage had come to meet a number of influential people who were interested in contemporary painting and music. Cage was still painting energetically then—what he has called "squintings at landscape," verging toward abstraction—and he had not been able to make a decision between painting and music. More and more, though, he realized that people like the Walter Arensbergs and Galka Scheyer (a painter and collector who had introduced the works of the Munich "Blue Rider" school to America) were showing a good deal of enthusiasm for his music and very little for his painting. Henry Cowell's interest really tipped the scale and helped him to make the decision he had been unable to make with regard to architecture in Paris; hence-

forth he would devote himself entirely to music. Cowell
had told him that he should study with Schönberg, and
Cage readily agreed; it was necessary at that time to make
a choice between Stravinsky's neo-classicism and Schön-
berg's serialism, and he had already chosen Schönberg.
Since Cage's musical training was so sketchy, Cowell sug-
gested that he prepare himself for the great German master
by studying first with Adolf Weiss, a former pupil of
Schönberg, who lived in New York. In the spring of 1933
Cage said good-by to family and friends and climbed
aboard that invaluable depression conveyance, an east-
bound freight train.

Cage spent a year and a half in New York, living in a
series of cheap furnished rooms, and earned a living of
sorts washing walls at the Brooklyn YWCA. He studied
harmony and composition with Weiss for two hours after
work each day, and usually spent his evenings playing
bridge with Mr. and Mrs. Weiss and Henry Cowell, who
was then teaching at the New School for Social Research
on Twelfth Street. No matter how late the previous evening's
bridge game had lasted, he got up at four a.m. every day
and composed for four hours. He eventually became a
scholarship student at the New School and took all of
Cowell's courses, which put him in touch with the whole
world of modern music. By the fall of 1934 he felt suffi-
ciently enlightened to approach Schönberg, who had re-
cently come to America and was teaching, by a pleasant
coincidence, at the University of Southern California. Cage
drove back across the country with Cowell and presented
himself immediately to Schönberg. Their initial meeting
was brief. Schönberg questioned whether Cage could afford
to study with him. "I told him," Cage has said, "that there
there wasn't any question of affording it, because I couldn't

pay him anything at all. He then asked me whether I was willing to devote my life to music, and I said I was. 'In that case,' he said, 'I will teach you free of charge.' " Cage has since tried to pay back this debt by teaching his own students free of charge whenever they cannot afford to pay him, and sometimes when they can.

"Schönberg was a magnificent teacher, who always gave the impression that he was putting us in touch with the musical principles," Cage has said. "I studied counterpoint at his home and attended all his courses at USC and later at UCLA when he moved there. I also took his course in harmony, for which I had no gift. Several times I tried to explain to Schönberg that I had no feeling for harmony. He told me that without a feeling for harmony I would always encounter an obstacle, a wall through which I wouldn't be able to pass. My reply was that in that case I would devote my life to beating my head against that wall —and maybe this is what I've been doing ever since. In all the time I studied with Schönberg he never once led me to believe that my work was distinguished in any way. He never praised my compositions, and when I commented on other students' work in class he held my comments up to ridicule. And yet I worshiped him like a god." It was not until many years later, after Schönberg's death, that Cage learned, from the critic Peter Yates, what his teacher's real opinion of him had been. Schönberg had once confided to Yates that Cage was "not a composer, but an inventor—of genius."

Soon after he began studying with Schönberg, Cage got married. His wife, Xenia Andreevna Kashevaroff, was one of six talented, striking, and volatile daughters of a Russian Orthodox priest in Juneau, Alaska, and they had met two years before, when Cage was working in a crafts

shop in Los Angeles. Xenia, then an art student, came in to look around and left soon afterward without saying a word, but her effect on Cage was so shattering that the next time she came in he asked her to have dinner with him that night, and during the meal he asked her to marry him. "She said she'd have to think about it," Cage says. She had thought about it while Cage was in New York, decided favorably, and they were married soon after his return. Cage supported them while he studied by doing library research for his father. He picked up other odd jobs from time to time, one of which turned out to be of great importance to his future career. Through a friend he met one of the pioneers of abstract film-making, Oskar Fischinger, and was commissioned to do the music for one of Fischinger's films. Fischinger had an idea, which he expressed to Cage, that every inanimate object possessed its own indwelling spirit, which was released when the object made a sound. This slightly whimsical notion suddenly opened up for Cage a whole new world of musical possibilities, a world that did not depend on harmony for its structure; it thus pointed the way out of the impasse to which his studies with Schönberg were leading, and it led directly to the compositions for percussion instruments that were to occupy him for the next decade.

There had been a flurry of interest in percussion music during the 1920s, stimulated in part by the 1913 Italian Futurist manifesto, by Luigi Russolo, calling for an "art of noises." In the early thirties, Edgard Varèse had, as Cage put it, "fathered forth noise into twentieth-century music"—Varèse's famous score *Ionization*, with parts for forty-one percussion instruments and two sirens, was written in 1931—and some of Henry Cowell's work came close to pure noise-music. Cage, who got to noise through Varèse

and to his own particular idea of sounds through Fisch-
inger, was very clear from the start about the direction
in which these ideas were leading. "I believe that the use
of noise to make music will continue and increase until we
reach a music produced through the aid of electrical in-
struments which will make available for musical purposes
any and all sounds that can be heard," he stated in a 1937
lecture. "Whereas in the past the point of agreement has
been between dissonance and consonance, it will be, in the
immediate future, between noise and so-called musical
sounds." In answer to the charge that noise itself could not
be music, Cage's reply was equally explicit. "A single
sound by itself is neither musical nor not musical," he said.
"It is simply a sound. And no matter what kind of a sound
it is, it can become musical by taking its place in a piece
of music."

Cage's unique contribution to this development was his
use of silence. He used it not simply as a gap in the con-
tinuity or a pause to lend emphasis to sounds, but in much
the same way that contemporary sculptors were using open
space, or "negative volume"—as an element of composi-
tion in itself. The music he wrote in this period was full
of silences, some rather long, woven into the context of
delicate, generally quiet noises, which Cowell once de-
scribed as "a shower of meteors of sound." Cage organized
his own percussion orchestra to play his new music, and
its members—as was proper for this breaking of new
ground—were not musicians at all. He and Xenia were
friends of a well-known Los Angeles bookbinder named
Hazel Dreis, who had a large house that was usually filled
with apprentices. Cage collected a variety of novel percus-
sion instruments, salvaged for the most part from local
junkyards—automobile brake drums, hub caps, and so on

—and brought them to Hazel Dreis's, where, each evening, the bookbinders became musicians under Cage's tutelage. Outsiders began coming in to hear the percussion concerts, and Cage was so pleased with the results that he invited Schönberg to come. "Ah, so?" said Schönberg, when invited, but said he was busy that night. Cage said he would arrange a concert for any other night that Schönberg was free. Schönberg said he would not be free any other night either.

Fortunately for Cage, there was another branch of the music world that welcomed all such experiments. For some time the modern dance had been the real patron of twentieth-century music. The followers of Martha Graham not only took an interest in the innovations and experiments of young composers, but commissioned new works and used them as scores for their dance performances. Cage joined a modern dance group at UCLA; he improvised at the piano during its technique classes and was soon composing percussion pieces for their dances. He kept adding to his stock of percussion instruments—and discovering new sounds in the process. His "water gong," for example, came into being when he was asked to compose a score for the UCLA swimming team's annual water ballet. Cage discovered that when the swimmers were under water they could hear nothing, so he tried lowering into the pool a gong that had been struck; the swimmers could hear that, all right, and the gong's sound went through such amazing transformations on immersion and removal from the water that Cage happily used it in other non-aquatic pieces

In 1937, having completed his studies with Schönberg Cage and Xenia moved to Seattle, where Cage had been offered a job working as composer-accompanist for Bonnie Bird's dance classes at the Cornish School, a progres

sive institution with a curriculum that stressed the arts.
The two years they spent there were highly productive.
Cage organized a student percussion orchestra and gave
percussion concerts throughout the Northwest. He also
wrote letters to all the contemporary composers he could
think of, suggesting that they try their hand at percussion
pieces; a number of composers did so, and the library of
American percussion music grew as a result from a dozen
or so to more than a hundred works. Cage's concerts at-
tracted the attention of Seattle's lively art and music
colonies. The painters Mark Tobey and Morris Graves
came to the concerts and became friends of the Cages. A
gifted young composer named Lou Harrison, who was
teaching at Mills College in California and who had con-
tributed enthusiastically to Cage's library of percussion
music, arranged to have Cage attend the summer program
at Mills, where three of the leading modern dance groups
and a galaxy of artists and intellectuals from the Chicago
School of Design, including László Moholy-Nagy and
Gyorgy Kepes, provided an atmosphere of brilliance and
excitement.

Back at Cornish in the fall of 1938, Cage was asked
by Syvilla Fort, a Negro student who later became well-
known as a dancer, to write the music for a new dance of
hers called *Bacchanale*. His solution to the problems posed
by this request was to invent a totally new instrument, the
prepared piano, and it marked a turning point in his
career. "I was still writing twelve-tone music for piano
then," he has recalled, "and I knew that wouldn't work
for *Bacchanale*, which was rather primitive, almost bar-
baric. My percussion music would have been fine, but there
was no room in the dance theatre for all those instruments.

I worked and worked without getting anywhere. The performance was only three days off. Then suddenly I decided that what was wrong was not me—it was the piano. I remembered that Henry Cowell had used his hands *inside* the piano and had even used a darning egg to slide along the strings, so I began trying things inside the piano too— magazines, newspapers, ash trays, pie plates. These seemed to change the sound in the right direction, making it percussive, but they bounced around too much. I tried using a nail, but it slipped around. Then I realized that a bolt or a large wood screw, inserted between two strings, was the answer. This changed every aspect of the sound. I soon had a whole new gamut of sounds, which was just what I needed. The piano had become, in effect, a percussion orchestra under the control of a single player."

In its subsequent refinements, which included the use of rubber, wood, glass, and other materials inserted between the strings, the prepared piano became the most widely admired of all Cage's innovations. Virgil Thomson, reviewing a 1945 concert for two prepared pianos in New York, spoke of the "gamut of pings, plucks, and delicate thuds" as being "both varied and expressive" and described the effect as "slightly reminiscent, on first hearing, of the Balinese gamelang orchestra, although the interior structure of Mr. Cage's music is not Oriental at all." Oddly enough, at the time Cage invented it he believed that his own talent was primarily technological. "I was under the impression then that everything in art that could be done had already been done," he has said, "and that my function was as an inventor and research worker rather than as an artist. I had been very much influenced by two books— Henry Cowell's *New Musical Resources* and Carlos Chavez' *Toward a New Music*—both of which were concerned

with the need to apply modern technology to music. I was
also very taken with the ideas of Varèse, who saw all
these things before I did. It's funny, I think of myself as
an inventor, but I almost always find that what I think is
really original in my work has been done before by some-
one else."

During his two years at the Cornish School, Cage also
evolved a musical theory that freed him once and for all
from the shackles of harmony. "Schönberg always stressed
the structural function of harmony, as a means of relating
the parts to the whole," Cage has explained. "But tra-
ditional harmonic structure had been in a process of dis-
integration ever since Beethoven—a process that shows
up very clearly in the music of Wagner and of Schönberg
himself. I realized, moreover, that harmony relates only to
pitch, but that pitch does not really apply to percussion
music—to noise—and that it certainly does not apply to
silence, which I had come to regard as an essential com-
plement to sound. Now, when you analyze the physical
nature of sound, you find that it has three other character-
istics besides pitch—it has timbre, loudness, and duration.
The only one of these four characteristics that *does* relate
to both sound and silence is, quite obviously, duration.
And so I came to realize that any structure for percus-
sion music—for a situation in which harmony does not
exist—must be based on duration, or *time*."

Rhythmic structure based on time lengths was Cage's
alternative to the classical harmonic structure of Western
music. His system was to devise for each composition a
structural whole divisible into small parts, each of which
had a mathematical relation to the whole. For example, in
his *First Construction (in Metal)*, a percussion piece com-
posed at Cornish School, there is a total of sixteen parts,

each of which contains sixteen measures; each of the six-
teen measures is divided into five phrases of, respectively,
four measures, three measures, two measures, three meas-
ures, and four measures; similarly, the sixteen parts as a
whole are divided into five large sections in the same pro-
portion: 4,3,2,3,4. All this was plotted out mathematically
in advance, and it is significant to note that the extremely
complex procedure made it very difficult for the composer
to work in any sort of personal self-expression. Cage saw
no drawback in this. His work with modern dancers had
taught him to compose scores according to "counts"—
dance movements that had already been choreographed
and timed—so that his dance scores did not express his
own ideas but simply accompanied the dancer's actions.

In addition to the percussion music in rhythmic struc-
ture, which he continued to write for the next ten years,
Cage kept on composing twelve-tone pieces and experi-
menting with new materials. Access to the recording studio
at Cornish School enabled him to start a series of works
that he called *Imaginary Landscapes*, which, with their
use of constant and variable frequencies on test recordings
and other electrical engineering devices, can be described
as the first electronic scores ever composed. By the end of
his second year at the school, though, Cage was feeling
the need for a wider field of operations. More and more he
had come to feel that what he should do was persuade
some affluent patron or organization to set up a center for
experimental music in which he and other young innova-
tors could work in collaboration with sound engineers. In
1939 Cage and his wife moved to San Francisco, where
he took a job with the WPA, working as a recreational
leader in hospitals and community centers, and spent all
his free time writing letters to foundations, universities,

laboratories, motion-picture studios, and assorted tycoons, none of whom showed any burning desire to finance a center for experimental music.

"Trying to establish the center had made me ambitious, though," Cage has said, "and giving performances had brought me before increasingly large audiences. I was beginning to think that I might become an artist after all." An invitation from Moholy-Nagy to teach a class in experimental music at the Chicago School of Design seemed to point in the direction of even wider horizons, and although the salary was minimal the Cages moved to Chicago in 1941. Cage took a supplementary job accompanying the dance classes of Katherine Manning. He also recruited and trained a group of amateur percussion players and gave a concert at the Chicago Arts Club. There he made contact with some influential Chicagoans, who in turn introduced him to officials of CBS Radio, which had its Chicago offices in the same building as the Arts Club. The result of all these meetings was a commission from the CBS "Columbia Workshop" to do a radio show in collaboration with the poet Kenneth Patchen. The program, which was called "The City Wears a Slouch Hat," had as its theme the visit of a Christ-figure to a modern city. Cage wrote a 250-page score in which various sound effects suggestive of the actual sounds of the city were to be considered not as "effects" but as music. A week before the performance the CBS engineers informed him that his score was utterly impractical and could not be done. Cage worked day and night for the next week writing a new score for percussion instruments and some sound effects that *were* practical, and the program was broadcast on schedule, over a national hookup. "Afterward," Cage has said, "we received many letters in Chicago from listeners

in the West and Middle West, and they were almost all enthusiastic. So I decided that I was going to be a great success, and because of that I should go to New York." Cage and Xenia had just enough money at that point to pay the bus fare, but they had recently met Max Ernst, the painter, when he was passing through Chicago, and Ernst had invited them to come and stay with him and his wife, Peggy Guggenheim, in their New York apartment. This seemed to clinch matters. The Cages left Chicago in the spring of 1942 and arrived in New York with exactly twenty-five cents between them.

Cage used a nickel of that to dial the number Ernst had given him. What followed was suitably surrealistic. "Max Ernst answered," Cage has related in *Silence*. "He didn't recognize my voice. Finally he said, 'Are you thirsty?' I said 'Yes.' He said, 'Well, come over tomorrow for cocktails.' I went back to Xenia and told her what had happened. She said, 'Call him back. We have everything to gain and nothing to lose.' I did. He said, 'Oh, it's you. We've been waiting for you for weeks. Your room's ready. Come right over.'

"We stayed with Max and Peggy for about two weeks, in their lovely apartment overlooking the East River, and met a great many people whose names were written in gold in my head—Piet Mondrian, André Breton, Virgil Thomson, Marcel Duchamp, even Gypsy Rose Lee. I was just flabbergasted by the whole situation. Somebody famous was dropping in every two minutes, it seemed."

This agreeable situation came to an abrupt end as a result of Cage's new-found ambitions. Peggy Guggenheim was then preparing to open her "Art of This Century" gallery on West Fifty-seventh Street, and she had decided that the opening should be celebrated with a concert of Cage's

music. At the same time Cage was pulling strings to get a
concert at the Museum of Modern Art, "which, from Cali-
fornia and Chicago, had just loomed as the center of the
world for me. I didn't even think of Carnegie Hall, be-
cause the conventional musicians had already turned me
down—besides which, the musical ideas I was developing
seemed more related to modern painting than to anything
else. In any case, when Peggy learned that I had arranged
to have a concert at the Modern Museum the following
winter, she was furious. She canceled the concert at her
gallery and refused to pay for the transportation of my
percussion instruments from Chicago, which she had
agreed to do earlier. Worse still, she let us understand that
our living in her house was not a permanent arrangement,
as we had been inclined to think it was."

The Cages suddenly found themselves homeless, penni-
less, and without prospects. The Modern Museum concert
was still six months off. CBS officials in New York, whose
mail on the Cage-Patchen radio program must have come
from different sources than Cage's, were in no mood for
further sallies into experimentation. Cage and Xenia
found temporary lodging for the summer in an apartment
that belonged to Jean Erdman, the dancer, who was to give
a program at Bennington College in collaboration with a
former Cornish School student and soloist in Martha Gra-
ham's company, Merce Cunningham; in return, Cage wrote
the music for a Cunningham-choreographed duo called
Credo in Us. "But we still didn't have any money," Cage
has recalled. "It was the first time I'd actually been at the
point of not having *anything,* not even a nickel. And be-
cause of this it became a different situation somehow—as
though I were suddenly free of the economic problem. I
simply took the attitude that people should give me money.

I wrote to several friends in Chicago and other places, and
some of them sent checks." They got through the summer
this way. From then on Cage was able to make his living
mainly by writing music for modern dancers, at the rate of
five dollars for each minute of music. He also got some
library research work from his father, who had moved to
New Jersey and was engaged in a top-secret project for
the government that had to do with a device to help air-
plane pilots see through fog. As a result of this work
Cage was deferred from military service in the war.

Cage's concert at the Museum of Modern Art in February
1943 was the first in a series of New York concerts and
recitals that quickly established his reputation as the most
discussed young composer of the avant-garde. Although the
performances of his work seldom made money—and often
lost fairly impressive sums—they interested important ele-
ments of the music world and made for Cage a number of
influential friends. The most influential of these was Virgil
Thomson, the composer, who at that time was the music
critic of the *Herald Tribune* and a member of numerous
committees on musical matters. He was usually the first
person to see Cage's scores, as soon as they were com-
pleted, and he wrote penetrating and enlightening reviews
of all Cage's concerts. "Mr. Cage has carried Schönberg's
twelve-tone harmonic maneuvers to their logical conclu-
sion," Thomson wrote in 1945 after a prepared-piano con-
cert at the New School. "By thus getting rid, at the begin-
ning, of the constricting element in atonal writing—which
is the necessity of taking constant care to avoid making
classical harmony with a standardized palette of instru-
mental sounds and pitches that exists primarily for the pur-
pose of producing such harmony—Mr. Cage has been free
to develop the rhythmic element of composition, which is

the weakest element in the Schönbergian style, to a point of sophistication unmatched in the technique of any living composer. . . . His work represents . . . not only the most advanced methods now in use anywhere, but original musical expression of the very highest poetic quality."

Gratifying as this sort of recognition must have been, Cage found himself increasingly assailed by doubts concerning the validity of his musical approach. Much of the music he had written in Chicago and New York had been an attempt to express his own personal ideas. *Imaginary Landscape No. 3,* with its thunderous sound effects and loud electronic buzzes, was intended to suggest war and devastation. In *Amores,* a suite of four pieces of which two were for prepared piano and two for percussion trio, Cage had tried to express his belief that even in wartime beauty remains in intimate situations between individuals. *The Perilous Night* suite, which followed, was concerned with "the loneliness and terror that comes to one when love becomes unhappy." To a good many listeners, though, the effect was rather different. When a critic wrote, for example, that the last movement of *The Perilous Night* sounded like "a woodpecker in a church belfry," Cage was genuinely dismayed. "I had poured a great deal of emotion into the piece, and obviously I wasn't communicating this at all. Or else, I thought, if I *were* communicating, then all artists must be speaking a different language, and thus speaking only for themselves. The whole musical situation struck me more and more as a Tower of Babel." Along with these feelings of uncertainty about his ability to express anything musically, Cage was undergoing severe strains in his personal life. He and Xenia separated in 1945, and were divorced soon afterward, and Cage went to live on the top floor of a tenement building on Monroe

Street, on the lower East Side. He became deeply absorbed
in the composition of a long work for prepared piano—
longer by far than anything he had yet done—in which he
set out to express the "nine permanent emotions" of Indian
aesthetic tradition (a concept he had encountered in a book
by Ananda K. Coomaraswamy), and which took the form
of sixteen sonatas and four interludes. At the same time his
doubts and anxieties had become so pressing that he took
the advice of several of his friends and went to see a psy-
chiatrist. The doctor announced cheerfully that he would
soon have him writing "much more music than you do
now." "Good heavens," Cage replied, "I write too much
as it is!" and never returned for a second visit. Cage felt
nevertheless that he had some severe problems and that
something should be done about them. "And then in the
nick of time," he said later, "Gita Sarabhai came like an
angel from India."

Gita Sarabhai was a young woman from a brilliant and
wealthy Indian family, and she had come to America to
study Western music. She elected to study counterpoint
and contemporary music with Cage, who in turn persuaded
her to teach him about Indian music and the ideas and tra-
ditions behind it. It would have been difficult to have found
a student more receptive to the wisdom of the Orient than
Cage. His own music for the prepared piano was so East-
ern in quality that the OWI, during the war, used to beam
it on short wave to the South Pacific "with the hope," Cage
wrote, "of convincing the natives that America loves the
Orient." Cage's concept of rhythmic structure was remark-
ably close to the rhythmic systems called *tala*, on which
traditional Indian music is based; he discovered this for
the first time after meeting Miss Sarabhai. "We were to-
gether almost every day," Cage has recalled, "often with

Lou Harrison. One day I asked what her teacher in India
had thought was the purpose of music. She replied that he
had said the function of music was 'to sober and quiet the
mind, thus rendering it susceptible to divine influences.'
I was tremendously struck by this. And then something
really extraordinary happened. Lou Harrison, who had
been doing research on early English music, came across a
statement by the seventeenth-century English composer
Thomas Mace expressing the same idea in almost exactly
the same words. I decided then and there that this *was* the
proper purpose of music. In time, I also came to see that
all art before the Renaissance, both Oriental and Western,
had shared this same basis, that Oriental art had continued
to do so right along, and that the Renaissance idea of self-
expressive art was therefore heretical."

For the next eighteen months, while he was working on
his *Sonatas and Interludes,* Cage immersed himself in the
philosophies of both East and West. He had started out
with the feeling that East was East and West was West, but
the more he read, the more correspondences he found be-
tween the two supposedly separate states of mind, "so that
I gave up thinking that the Orient was not for us." Toward
the end of this period of study, just as he was beginning to
feel ready to stop "window shopping" among the world's
philosophies and religions, he discovered Zen. Dr. Daisetz
T. Suzuki, the first important spokesman for Zen Buddhism
in the West, had recently come to America and started giv-
ing his weekly lectures at Columbia University. The lec-
tures were attended by psychoanalysts, scientists, painters,
and sculptors, as well as by philosophy students. Cage was
the only musician who came to them. He went regularly for
two years and he felt that they took, for him, the place of
psychoanalysis. "I had the impression that I was changing

—you might say growing up. I realized that my previous understanding was that of a child."

Although convinced that what he learned from Suzuki made possible all the new work he was to do, Cage has been anxious that Zen not be *blamed* for any of his activities. "I went up to Suzuki after one lecture," Cage has related, "and asked him what he had to say about music. He said he knew nothing about music and had nothing to say. I then asked him what he had to say about art, and he said he had nothing to say about art either. Of course, this may just have been the Zen form of teaching by not teaching. At any rate I got no help from him there and had to do my own thinking." Cage saw that Zen, like psychoanalysis, was an attempt to open up the psyche from within to a more intense awareness (enlightenment, or *satori*) of everyday life. He soon went on to the conclusion that, if the function of music was truly, as Miss Sarabhai's teacher said, "to sober and quiet the mind, thus rendering it susceptible to divine influences," it could be said that music should try to do *externally* what Zen and psychoanalysis attempted *internally*; the "divine influences," in Cage's view, simply signified the Zen idea of "waking up to the very life we are living." Music, then, should not be concerned primarily with entertainment, or communication, or the symbolic expression of the artist's ideas and tastes, but should rather perform the specifically useful function of helping men and women to attain a more intense awareness of their own life, not only in the concert hall but during every waking moment. How could music do this? Cage found his answer in the statement by Coomaraswamy that all art should "imitate nature *in her manner of operation*" (i.e., rather than in her outward appearances), and this is precisely what he has tried to do in his own music ever since. Cage

freely admitted that no music could ever be as interesting
as life itself. "Of course what we do is inferior to life in
complexity and in unpredictability," he has said. "But
this also makes it easier to experience, and hearing it in the
special situation of the concert hall may make people
aware in a way they would not have been otherwise. I
would like to think that the sounds people hear in a concert
could make them more aware of the sounds they hear in
the street, or out in the country, or anywhere they may be."

Now that his doubts about the value of composing music
had been resolved, Cage threw himself into his work with
renewed vigor. Through Lincoln Kirstein, whom he had
met at Virgil Thomson's, he was commissioned to write a
score for the Ballet Society; this was *The Seasons,* his first
work for an orchestra of conventional instruments. He
continued work on his *Sonatas and Interludes* and also
made several tours as accompanist and, eventually, as
musical director of the Merce Cunningham Dance Com-
pany, which was just beginning to gain recognition as one
of the most interesting and adventurous modern dance
groups in the country. During one such tour, in 1947,
Cage and Cunningham were especially well received at
Black Mountain College in North Carolina, an experi-
mental institution, now defunct, which placed its emphasis
on original work in the arts. As a result they were invited to
return to Black Mountain the following summer to teach.
The idea was that Cage would offer a survey course in mod-
ern music, but by the time the summer came around he had
decided to present instead a festival of the music of Erik
Satie.

Cage had long been interested in Satie, whose ironic and
bizarre spirit had presided, somewhat mysteriously, over
the activities of Les Six in Paris during the 1920s; indeed,

Cage thought he could detect in Satie's then little known symphonic drama, *Socrate*, a type of rhythmic structure similar to his own, a structure which, he firmly believed, had enabled Satie to break with the harmonic structure of Beethoven. (Some years later Cage saw Satie's notebooks in Paris and found, sprinkled about the margins, clusters of numbers that seemed to correspond to the numbers Cage used to work out his own rhythmical structures. Hugely excited, he mentioned his discovery to Darius Milhaud, who had known Satie well. "Oh, no," said Milhaud. "Those numbers referred to shopping lists.") In any event Cage not only talked the Black Mountain authorities into letting him put on his Satie festival, but persuaded them to publish his lectures at the end of the summer. This latter project came to grief when Cage, in one of his lectures, was moved to denounce Beethoven. "With Beethoven the parts of a composition were defined by means of harmony," Cage told the assembled students and faculty. "With Satie and Webern they were defined by means of time lengths. The question of structure is so basic, and it is so important to be in agreement about it, that we must now ask: Was Beethoven right, or are Webern and Satie right? I answer immediately and unequivocally, Beethoven was in error, and his influence, which has been as extensive as it is lamentable, has been deadening to the art of music." This was going a bit too far even at Black Mountain, and some of the members of the faculty never forgave him. The talks on Satie were not published.

The following year, 1949, was an auspicious one for Cage. His *Sonatas and Interludes*, finished finally in late 1948, received its first New York performance in January at Carnegie Recital Hall by the pianist Maro Ajemian and was well received. ("Delightful, varied, sprightly," wrote

Virgil Thomson, "recalling in both sound and shape the esercizi . . . for harpsichord by Domenico Scarlatti.") The National Academy of Arts and Letters, rarely a forum of advanced ideas, voted Cage a thousand-dollar award "for having extended the boundaries of musical art" through his invention of the prepared piano, and this was followed soon afterward by a twenty-four-hundred-dollar grant from the Guggenheim Foundation. Cage deferred the Guggenheim money until a later date and added the National Academy award to the profits from a Cage-Cunningham tour to send himself and Cunningham to Europe.

Virgil Thomson had given him the names of two young French composers, Serge Nigg and Pierre Boulez, and Cage lost no time in looking them up when he got to Paris. Although Nigg's music failed to impress him, he was immediately and powerfully struck by that of Boulez. Hearing Boulez play his *Second Piano Sonata*, Cage felt what he described as that "trembling in the face of great complexity" that he had also felt on first hearing the music of Anton Webern, the most important of Schönberg's followers. Cage played for Boulez his own *Sonatas and Interludes* and showed him some of the articles and lectures he had written to advance his musical ideas.

Through Boulez, he was introduced to everyone of importance in the Paris new-music circles. Cage and Cunningham gave several concerts and dance recitals in Paris, including a brilliant program in the Vieux Colombier, where Cunningham's partners were Tanaquil LeClerc and Betty Nichols, two dancers from the Ballet Society, which later became the New York City Center Company. Cage also met Pierre Schaeffer, the inventor of *musique concrète*, or music created directly on magnetic tape by electronically manipulating recordings of various sounds. (Oddly

enough, it was not until several years later that Cage became seriously interested in tape, whose wartime development by the Germans had made it suitable for high-fidelity recording.) In the midst of all this activity Cage still managed to work on his unfinished *String Quartet* and to continue his research on Erik Satie. He was particularly struck by a Satie manuscript, loaned to him by Henri Sauguet, which was aptly titled *Vexations*. A single sheet of music for piano that could be played in eighty seconds, it bore the composer's blithe notation at the top, "To be played 840 times." Cage got the piece published in a review called *Contrepoints* and brought a photostat of the score back home with the idea that it should be performed.

Cage's attitude toward Satie sheds a certain light on the question so often asked about Cage himself—that is, does he *mean* to be funny? The bizarre notations on Satie scores (for example, the famous passage that was to be performed "like a nightingale with a toothache") led many of his contemporaries to dismiss him as a mere practical joker, an impression that was not diminished by Satie's eccentric habits and his theories on such matters as how to measure "the weight of an F sharp from an average-sized tenor." Cage was beguiled by this sort of absurdity, but he believed strongly that even Satie's most absurd statements could be found to contain a kernel of serious thought. When Cage and nine fellow pianists gave the *Vexations* its first performance, in New York's Pocket Theater in September 1963, the results fully justified, for Cage at least, his conviction that it was no joke; after about an hour and a half of the 840 repetitions, he said later, "we all realized that something had been set in motion that went far beyond what any of us had anticipated," and by the end of the performance, which lasted continuously for eighteen hours,

the work's hypnotic effect had been attested by many
listeners, one of whom stayed through from beginning to
end. If Satie's jokes often turn out to be serious, Cage's
serious ideas sometimes appear hilarious in performance.
He does not intend them to be funny, nor does he show,
by facial expression or gesture when conducting them, that
he sees the joke. But if humor is there he accepts it with
equanimity, just as he accepts everything else that can
enter into the work.

After three months in Europe Cage returned home and
soon found himself moving into a new and uncharted area
of composition. Up to this point he had still been concerned
to some degree in his music with the problem of expres-
sivity, even though it was no longer his own ideas that were
being expressed. In *The Seasons* and *String Quartet*, for
example, what he had tried to express was the concept of
seasonal cycles found in Indian philosophy—spring sym-
bolizing creation; summer, preservation; fall, destruction;
and winter, quiescence. By using what he called "gamuts
of aggregates of sound" within a rhythmic structure, Cage
had sought to make the conventional instruments for which
he was writing sound as fresh and unfamiliar to his ear as
the prepared piano. In the spring of 1950, to facilitate the
composition of a score he was writing for Merce Cunning-
ham called *Sixteen Dances*, Cage drew up a series of large
charts on which he could plot rhythmic structures. In
working with these charts, he caught his first glimpse of a
whole new approach to musical composition—an approach
that led him very quickly to the use of chance. "Somehow,"
he has said, "I reached the conclusion that I could compose
according to moves on these charts instead of according to
my own taste." The transition was carried out, one could

say dramatized, in terms of the two compositions he was writing that spring, the *Sixteen Dances* and the *Concerto for Prepared Piano and Chamber Orchestra.*

In the first movement of the *Concerto,* Cage "let the pianist express the opinion that music should be improvised or felt, while the orchestra expressed only the chart, with no personal taste involved. In the second movement I made large concentric moves on the chart for both pianist and orchestra, with the idea of the pianist beginning to give up personal taste. The third movement had only one set of moves on the chart for both, and a lot of silences." Cage was pleased and excited by the results. "Until that time, my music had been based on the traditional idea that you had to say something. The charts gave me my first indication of the possibility of saying nothing."

The move into chance operations, which he began to investigate seriously soon afterward, represents a dividing line in Cage's career. He had reached an age, thirty-eight, when revolutionary experiments often give way to quieter development and the securing of aesthetic beachheads. He had won praise and serious consideration from some of the leading musicians of the day. From that point on he was to experience little but rejection and hostility from the New York musical establishment, which accused him of artistic irresponsibility, and a cold shoulder from the European avant-gardists, who took up his ideas one by one, often not bothering to acknowledge the source. It is characteristic of Cage that he pursued his new and highly unpopular course without hesitation and in the very best of spirits. Many years before, he had accepted Gertrude Stein's notion that all vigorous art was *irritating,* and that when it ceased to be irritating and became pleasing it was no longer useful. Cage has denied the charge of his detractors that his whole

purpose is to be irritating merely for the sake of being
irritating. "But whenever I've found that what I'm doing
has become pleasing, even to one person, I have redoubled
my efforts to find the next step." In this case the next step
seemed clearly indicated: through chance operations, to
discover a kind of music that would more truly imitate
nature in her manner of operation.

Although his venture into chance alienated a good part
of the music world, Cage did find allies who were willing
to move in the same direction. Leaving a Philharmonic
concert early one evening—he had come to hear Webern's
Symphony Opus 21 and had been so overwhelmed by it
that he did not want to stay for the Rachmaninoff that fol-
lowed—he met a large man in the lobby who was leaving
at the same time and, as it turned out, for the same reason.
This was Morton Feldman, a composer several years
younger than Cage. "We introduced ourselves," Cage has
recalled, "and that began our immediate friendship." Cage
showed Feldman the Boulez *Second Piano Sonata,* which
he had brought back from Paris. Feldman then introduced
Cage to David Tudor, a young pianist whose brilliant
technique and advanced ideas made him seem ideally
suited to perform the Boulez work. Cage had already ar-
ranged for its première performance by another pianist,
William Masselos, in a League of Composers concert in
New York later that season, but he was able to persuade
Masselos to defer to Tudor. Tudor's approach to the in-
credibly difficult sonata was thorough; feeling the need to
penetrate deeper into its spirit, he had taught himself
enough French to read the books that he knew Boulez
had been reading when he composed it—Mallarmé, René
Char, and Antonin Artaud's *The Theater and Its Double.*

Cage, Feldman, and Tudor met nearly every day from then on, in Cage's Monroe Street apartment, which had been transformed by Cage's friend Richard Lippold, the sculptor, into a whitewashed aerie; its sole furniture was a long marble table and a grand piano that had been given to Cage by Maro Ajemian in exchange for his collection of Satie manuscripts. They were often joined by Christian Wolff, a young music student and composer, who was still in high school. "Things were really popping all the time," Cage has said of this period. "Ideas just flew back and forth between us, and in a sense we gave each other permission for the new music we were discovering."

Feldman left the room one evening, in the midst of a long conversation, and returned later with a composition on graph paper, which provided three numbered "ranges" (high, middle, and low) of sound in which the performer was to play a given number of notes—any notes he chose within the specified range—during a given length of time. It was the first step toward a music that went beyond chance, into what is now called indeterminacy—music whose sounds cannot be foreseen. Christian Wolff composed a piece vertically, writing down the page in columns; it was to be read in the normal, horizontal fashion by the performer, thus placing another barrier in the way of the composer's personal tastes. When he came to their gatherings Wolff sometimes brought copies of the beautiful and expensive books published by his father, Kurt Wolff, who had come to the United States from Germany just before the war and founded Pantheon Press. One day, he brought a copy of the most ancient book of China, the *I Ching*, or *Book of Changes*, which Pantheon had just published in English translation. "The moment I opened the book," Cage has said, "and saw the charts and the hexagrams

which were used for obtaining oracles according to the tossing of coins or yarrow sticks, I saw a connection with the charts I had been using on my *Concerto*. It was immediately apparent to me that I could devise a means of composing by using these operations, and right then and there I sketched out the whole procedure for my *Music of Changes*, which took its title from the book. I ran over to show the plan to Morty Feldman, who had taken a studio in the same building, and I can still remember him saying, 'You've hit it!' "

Reminiscing about the Monroe Street days, Feldman has said it would be almost impossible to describe the sense of utter freedom and excitement they all felt. "You have to remember how straight-laced everything had always been in music. Think of the number of painters since Piero della Francesca who have been absolutely first rate —hundreds. And then think of the number of composers in the same period. You can almost count them on your fingers. Just to change one little thing in music was a life's work. But John changed everything. We got out of that strait jacket, and it made everything much more simple in one way and a lot harder in other ways. What we learned was that *there are no catastrophes*. Of course, John was freer than the rest of us. I've never wanted to give up my own taste completely, to give up all control. He's gone much further than anyone else—whether because he had less to lose by it, or more, I wouldn't know."

The use of chance in music was not altogether without precedent. Charles Ives, the turn-of-the-century American composer, had written pieces in which performers were free to make certain choices, and Mozart himself is said to have composed a set of *contredanses* in which dice were thrown to determine which of certain measures was to be

performed. In the visual arts, which have usually been a generation or two ahead of music in applying new techniques, chance effects of a far more advanced nature had been in vogue for many years. The accidents of thrown or dripping paint figured prominently in the canvases of the New York Abstract Expressionists, and the Surrealists of a preceding generation had gone in heavily for random association of unrelated images as a means of penetrating the dream world of the subconscious. Cage, who had known Max Ernst, André Breton, and other leading Surrealists, and who had stayed close to the world of painting ever since he had come to New York, found himself turning more and more to the painters for friendship. With Robert Motherwell and Harold Rosenberg, he helped to edit a new art and literary magazine called *Possibilities*, which lived up to the most hallowed avant-garde traditions by publishing only one issue. When Motherwell and a group of his fellow artists started a series of weekly lecture-and-discussion meetings in a loft on Eighth Street, a series that led to the formation of the Artist's Club, which played such an important role in the evolution of Abstract Expressionism, Cage became an active participant. His "Lecture on Nothing," written, as most of his lectures have been, according to his methods of musical composition at the time (in rhythmic structure, with silences up to several minutes in length), was a great sensation; so was his subsequent "Lecture on Something," the "something" in this case being the music of Feldman. Although Cage was virtually penniless, his Monroe Street apartment, in what had come to be known around town as the "Bozza Mansion" (the landlord's name was Bozza), was hung with paintings and sculptures he had received as gifts or bought on long-term installments. People came from all over the city

to see them and to hear Cage's at-home concerts of new music by himself and his associates, and *Vogue* and *Harper's Bazaar*, in an accolade of chic, sent models down to be photographed in his splendidly underfurnished surroundings. Cage entertained all his guests with consummate charm, telling witty stories from Hindu and Zen literature, creating an atmosphere of great elegance with no visible resources, and gently preaching, as was his wont, the purpose of purposelessness.

While chance was nothing new in the painting world, no painter had ever used it in quite the way that Cage did. Generally speaking, the painters saw chance as a means of getting past their conscious control, so that their subconscious might express itself more directly on canvas. This has never been Cage's idea. He was as anxious to rule out the subconscious, with all *its* desires and tastes, as he was the conscious mind. For this reason chance became, for Cage, a vastly complex operation. In his *Music of Changes* he began by drawing up twenty-six large charts on which to plot the various aspects of the composition—sounds, durations, dynamics, tempi, and even the silences, which received equal value with sounds. Every single notation on each of these charts was determined by chance operations based on the *I Ching*. To plot a single note, for example, Cage would toss three coins six times; the results, carefully noted down on paper, would direct him to a particular number corresponding to a position on the chart; this would determine only the pitch of the note, though, and the whole procedure would have to be repeated over and over to find its duration, timbre, and other characteristics. Since the piece lasts forty-three minutes, the total number of coin tosses that went into it was astronomical. Cage worked on it steadily for nine months,

giving each movement as it was finished to David Tudor,
who played sections of it in concerts at Black Mountain
and at the University of Colorado. The completed work
had its première at the Cherry Lane Theater in New York
in the winter of 1952. It was later reviewed with charac-
teristic perception by Virgil Thomson, who pointed out
that there was a good deal more to the music than mere
hazard. "The sounds of it, many of them quite complex,
are carefully chosen, invented by him," Thomson wrote.
"And their composition in time is no less carefully worked
out." Chance was therefore "regulated by a game of such
complexity that the laws of probability make continued
variation virtually inevitable. Thus, in Cage's hands, the
use of chance in composition gives a result not unlike that
of a kaleidoscope . . . all the patterns turn out to be in-
teresting."

The point that Thomson was making comes up again and
again in discussions of Cage's music. If Cage selects the
materials he will use, and makes all the decisions neces-
sary to set up the mechanism of chance, is the result really
controlled by chance at all? "What happens is that a hu-
man being has to decide what goes into the chances,"
Henry Cowell said once. "And being human, Cage's ex-
pression enters into it." A great many of his fellow musi-
cians and friends agree that Cage's music does express the
man—his sensitivity, his humor, his ability to invent in-
tricate games—and Cage himself is alive to this difficulty.
His answer is that whether or not personal taste does creep
into his work, the work itself is an attempt to move in a
new direction, toward a new situation that he does *not*
control, and that this is the main point.

The next step proved to be highly unsettling even to his
closest associates. For some time Cage had been mulling

over the idea of writing a piece of music for radios, whose sound he had always detested. It has been his custom to come to terms with sounds he does not like by using them in a composition (he would later come to terms with Beethoven by using a snatch of the *Ninth Symphony* in his *Williams Mix*), and he felt that it was high time he overcame his dislike of radio sound. Accordingly, when the New Music Society asked him to write something for a concert in New York in the winter of 1952, Cage set to work on a four-minute piece for twelve radios, which he called *Imaginary Landscape No. 4*. His musical materials in this case were sound (any sound picked up by turning the dial), static, and silence. Each radio was to be "played" by two performers, one working the station selector and the other the volume and tone controls—"like fishermen catching sounds," as Cage described it.

The concert took place in Columbia University's McMillin Theater before a large audience (admission free). Interest in the Cage piece was running high as a result of a recent article by Virgil Thomson in which he drew a parallel between Cage's chance operations and the work of some contemporary abstract painters. Over Cage's objections, the *Imaginary Landscape* was placed last on the program as the *pièce de résistance*. The earlier part of the program turned out to be exceptionally long. In plain view on the stage throughout the evening were the twelve RCA "Golden Throat" radio sets, lent by the manufacturer. By midnight, when the time came for the Cage work, nobody had left the hall and a buzz of anticipation filled the air. Unfortunately this was very nearly all that did fill the air. The twenty-four performers took their places at the twelve radios and for four bewildering minutes the audience listened to a great deal of silence broken only

by a few faint wisps of sound, when a station selector happened to hit a station at the same moment that the volume dial was turned on loud enough to hear it. Cage had been prepared to draw a blank much of the time, but he had not counted on the piece being performed after midnight, when most stations went off the air. "It certainly was not what Lou Harrison used to call a rabble-rouser," he admitted later. The disappointment of the audience was intense, and when Cage went backstage afterward he found both Virgil Thomson and Henry Cowell looking decidedly glum. "Virgil told me later I had better not perform a piece like that before a paying public," Cage has recalled. "And so we had difficulty after that."

The rift between the two composers, which this incident helped to create, has never been fully closed. There had already been differences of opinion over a book on Thomson which Cage had originally been commissioned to write, then un-commissioned (Thomson felt that the second chapter was "definitely unfriendly"), and finally recommissioned as co-author with Thomson's friend Kathleen Hoover, who wrote the biographical narrative while Cage confined himself to musical analysis. Cage became so irritated at one point by what he considered editorial tamperings with his text on Thomson's music that he plotted an insidious revenge; having recently co-authored with Lois Long, the designer, a book for children on the various ways to make pies and cakes out of mud, he wanted to have his name appear on the jacket of the Thomson biography as "John Cage—co-author of *The Mud Book*." He refrained from doing so, but his relations with Thomson remained somewhat delicate. As Thomson explained it later, "John and I have always been friends in a real sense, but we're also enemies. He could never understand

why I wasn't as far out as he was. He felt that, since I was bright, and gifted, and had done things in music he liked, then why the hell wasn't I? And did my not being so far out imply a possible error on his part?" They see each other only infrequently, but, as Cage has said, "our friendship is basically so strong that every so often one of us makes an effort to enjoy it."

Undeterred by the adverse reaction to his radio piece, Cage continued to work at a lively pace all through 1952. He had become seriously interested in the possibilities of making music on tape, and that spring he composed his first piece of tape music as a score for a dance by Jean Erdman. The piece, *Imaginary Landscape No. 5*, was made fairly quickly by fragmenting the sounds of forty-three jazz records and rerecording the fragments on tape, following a score written according to chance methods. Cage wanted to compose a more complex tape work, though, and as usual there was the problem of money. Working with tape is expensive; it involves the use of complex electronic equipment and the assistance of engineers trained in its use. Cage applied to the Rockefeller and Ford Foundations without success. At about this time, though, a former Black Mountain College student named Paul Williams, who had inherited a great deal of money and wanted to make it available to people working in the arts, came through with an offer of a thousand dollars a month to Cage and any assistants he might choose in composing a major work for magnetic tape. Cage and David Tudor set up shop in a small studio on Eighth Street, where they worked for many months with sound engineers Louis and Bebe Barron on the incredibly intricate task of recording a library of sounds (city sounds, country sounds, and so on), and then cutting, splicing, altering, and com-

bining all the various aspects of these sounds on eight tracks
of tape according to chance operations derived from the
I Ching. Precise measurements were essential in cutting
and handling the tape, since space on tape is equivalent to
time in performance. In the course of their work, though,
Cage became aware that it was almost impossible to make
precise measurements or to achieve perfect synchroniza-
tion. Working across the table from Earle Brown, a young
composer whom Cage had met in Colorado and who had
recently come east and joined the little group around Cage,
he was able to trace persistent errors in measurement to
the fact that he and Brown invariably measured one inch
differently even when they used the same ruler. He also
found that changes in the weather caused the tape to ex-
pand or contract. "The usual attitude in this kind of situa-
tion," Cage has said, "is that you'll do the best you can
and accept whatever imperfections are unavoidable. In this
case, though, I began to move away from the whole idea of
control, even control by chance operations. It was a cross-
roads for me. I took our failure to achieve synchronization
as an omen to go toward the unfixed, rather than to change
my methods so as to make it more fixed. Now, of course,
they have equipment that makes possible much more pre-
cise control, and a lot of people are using it to go in that
direction."

As he moved toward no-control, Cage also moved toward
theater. The idea that things should be seen as well as
listened to was already evident in the *Water Music* he had
composed that spring; although the method was the same
as he had used in his *Music of Changes*, the materials in-
cluded water being poured from pots, whistles blown under
water, and all manner of aqueous sounds that made for
diverting sights as well. Cage's theatrical inclinations

really took wing that summer when he was invited down to Black Mountain College by Lou Harrison, who had become head of the music department there and who felt enough time had elapsed since the Beethoven denunciation for Cage to reappear on the scene. During an active summer of work on the *Williams Mix* and lively discussions with young artists like Robert Rauschenberg, whose all-black and all-white paintings he greatly admired, Cage also found time to organize and put on an astonishing theatrical performance, or "concerted action," in the main dining room of the college. There was a score of sorts, arrived at by chance methods, but the performers also had considerable freedom of action during the forty-five minutes that the event lasted. Their actions took place simultaneously, and included Cage reading one of his lectures from the upper rungs of a stepladder; Merce Cunningham dancing, both around and amid the audience, which was seated around four sides of a hollow square so that it faced itself; David Tudor playing the piano; Mary Caroline Richards and Charles Olsen reading their poems, in turn, from another stepladder; Robert Rauschenberg playing scratchy records on an ancient wind-up phonograph with a horn loudspeaker; and two other people projecting movies and still pictures on the walls around the room. Rauschenberg's white paintings were hung from the rafters above the audience.

This curious spectacle caused a huge sensation at Black Mountain and was without question the prototype of a whole series of improvisational events, called "Happenings," put on by artists in New York and elsewhere in the early 1960s. Its success went a long way toward persuading Cage that theater, more than music, offered the opportunity to imitate nature in her manner of operation.

Theater he defined as everything going on at the same time, including music, and in Cage's view it came close to being synonymous with life. "Theater takes place all the time wherever one is," he wrote soon afterward, "and art simply facilitates persuading one this is the case."

The clearest possible expression of this idea may very well be the famous "silent" piece in three movements that Cage composed at Black Mountain that summer and called 4′33″. The title refers to the number of minutes and seconds the piece takes to perform, but Cage liked the thought that it could also refer to feet and inches—a sort of personal space-time continuum. Cage had come to realize that there was really no such thing as silence. This was brought home to him with great force when he was taken into a sound-proof room, called an anechoic chamber, in the physics laboratory at Harvard; instead of the total silence he had expected, he heard two sounds in the chamber, one high and one low, and was told when he came out that the high sound was his nervous system in operation and the low one was his blood circulating. If true silence did not exist in nature, then the silences in a piece of music, Cage decided, could be defined simply as "sounds not intended," and Cage made up his mind to write a piece composed entirely of just such sounds. Seeing Rauschenberg's all-white paintings at Black Mountain—canvases painted flat white, on which the only images to be seen were the shadows and reflections of the painting's environment—gave him the encouragement he needed. Cage's 4′33″ received its first performance in August of 1952, at the Maverick Concert Hall in Woodstock, New York. David Tudor, who performed it, solved the problem of the piece's division into three parts by closing the cover of the piano keyboard at the start of each movement and opening it at the end

of the specified time. Aside from these actions he did nothing but sit on his bench, immobile but intent. The Woodstock audience considered the piece either a joke or an affront, and this has been the general reaction of most people who have heard it, or heard of it, ever since. Some listeners have been unaware they were hearing it at all. Just before its New York première, Cage's mother, a loyal and fervent partisan, whispered to her neighbor in the audience that 4'33" could be thought of as being "like a prayer." As it happened, 4'33" was followed on the program by Cage's *Music of Changes*, which took forty-three minutes, and when that was over Mrs. Cage's neighbor leaned across and said, "Good heavens, what a long and intense prayer!" From Cage's point of view, however, both performances were miraculously successful. In the Woodstock hall, which was wide open to the woods at the back, attentive listeners could hear during the first movement the sound of wind in the trees; during the second, there was a patter of raindrops on the roof; during the third, the audience took over and added its own perplexed mutterings to the other "sounds not intended" by the composer. Whether this was a case of art imitating nature or nature imitating art is perhaps an open question.

The silent piece did not enhance Cage's position in musical circles. Although he was gaining new friends among younger artists like Rauschenberg and Jasper Johns, he was losing old ones; that fall, to his great dismay, he had a decisive break with Pierre Boulez. The two composers had been arguing by mail for some time over Cage's use of chance operations. Boulez, who was also using charts to plot his complex works, felt nevertheless that Cage's desire to renounce all control was going much too far. When he came to New York in the fall of 1962 as

musical director of the Jean-Louis Barrault troupe, Bou-
lez had it out with Cage in a series of extended arguments.
Cage now believes that in taking personally the kind of
vituperative intellectual argument that the French delight
in conducting, he may have made a typically American mis-
take; but he did take it personally, and the two men are
no longer friends. Ironically enough, Boulez later dis-
covered in a "lost" book by his literary idol, Stéphane
Mallarmé, certain suggestions that led him to embark on
chance operations of his own, which he called "aleatory,"
after the Latin *alea* (chance). Boulez' aleatory music
differs essentially from Cage's in that he employs elements
of chance in a composition that is characterized mainly
by his own control. Since chance, for Cage, is a means of
leaping into an entirely new situation beyond his control,
he does not consider his own work aleatory and somewhat
resents the frequent application of that term to his music.
The attitude of Boulez toward Cage may have been summed
up in a slightly condescending remark he once made to
Morton Feldman. "I love John's mind," Boulez said, "but
I don't like what it thinks."

For the next two years Cage spent a good deal of his
time on tour with the Cunningham company. Working with
Cunningham offered Cage an excellent opportunity to
develop his own theatrical leanings. The two men shared
many of the same artistic ideas, chief among them the
notion that dance and music should not be dependent
on each other, as they were in the work of other modern
dancers, as well as in classical ballet, but simply two
activities going on at the same time in the same place.
Their method of collaboration was to decide in advance
upon a certain time structure for a new work; then Cun-
ningham would go off and choreograph movements within

that time structure, and Cage, working independently, would compose a score to last the same length of time. "We are not, in these dances, saying something," Cage explained in one of his lectures. "We are simple-minded enough to think that if we were saying something we would use words. We are rather doing something. The meaning of what we do is determined by each one who sees and hears it." They performed mainly at colleges and universities, often in remote parts of the country, and if the meaning of their work was determined by relatively few onlookers, it nevertheless had a profound effect upon the younger generation of dancers such as James Waring and the members of the Judson Dance Theater in New York, who have been creating works by similar methods and in very much the same spirit.

When he was not on tour Cage continued his close association with Feldman, Brown, and Wolff, all three of whom were then composing magnetic-tape works in the Eighth Street studio that was still being financed by Paul Williams. A domestic crisis now arose. Urban renewal had scheduled for demolition the Bozza Mansion, in which Cage had been happily established for nine years. To find living and working quarters of equal charm and at a comparable price seemed hopeless. At this crucial juncture Paul Williams and his wife stepped in again, with the idea of establishing a cooperative community in a rural area of Rockland County, forty miles from New York, which would eventually contain a theater for dance and music recitals and a tape laboratory that could become the basis for Cage's long-dreamed-of center for experimental music. Reluctant though he was to leave New York and all his friends, Cage found the prospect irresistibly appealing. In the summer of 1954 Cage, David Tudor, Mary Caroline

Richards, and the sculptor David Weinrib and his wife
Karen moved into an old farmhouse on a tract of land that
the Williamses had bought near Stony Point and took up
community living in the lap of nature.

Moving to the country, according to Cage, was "a com-
plete change of experience, like moving from one color
into another. I realized immediately that I'd had a pro-
found need for nature. I had lived in cities mostly and
always hated country weekends—for one thing, there were
all those biting insects, unlike city bugs that are only in-
terested in getting food. Suzuki once said that he couldn't
conceive of anyone's living a Zen life in the city, and I
had rejected this idea at the time, but now I began to see
the point of it."

Cage lived and worked in an attic room that he shared
with a colony of wasps, and almost immediately he began
taking long, solitary walks in the woods. His eye was
caught right away by the mushrooms, which grow abun-
dantly in Rockland County, in all shapes, sizes, and bril-
liant colors. Fascinated, he started to collect books on the
subject of mushrooms and to learn everything he could
about them. Among the many reasons that can be given
for Cage's passionate devotion to mushrooms may be the
fact that mushroom hunting is a decidedly chancy, or in-
determinate, pastime. No matter how much mycology one
knows—and Cage has become one of the best amateur
mycologists in the country, with perhaps the most extensive
private library ever compiled on the subject—there re-
mains always the possibility of a mistake in identification.
Cage has had one or two brushes with disaster himself,
once from eating poisonous hellebore that he took to be
edible skunk cabbage, and once from downing *Boletus
piperatus*, a raw mushroom that is labeled edible in some

books, dangerous in others. "I became aware that if I approached mushrooms in the spirit of my chance operations I would die shortly," Cage has said. "So I decided that I would not approach them in this way." But he has continued to approach them, at every opportunity and wherever he has happened to be, to the point that he has frequently been reprimanded by highway patrolmen for leaving his car to pick attractive specimens he has seen growing near the parkways. For several months in 1960 he even supplied the Four Seasons restaurant in New York with regular shipments of wild mushrooms. With three fellow enthusiasts he founded the New York Mycological Society in 1962, and on pleasant spring and fall weekends, whenever possible, he is out in the woods on mushroom walks. It may be worth noting in this connection that Cage has never eaten any of the hallucinatory varieties of mushroom. No mystic, he has a deep-seated aversion to trances, visions, and all the spookier aspects of Orientalism. (When a lady once asked him to explain the significance of the legend according to which the Buddha had died from mushroom poisoning, Cage pondered the question for a few weeks and then wrote her a Zen-like reply: "The function of mushrooms is to rid the world of old rubbish. The Buddha died a natural death.") Cage has also been delighted to discover that the words *mushroom* and *music* are contiguous in most English dictionaries.

The music he composed during the next few years shows Cage finding ever more ingenious ways to move beyond his own taste and control. He wrote eighty-four piano pieces by a new, rapid method of chance operations that involved marking the imperfections in a sheet of white paper (specks, holes, watermarks), tossing coins to see which would be silences and which would be sounds, placing over

the marked paper a transparent sheet on which musical
staves had been drawn, and noting where the marks fell
within the staves. Marks that fell outside the staves, he
decided, were to be considered noises made on the body
of the piano. Cage was leaving more and more of the
decisions as to tempo and dynamics up to the individual
performer, for he had come to the conclusion that chance
methods of composition, in themselves, were not sufficient
to his purpose. Once a composition had been arrived at by
chance operations, the results were fixed, written down,
and thus entirely predictable for each performance. In
works which left some of the decisions up to the performer,
though, it was possible to arrive at results that the composer
could not foresee—music that would be truly *indeter-
minate*. Going even further in this direction, Cage wrote
five instrumental pieces which were meant to be performed
together but which were not related even in time; the
longest piece set the performance time, and the others could
enter in at will, with no sense of beginning, middle, or end.
Cage's idea was that the parts could go together like the
parts of a Calder mobile, moving independently but related
by their presence in the same time length. None of this new
work would have been possible, Cage has insisted, had it
not been for his close collaboration with the pianist David
Tudor. Cage himself could not hear what he had written
until Tudor got the score and played it (Cage had given
up his own piano when he moved out to the country), and
Tudor's solutions to the problems of performance would
often open up whole areas of sound that Cage had never
foreseen. The collaboration seems to have been as stim-
ulating to Tudor as it was to Cage. "John's music is very
different from other composers'," he has said. "When I'm

performing it I feel more free, and at the same time more
intensely aware."

Cage and Tudor performed some of these works at the
1954 festival of new music in Donaueschingen, Germany, in
the course of a concert tour that took them to Cologne, Paris,
Brussels, Stockholm, Zurich, Milan, and London. The
European audiences responded to them with loud and often
angry disapproval, and the critics tended to look upon them
as a pair of clowns, amusing but not serious. Soon after the
Cage-Tudor concert in Cologne, though, Karlheinz Stock-
hausen, the rising young German experimentalist, wrote a
piano piece (*Klavierstucke XI*) in which the pianist was at
liberty to play the separate parts of the score in any order
he chose, stopping when he found himself playing one part
for the third time; it was the first piece of indeterminate
music composed by a European, and there have been many
others since.

The generally hostile reception in Europe did nothing to
dampen Cage's spirits. With the help of an energetic en-
trepreneur named Emile de Antonio, moreover, he was
soon to bring his musical ideas before a wider public at
home. De Antonio, who later went into film producing, was
at that time the director of the Rockland Foundation, an
arts center in Cage's neighborhood. After meeting Cage,
he decided that the local populace should be exposed to
the work of one of its more illustrious members, and he
arranged and promoted a Cunningham-Cage concert in the
auditorium of the Clarkstown High School in New City.
The concert, on October 15, 1955, fell on a night of such
torrential rains that the police warned Rockland County
residents to keep off the roads, many of which were
washed out. Despite such dire portents, the auditorium was

filled to capacity, with a mixed crowd of local music lovers
and avant-garde painters, dancers, and loyal Cage and
Cunningham partisans who had beat their way out from
New York City. The New York contingent responded with
high enthusiasm to the indeterminate events on stage.
Many of the uninitiated, as usual, looked and listened for a
few minutes in utter astonishment and then got up to
leave, only to find that the rain was coming down outside
harder than ever ("It was even worse outside than in,"
Cage said). The evening was a memorable one, and some
Rockland County residents still speak of it with an indigna-
tion that approaches disbelief.

Nearly three years elapsed before the next major presen-
tation of Cage's music, which took place at Town Hall in
May 1958. Feeling that Cage had been unjustly neglected
by the New York music world, de Antonio, Rauschenberg,
and Jasper Johns decided to pool their resources (Rau-
schenberg and Johns were making money then by designing
window displays) and put on a "retrospective" concert of
his music covering the last twenty-five years. When Rau-
schenberg called to tell Cage of their plan, Cage was flat-
tered but reluctant. He was deep in the composition of his
Concert for Piano and Orchestra, a long and complex work
that marked an important break with his previous methods:
instead of starting with a rather limiting structural focus
and elaborating the details, as he had always done in the
past, he was seeking in his *Concert* the widest possible
focus and was employing a great many different methods
of composition, an idea that he has attributed to his first-
hand observation of nature and his study of mushrooms,
whose infinite variety has never ceased to amaze him. "The
only thing I was being consistent to in this piece was that I
did not need to be consistent," he has said. His friends in-

sisted that they would handle all the details of the concert, even to selecting the works to be performed (David Tudor undertook that job), leaving Cage entirely free to continue his own work. Cage agreed to this. He redoubled his efforts on the *Concert,* working day and night for the next few months so as to finish it in time for the Town Hall engagement. His friends did the rest.

The entire New York avant-garde turned out for Cage's retrospective, in a demonstration of artistic solidarity seldom duplicated before or since. Painters prevailed upon their dealers to buy up boxes in Town Hall, and the Stable Gallery seized the occasion to mount an exhibition of Cage's exquisitely hand-written scores, many of which were sold. The orchestra of specially selected instrumentalists shared the stage with a great variety of percussion and electronic equipment, and reacted in various ways to Cage's newly invented conducting technique for his *Concert,* in which the conductor turns himself into a human chronometer, making his arms function like the hands of a clock as he guides the orchestra through the performance. The reactions of the audience were equally varied. During the first part of the program, which included some of Cage's percussion music from the 1930s, and after the *Sonatas and Interludes* for prepared piano that followed, the applause was unrestrained. Occasional laughter and a few catcalls served to indicate that the audience was not *all* avant-garde, but the protests did not become general until the third section of the program, which offered the first New York performance of the *Williams Mix.* Loud and sustained booing contended with the applause for this electronic work, and the atmosphere of the hall itself had become fairly electric by the time Merce Cunningham, who was to conduct the final work, the *Concert for Piano and Orchestra,* took the podium

and turned himself into a chronometer. Midway through this work a group in the rear of the balcony stood up and tried to stop the performance with a sustained burst of applause and catcalls. The orchestra played on, despite increasing competition from the other side of the footlights, and the concert ended in a din of cheers, boos, shouts, whistles, and vigorous disputation.

In his notes for the recording that was made of the concert, George Avakian relates his conversation with a painter who had attended both the Cage retrospective and the celebrated première of Stravinsky's *Le Sacre du Printemps* at the Théâtre des Champs Elysées in Paris in 1913, and who found the two concerts approximately equal in shock value. "The laughter tonight when the tuba player pointed the bell of one tuba into the bell of another was about the same that greeted some of the extreme bassoon and trombone notes in the Stravinsky," he said, "and I think tonight's big burst of applause was more of a disturbance than anything that happened at the Champs Elysées."

Reviewing the record album two years later, Virgil Thomson recalled the concert fondly as "a jolly good row and a good show. What with the same man playing two tubas at once, a trombone player using only his instrument's mouthpiece, a violinist sawing away across his knees, and the soloist David Tudor crawling around on the floor and thumping his piano from below, for all the world like a 1905 motorist, the Town Hall spectacle, as you can imagine, was one of cartoon comedy. . . . And if the general effect is that of an orchestra just having fun, it is doubtful whether any orchestra ever before had so much fun or gave such joyful hilarity to its listeners." Whatever one's reactions may have been to the spectacle, it seems

safe to say that Cage's talent for stirring people up was amply demonstrated.

The summer of 1958 found Cage again in Europe, teaching a class in experimental music at Darmstadt, giving concerts, lecturing, and developing a new method of composition with the aid of plastic transparencies. The new method carried indeterminacy a long step further by giving to each performer certain materials with which he could compose his own score—a score that would necessarily be wholly different at each performance. These materials were in the form of transparent plastic sheets, on which Cage had inked lines, dots, or biomorphic shapes; the lines and dots were understood to refer to the various aspects of sound that would be used, and when the performer superimposed one sheet over another, the intersection of the lines and dots on one with the biomorphic shapes on another would give him the information he needed to "compose" the piece. Since Cage had no idea how the performer would superimpose one sheet over another, he could not foresee what would take place. Implicit in this whole process, he has explained, is the Buddhist belief that all things in the world are related and thus *relevant* to each other, so that no matter who used the transparencies or how he used them, each performance would be simply another aspect of the same (indeterminate) work.

This same Buddhist notion of interrelatedness was behind the collection of thirty brief anecdotes, taken from his own experiences, his readings in Zen and other literatures, and stories he had heard from others, that went into a lecture called "Indeterminacy, New Aspect of Form in Instrumental and Electronic Music," which he delivered for

the first time at the Brussels World's Fair that summer.
"I had this faith that stories out of my personal experi-
ence would be related to one another because I recounted
them," he said afterward, "even if they seemed on the sur-
face to have very little to do with each other or with mu-
sic." Cage has kept on adding to this collection of stories, and
they now number well over two hundred. He reads them at
the rate of one a minute, going slowly with the short ones
and speeding up as necessary, and most non-Buddhist lis-
teners, while they may at times fail to grasp the ultimate
relevance of it all, find them a wholly delightful distillation
of Cage's irrepressible humor, his high spirits, and his
surprising clarity of expression.

Electronic music had captivated Europe by this time.
Many leading avant-garde composers had maneuvered
themselves into positions with the laboratories of govern-
ment radio stations—something Cage has never been able
to do in this country, where radio is controlled by com-
mercial and highly conservative interests. When the
Italian composer Luciano Berio invited Cage to come
and work in the tape studio attached to the Milan radio,
he accepted with pleasure. Cage spent four months in
Milan, composing a work for magnetic tape called *Fontana
Mix* (his landlady's name was Signora Fontana), in which
all the decisions as to sound manipulation, cutting, splic-
ing, etc., were made with the use of his plastic transparen-
cies. During this period he was also asked to appear on the
Italian television program *"Lascia o Raddoppia,"* an im-
mensely popular quiz show based on well-known American
prototypes. The basic format was for each contestant to
answer questions about a subject of his own choice. Each
week the questions became harder and the rewards more

munificent; a wrong answer at any point retired the contestant, who then kept half his winnings, but if he answered every question right for five weeks running he won the jackpot of five million lire, or about eight thousand dollars. Cage chose mushrooms as his subject and also agreed to perform as a musician before answering the questions on each program.

The first week he answered all questions correctly, after playing his *Amores* suite on a piano that he had prepared. For his second appearance he decided to compose and perform a "theater piece." He had found that television studios will procure on short notice any conceivable sort of prop, and he made out a list of things with which, he said, he would "like to associate" himself—a bathtub, a pressure cooker, a siphon, a Waring Blendor, a vase of roses, a watering can, a large rubber fish, and several other objects that had to do with water in some form. His plastic transparencies, which now struck him as being applicable to any sort of composition, gave him a running score which he rehearsed until he was letter perfect. The piece, called *Water Walk*, required split-second timing, for a great many separate actions took place in the time limit of three minutes, and every prop was used. It began with the rubber fish inside a piano, flopping its tail against the strings, and ended with the fish in the bathtub, swimming around the vase of roses which Cage watered from above, while the pressure cooker let off great jets of steam. The marvelous irrationality of it all won the hearts of the Italian television public, and Cage, who answered all questions right again and was thus eligible to return the next week, began to draw a crowd of admirers whenever he appeared on the Milan streets. He replied faultlessly to the mushroom questions of the third program and delighted more Italian

hearts by performing another theater piece called *Sounds of Venice;* the sounds had been taped the previous weekend on a visit to the Venetian *palazzo* of Peggy Guggenheim, whose friendship he had long since regained. By this time he was being interviewed daily, beseiged for autographs, photographed, and followed at every turn by the Italian press, which had nicknamed him "the good-looking Frankenstein" in reference to his spiky haircut. He was given a prize as the most *simpatico* contestant ever to be on the program. Asked whether he was nervous about going on for the fourth time and risking the loss of half his winnings, he replied cheerfully that even if he lost he would still receive more than the amount of a Guggenheim Fellowship, and so he was not nervous at all.

But the public's nervousness grew steadily more intense as Cage answered the increasingly arcane mycological questions of the fourth week. On the fifth and climactic program he was placed in a glass isolation booth. The final question was to name all the genera of white-spored mushrooms. Cage had expected something of this sort and had memorized the genera of white-spored, black-spored, and every other spore-colored species. He started in very slowly, naming them in alphabetical order, being very careful not to leave any out. He had no idea that there was a time limit on his answer. Gradually, in his isolation booth, he became aware that people in the studio audience were getting excited, jumping up and down in their seats and gesturing wildly toward a clock on the wall above his head, but Cage could not see the clock and he continued to take his time. As each of his careful answers filtered out through the booth and was translated, the hysteria in the studio increased. Finally, half a second before his time was up, he named the last white-spored mushroom, and the audience

exploded in delirium. Exhausted by the strain of such celeb-
rity, Cage collected his winnings (which came to six
thousand dollars after all the various transactions of ex-
change), turned down an offer from the film director
Federico Fellini to appear in his next movie, to be called
La Dolce Vita, and flew home.

It took him several months after that to recover from a
severe bronchitis brought on by the Milanese climate. By
spring, though, he was planning a new tour with the
Cunningham company, in a Volkswagen Microbus pur-
chased with the *"Lascia o Raddoppia"* funds, and giving
three courses in the meanwhile at the New School for Social
Research—one on mushroom identification, one on the
music of Virgil Thomson, and one on experimental com-
position. Cage's teaching method in the music course was to
introduce his students to the work he was currently en-
gaged in, and the ideas behind it, and then encourage them
to experiment on their own. Not surprisingly, his students
became thoroughly involved in theatrical experiments that
employed chance methods and indeterminate performances
and showed a general tendency to confuse the demarcations
between art and everyday life. The class seldom numbered
more than eight students, several of whom aspired to be
painters rather than musicians, and all of whom seem to
have been fanatically devoted to Cage. "He established this
feeling of suspended gentleness right at the start," said
Allan Kaprow, who took the course for two years, "and
most of the people who started out in it just weren't on his
wavelength at all, so the class soon narrowed down to
seven or eight. We all felt that something terrifically ex-
citing and new was happening in there. I just couldn't
wait to get back to his class each week."

Kaprow went on to become a leader in the group of

young artists who have involved themselves in "Happenings," those curious, unplanned theatrical manifestations that owe so much to Cage's influence, and about which Cage himself now has mixed feelings. It sometimes seems to Cage that the younger artists who embrace chance and indeterminacy do so in the wrong spirit. "The whole idea of chance operations," he has said, "is that the field of awareness that's now open to us is so big that if we're not careful we'll just go to certain points in it, points with which we're already familiar. By using chance operations, we can get to points with which we are unfamiliar. But that basic desire may be missing in people who use chance because they think it's easy."

Another aspect of the "Happening"-type events that concerns Cage is the tendency some of them have shown toward violence. Several of Kaprow's "Happenings" have been fairly violent, but the one that disturbed Cage the most took place in Cologne in a studio belonging to the painter Mary Bauermeister. It was put on by a Korean musician named Nam June Paik, an ardent disciple of Cage (he is also the founder and sole member of the Institute for Avant-Garde Hinduism), and it was called, distressingly enough, "In Homage to John Cage." After wrestling for a while with the innards of an eviscerated piano, Paik suddenly leaped down to where Cage was sitting, removed Cage's jacket and slashed his shirt with a wickedly long pair of scissors, cut off his necktie at the knot, poured a bottle of shampoo over his head, and then rushed out of the room. Everyone sat in stunned silence until a telephone rang at the back of the studio; it was Paik calling to say the performance was over. This sort of thing has led Cage to wonder whether his influence on the young was altogether a good one. Too many of them seemed to

have interpreted Cage's view of the new situation in art as meaning simply that anything goes. Cage has repeatedly tried to point out that anything does go, "but only when nothing is taken as the basis"—that is, only when personal wishes and desires are ruled out of the picture, so that one then be free without being foolish. Not many young artists are willing to take nothing as the basis, though, and for this reason Cage has withdrawn from teaching.

Ideally, what he would like to do is to establish a center for experimental music at some university, where he would not teach formal classes but, rather, act as resident composer, making his ideas and the center's equipment available to anyone seriously interested in either. It is his oldest dream, perennially thwarted. (The laboratory and theater project planned for Paul Williams' community never did come into being.) Cage was enormously stimulated by the year (1961–1962) he spent as a Fellow at the Center for Advanced Studies at Wesleyan University. He got a great deal of work done there, including the compilation of his lectures and essays that became the book *Silence*, published by the Wesleyan University Press, and he thoroughly enjoyed the intellectual atmosphere of the place. Wesleyan apparently found Cage equally stimulating, but the authorities there did not look with much favor upon a detailed project, submitted by Cage, for the establishment of a Center for Experimental Music. "There is something in the nature of my work that does not encourage universities," Cage has admitted. "My language is wrong, for one thing. I suspect that if I had called it an Institute for Advanced Musical Studies it might be in operation right now."

The nature of Cage's work in recent years has certainly done little to encourage established bodies of any kind, at home or abroad. Early in 1960 he began using contact

microphones to amplify the sounds made on any object to which they were attached. The trouble with electronic music produced in the laboratory, he had concluded, was that by the time it came to be performed it was stone dead; the audiences at electronic concerts, having nothing to watch on stage, often went to sleep. Cage's solution was to have the electronic sounds made by live performers in a concert situation that involved many elements of theater— and anyone who has been to a Cage concert, and seen Cage and Tudor threading their way about a stage cluttered with cables, amplifiers, speakers, and electrically wired instruments, can testify at least that the spectacle does not induce drowsiness.

Cage discovered while working with contact microphones that electronic circuits did more than amplify sounds; they changed all the characteristics of a given sound and sometimes introduced distortions so pronounced that the original sound was no longer even recognizable. Feeling that this process was "part and parcel of our contemporary science and technology," as well as a reflection of the Buddhist idea of perpetual reincarnation, Cage decided that he would accept in his work all the distortions caused by electronic circuits, including electronic feedback, with the idea that in this way new and unforeseen sounds could be brought into being. Sometimes these new feedback sounds came shrieking through the amplifiers with such unforeseen volume that members of the audience clapped their hands to their ears and made rapidly for the nearest exit, and indeed no single aspect of Cage's work has come in for such severe criticism as his acceptance of extremely loud sounds. Cage himself was troubled by this problem for a time. Although he could (and did) argue that hearing loud sounds in a concert hall might help people to accept

and perhaps even to enjoy the increasingly loud sounds to which they were being subjected in modern life, such as the sound of jet planes taking off, he was sufficiently uneasy about the whole issue to consult the *I Ching* about it one winter day in 1964. "I got perfectly marvelous hexagrams," he said afterward. "They told me to continue with what I was doing and to spread joy and revolution."

Cage has also been reassured and encouraged by reading statements of Marshall MacLuhan, a social philosopher at the University of Toronto, and R. Buckminster Fuller, the Dymaxion architect, both of whom, in their separate ways, see the present period of history as one of sweeping, revolutionary changes in man's relation to his world. The whole notion of an indeterminate, interrelated field of awareness, which man cannot possibly enter or comprehend with his conscious mind alone, strikes Cage more and more as one of the keys to an understanding of our time, and he is more and more certain that the methods he has chosen to use in his work—chance, indeterminacy, and theater—are in tune with the underlying temper of modern life. "Everything we do is music," Cage has said. In this spirit, his latest compositions have moved out of the field of time altogether, and into space. When performing his *Variations IV*, composed in 1963, Cage first obtains a map or plan of the performance area (which can be a concert hall, theater, or even a clearing in the woods); he then places over this map plastic transparencies with inked lines, dots, and circles, whose intersection determines *where* the sound will come from, and nothing else. Cage uses whatever sound-producing means are available, preferably but not necessarily electronic—radios, phonographs, conventional instruments, or, perhaps, the sound of a door slamming. "It doesn't matter what sounds are coming up,"

he says. "What's interesting is where they come from."

Very few of Cage's musical associates have cared to follow in the direction of these recent activities. Even Merce Cunningham, who has choreographed a dance to go with *Variations IV*, and whose work grows increasingly spontaneous, has hesitated to go all the way into indeterminacy because of an understandable anxiety that if dancers have no instructions at all they may end up running into one another at high speeds, to the detriment of bone and muscle. And yet those who say that Cage has left the real world entirely must somehow cope with the fact that his ability to shock, enrage, stimulate, and influence others has never been more evident than in the last few years. College students throughout the country no longer react with incredulous laughter to the Cunningham-Cage appearances; they pack the auditoriums to capacity and line up afterward to talk to the dancers and to Cage, whose works may perplex them but whose ideas they have read and discussed. A Cage concert in Zagreb in the spring of 1963 ended in a near riot when students jumped up on the stage to vent their opinions of the work, pro and con; the incident alarmed the local officials of the United States Information Service and led Gunther Schuller, an American composer who does not admire Cage's recent work, to write an article in the *New York Times* deploring the fact that Cage so often "represented" American music in European festivals. The Cage-directed performance of Satie's *Vexations* in New York in 1963 so mesmerized the news media that the *Times* sent out a relay team of nine critics and reporters to cover the eighteen-hour event; Movietone News asked the musicians to repeat a section of the work so that it could be filmed (Cage refused this request), and Radio Free Europe recorded part of it for

transmission behind the Iron Curtain. Shortly before the *Vexations* marathon, a series of six avant-garde concerts at the Judson Recital Hall uptown had served to indicate, if nothing else, the extent of Cage's influence on the younger generation of several countries. Frederic Rzewski, from Poland, enlivened the first concert by performing the Italian composer Giuseppe Chiari's *Teatrino,* a work for (to quote the *Times*) "five rubber dolls, a hand power saw, a piece of lumber, an alarm clock, a tape recorder, a table model phonograph, a snare drum, a ping-pong ball and paddle, some literature, a large white cardboard, and even a piano." Cage and David Tudor played a piece by Toshi Ichiyanagi (a former Cage student who has been spreading the Cage influence throughout Japan), the sounds of which were made by rubbing, stroking, and tapping on the body of two grand pianos to which contact microphones had been attached. Works by La Monte Young, George Brecht, and other participants were clearly in the Cage theatrical spirit, but nothing that was performed in the series could really compare with the simultaneous rendition, by Cage and Tudor, of Cage's *Variations II* and *Variations III.* The high point of the evening came when Cage gravely put a throat microphone around his neck, turned up the amplifier all the way, and drank a glass of water. Each swallow reverberated through the hall like the pounding of a giant surf.

Without doubt, though, the most impressive proof of Cage's spreading of revolution, if not joy, in the musical world, was the 1964 performance of his *Atlas Eclipticalis with Winter Music (Electronic Version)* by the New York Philharmonic at Lincoln Center. Cage started composing *Atlas* in 1961, at Wesleyan, when the Montreal Festivals Society commissioned him to write a work for full orches-

tra. The method of composition was fantastically complex, involving the use of large astronomical charts that he had discovered in the Wesleyan Observatory—the title refers to the stars in the great circle around the sun—together with transparencies and other chance materials to determine which stars on the chart would be notes and how they would go together. Months of work went into the composition, and the last of its eighty-six parts (one for each instrument of the orchestra) was not finished until 1962. When Leonard Bernstein scheduled the work, along with compositions by Earle Brown and Morton Feldman, to be performed by the Philharmonic during the last week of its five-week series of programs on the avant-garde, there was a feeling in some quarters that he might be planning to ridicule the whole idea of the "music of chance," as he called it on the program. Bernstein had never been noticeably sympathetic to Cage's work, and the knowledge that he was going to lead the orchestra in an "improvisation" of his own, on the same program, suggested to some that he believed there was no real difference between an improvisation and the music that Cage had spent more than a year composing. Ridicule, however, was far from Bernstein's intention. During the week of rehearsals that preceded the first performance Bernstein threw the full weight of his authority behind Cage, Feldman, and Brown, and firmly discouraged any tendencies on the part of his musicians to treat their work as a joke. For Cage's composition, Max V. Mathews of the Bell Telephone Laboratories had designed and installed an elaborate electronic sound system, and Paul Williams had constructed a mechanical "conductor"—a metal box on a stand, with colored lights to mark the divisions of the work and an extended arm that described a 360-degree circle in

the eight-minute time span of the music. Not in the least offended by this automation of the maestro's traditional role, Bernstein worked very closely with Cage in showing the orchestra members how to apply the contact microphones to their instruments, follow the motions of the chronometer-conductor, and read the score, which was utterly unlike anything they had seen before. As a result the attitude of the orchestra toward Cage and his associates was generally respectful—up to the time of the performance.

Philharmonic Hall was sold out for the opening concert, which took place on the evening of February 6. The first half of the program was comfortingly traditional—Vivaldi's *Four Seasons* and Tchaikovsky's *Pathétique Symphony*—and when the audience returned after the intermission Bernstein, in one of his platform chats, urged them to give their serious attention to the "music of chance" that followed. Whether his verbal explanation of it served to help or hinder the cause is a matter of conjecture; Cage would have preferred for the music to state its own case. In any event, after listening with amusement to the initial selection of music "composed" by a British computer named Pegasus, and responding tolerantly to Bernstein's brief orchestral improvisation, the audience flatly refused to give any attention whatsoever to Cage's *Atlas Eclipticalis*. As soon as the first electronic sounds issued from the six loudspeakers placed in strategic parts of the hall, people began to mutter angrily and leave their seats. More than half the audience walked out before the piece was finished. The irate Philharmonic subscribers, unshakably convinced that what they refused to listen to had nothing to do with music, made so much noise in leaving that the Cage partisans and those with open minds on the matter

could hear very little of what was coming through the loud-speakers. By the time the Feldman and Brown works had been performed, Philharmonic Hall was two-thirds empty.

There were three more performances of the same program. During the second performance, while Cage was taking his bows from the stage, he heard what he thought at first to be "the sound of escaping air." The same sound greeted Feldman and Brown when their works had been played, and Cage realized with a shock that the members of the Philharmonic orchestra were hissing them. Feldman, who took his bow from a seat in the audience, was so upset by this breach of musical decorum that he refused to stand up the second time and got Karlheinz Stockhausen to stand up for him, a gesture that Bernstein later described as being "entirely too aleatory." Matters on stage deteriorated even further during the third performance. The musicians laughed and talked among themselves throughout *Atlas Eclipticalis;* some of them played scales or melodies instead of the notes written, sang or whistled into their contact microphones, and in a couple of instances smashed the electronic equipment. Cage spoke to their union representative afterward, and Bernstein called a meeting of the full orchestra to demand that such activities cease. As a result the final concert went off without incident, and the avant-garde series ended in mutual relief.

Cage was saddened but not particularly surprised by his experience with the Philharmonic. He realized that if his current work was to be performed by conventional musicians, a great deal more preparation would be necessary in order that the musicians might have some understanding not only of the music but of the ideas behind it. At the same time Cage found that "even when *Atlas* is performed badly, it still sounds interesting," and he

cherishes the hope that "even a bad performance may help to educate musicians and listeners to the possibilities of this new work, and stretch their capacities to be interested in their experiences."

Professionally speaking, the Philharmonic concert probably did little to advance Cage's career. In spite of the extraordinary influence of his ideas among the younger generation of painters, musicians, and intellectuals, he has no status in the music Establishment. The annual royalties from performances of his work are minuscule, and he must make his living by constantly going out on lecture or concert tours, alone or with the Cunningham company. Not only is this physically taxing, but it leaves him little time to devote to the composition of new works. None of this seems to cause him a moment's depression, though, for he is convinced that his course is the right one, the only one, for him to follow. One day, soon after the Philharmonic affair, sitting on the floor of his glass-walled living room in the monkish, two-room house near Stony Point that is his home between tours, Cage told a friend of his that he feels sometimes as though he has come to the point reached many years ago by Marcel Duchamp, when Duchamp stopped painting any more pictures. "I understand Duchamp's not doing things," Cage said. "And it seems to me that I am somewhat in Duchamp's situation now, except that instead of not doing things I will keep on doing whatever there is to do. What I like very much to think about in this connection is the final image from the Ox-Herding Pictures, the Zen text that teaches by means of illustrations instead of words. There are two versions of the Ox-Herding Pictures, you know. One version ends with an empty circle—nothingness—the example of Duchamp. In the other version the final picture is of a big

fat man, with a smile on his face, returning to the village
bearing gifts. He returns without ulterior motive, but he
returns. The idea being that after the attainment of nothing-
ness one returns again into activity.

"One does what there is to do, that's all. I remember
during the rehearsals for the Philharmonic concert the
contact microphones seemed to be causing all kinds of
trouble, and Morty Feldman tried to persuade me not to
use them. 'Think how shimmeringly beautiful it would
sound,' he said, 'just the instruments playing that star
music, with no electronics.' 'Yes,' I said, 'but think how
magnificently ugly it will sound with the microphones on!'
That's how I feel now. I am going toward violence rather
than tenderness, hell rather than heaven, ugly rather than
beautiful, impure rather than pure—because by doing
these things they become transformed, and we become
transformed. Unless we do these things, nothing changes.
If I were moving toward the good, toward heaven, I would
simply search out the David Tudors of this world and work
only with them. After the Philharmonic, David came to me
and we talked about the possibility of doing *Atlas* at the
Guggenheim Museum with a selected group of musicians,
doing it properly, as it should be done. I will not refuse
this. But I also will not refuse situations such as the Phil-
harmonic, when and if they come up. I will let circum-
stances decide."

Jean Tinguely

It is characteristic of Jean Tinguely, the Swiss motion sculptor, that the bizarre, animated, anti-functional machines that constitute his art usually fail to work in the way they are expected to, and sometimes do not work at all. This is not always the fault of the machines. In Amsterdam in 1961, at the opening of a comprehensive show called "Art in Motion," at the Stedelijk Museum, a large Tinguely "meta-matic" sculpture, powered by a gasoline engine, was installed in the reception room, where it was supposed to produce its own abstract drawings and at the same time pump the exhaust from its engine into a balloon, which would eventually fill up and explode, pouring forth fumes and driving the guests from the room; the machine was unable to do any of this, because another artist, perhaps enraged at such theatrical egocentricity in a mere machine, had poured beer into its fuel tank. More

often, though, it seems to be a spirit of perverse individualism that leads Tinguely's machines to break down at critical moments, leap from their pedestals, and dash themselves against the floor, or otherwise perform in a manner different from what Tinguely had in mind—the most spectacular example being the enormous self-destroying construction called *Homage to New York*, which refused to commit suicide in the garden of the Museum of Modern Art in 1960. Although *Homage* failed to destroy itself completely, it managed nevertheless to execute a great many wholly unexpected and startling feats before the Fire Department closed in with extinguishers and axes to finish the job. Tinguely himself is always delighted by the eccentricities of his strange contraptions, whose freedom he seems to identify with his own. This identification is never more obvious than when he tries to describe a machine he has made or plans to make, and acts out its motion with his body—shoulders jerking, hands jiggling, head bobbing—while squeaks and rumbles and other appropriate mechanical noises issue from his throat. A short, dark-haired, unkempt young man with an affable, disreputable face, an athletic build, and an unbridled imagination, Tinguely neither sentimentalizes nor makes fun of machines; he simply wishes them well. "For me," he says, "the machine is above all an instrument that permits me to be poetic. If you respect the machine, if you enter into a game with the machine, then perhaps you can make a truly joyous machine—by joyous, I mean free. That's a marvelous thing, don't you think?"

There is no denying that these are trying times for machines, what with all the new demands being made upon them. At the Bell Laboratories, in Murray Hill, New

Jersey, a scientist named Max V. Mathews has obliged a
giant electronic computer to compose music on tape, while
his colleague Bela Julesz, in the course of his researches
in visual depth perception, has induced another such in-
strument to produce designs that contain elements of both
randomness and order, thus approximating the technique
of pure abstract painting. Several years ago, at the same
lab, Claude Shannon created the prototype of the little
black box now sold in novelty stores which, when turned
on by a switch, slowly opens its lid, extends a prehensile
hand, and turns itself off. But even Shannon's black box,
defiant and self-preservative as it may appear, is merely
reacting subserviently to the man who turned it on.
Tinguely's machines, by contrast, often seem free to do
whatever they please. Constructed for the most part of
material from the junkyards of Paris, where Tinguely
lives, and usually animated by castoff electric motors, they
perform (or fail to perform) in what most of their specta-
tors cannot help describing in human terms: they can be
gay, funny, satiric, or absurd, and they can also be angry,
anguished, and, in some cases, terrifying. Since they all
work on a basic system of asynchronous gears that makes
possible what Tinguely calls "the functional use of
chance," their motion is inherently unstable and nonrepeti-
tive. The chances that a meta-matic (the name is another
Tinguely invention and means "beyond the machine") will
repeat a drawing, Tinguely estimates, are about one in a
million. This has led Tinguely's good friend K. G. Hultén,
director of the Modern Museum in Stockholm and the main
organizer of the "Art in Motion" show, to describe the
Tinguely machines as "happy" ones. "They represent a
freedom that without them would not exist," Hultén has

written. "They are pieces of life that have jumped out of
the system—out of good and bad, beauty and ugliness,
right and wrong."

Whether or not Tinguely's freewheeling machinery can
be called art is another question, and one that Tinguely
himself does not propose to answer. "The fact that people
say 'But it's not art' makes me very happy," he maintains.
"I never disagree with them. I always say 'You're abso-
lutely right.' " He is equally unmoved by the charge that
what he is doing is anti-art. It is clear that his work has
been profoundly influenced by the anti-art spirit of the
Dada movement of the 1920s. "Dada prepared the way for
modern art, and I am in every way flattered to be com-
pared to it," Tinguely says. But neither he nor the so-called
neo-Dada artists active in New York and Paris show much
of the Dadaists' old combative violence. Tinguely has no
grudge against society, and his machines work, he says,
"without prejudice" to anyone. Marcel Duchamp, the
legendary Grand Dada, finds Tinguely immensely talented
but by no means a Dadaist. "That's absurd, you know,"
Duchamp has said. "The atmosphere today is nothing
like it was then. It is also absurd to say that Tinguely is
anti-art. To be what people call anti-art is really to affirm
art, in the same way that an atheist affirms God. The only
way to be really anti-art is to be indifferent."

In Paris, Tinguely has often been associated with the
group of young artists who call themselves *nouveaux
réalistes*. According to Pierre Restany, a French critic who
has written enthusiastically about the movement, the New
Realism of these pioneers consists in their having turned
away from easel painting ("which has had its day") in
order to pursue "a passionate adventure of the real . . .
seen in itself, and not through the prism of conceptual or

imaginative transcription." The passionate adventurers include César, a sculptor who uses giant industrial presses to crush automobiles and other artifacts into solid blocks, which he then exhibits as works of art; Arman, who fills glass cases with "accumulations" of machine-made objects, such as toy pistols, rusty spoons, and dolls' eyes; Martial Raysse, who is currently enlivening his canvases with neon tubes and motion pictures projected upon them; Daniel Spoerri, who glues his breakfast or whatever else he wants to trap to the top of a table and then hangs the table on a wall, in an effort "to assassinate life and reality"; and Niki de Saint-Phalle, an attractive female *réaliste*, who invites spectators to shoot at her plaster-encrusted collages with a .22 rifle, thus breaking the bags of pigment concealed therein. Until his death in 1962 at the age of 34, the real leader of this group was Yves Klein. Klein made his reputation with "blue paintings"—canvases covered flatly and exclusively with several layers of a pigment he named "International Klein Blue"—and progressed to painting with "living brushes," or nude models who daubed themselves with I.K.B. and then pressed their bodies against blank canvases, under Klein's supervision.

What separates Jean Tinguely from the other new realists is his passionate dedication to motion in art. Tinguely's kind of motion, moreover, is unique. It is neither motion represented, as in the sculptures of the Futurist Umberto Boccioni or the Cubist Raymond Duchamp-Villon, nor motion used as a fourth dimension, as in the elegant mobiles of Alexander Calder and the motorized "tangible-motion" sculptures of Len Lye. Tinguely's motion is the entire meaning and expression of each thing he does. At rest, his pieces are without interest. Only in motion do they come alive, leap into the human situation, and com-

municate (to some observers, at least) the sense of total
freedom that, Tinguely firmly believes, can come only
from accepting the impermanence, the accidents, and the
infinite transformations of life itself. "Life is movement,"
Tinguely says. "Everything transforms itself, everything
modifies itself ceaselessly, and to try to stop it, to try to
check life in mid-flight and recapture it in the form of a
work of art, a sculpture or a painting, seems to me a
mockery of the intensity of life." Tinguely sides with
Heraclitus in believing that change is the one aspect of
reality that can be called permanent. "I want only to in-
volve myself in the moving object that forever transforms
itself," he says and adds cheerfully, "If you want to stop
a painting and look at it, don't buy my work. Go and buy
a van Gogh."

A good many people have been buying Tinguely's work
in recent years, and a great many more have been flocking
to see it, in exhibitions here and abroad. The big "Art in
Motion" show, which provided a survey of the "movement
movement" in the work of seventy-two artists, broke all
attendance records at the Stedelijk Museum, and Tin-
guely's machines—he was represented by twenty-seven of
them, in addition to his beer-drowned entry in the recep-
tion room—were the main attraction. The Tinguely exhibit
filled one whole gallery, and included meta-matic painting
machines, "junk-mobiles," which plunged into action when
viewers stepped on floor switches, and a powerful engine
of destruction that smashed or chewed up whatever objects
the spectators put into its cast-iron mouth—cups, saucers,
glasses, and even articles of clothing. When the show moved
on to Stockholm, the question of precedence among mo-
tion artists was settled by placing Duchamp and Calder ex-
hibits at either side of the front door and allowing Tinguely

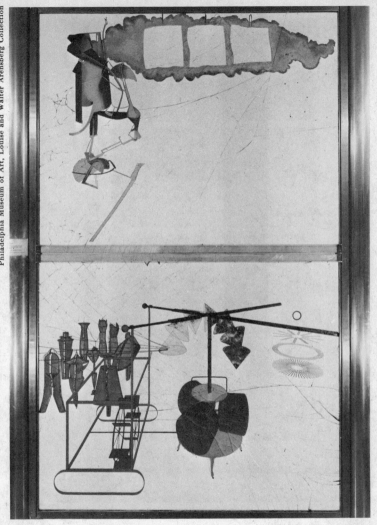

Marcel Duchamp's *The Bride Stripped Bare by Her Bachelors, Even* (*Large Glass*), 1915-1923.

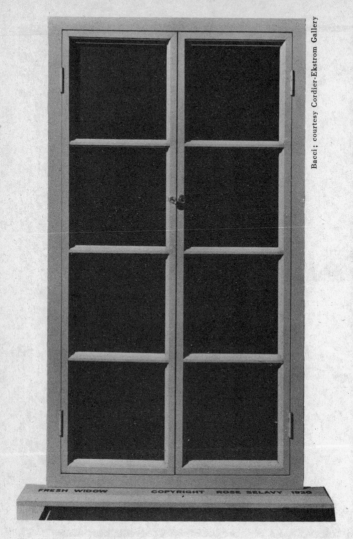

Fresh Widow (1920).

...ois Stoppages-Etalon (1913-1914).

...Propos de Jeune Sœur (1911).

Bottle Rack (replica).

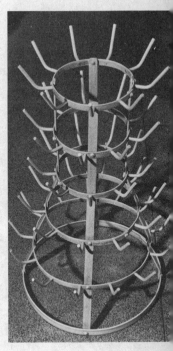

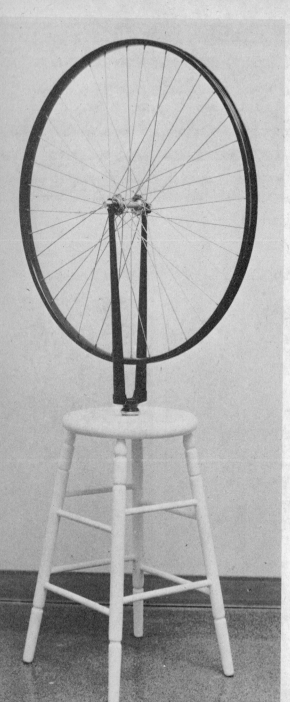

Bicycle Wheel
(replica).

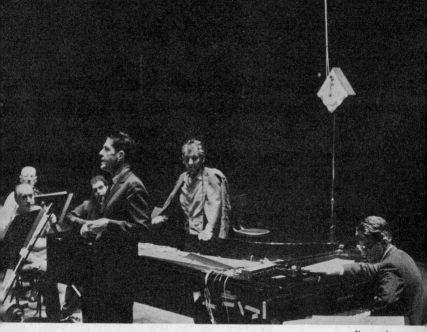

Cage, Bernstein, Tudor, and mechanical conductor
rehearsing *Atlas Eclipticalis*.

Sample pages from four Cage scores.

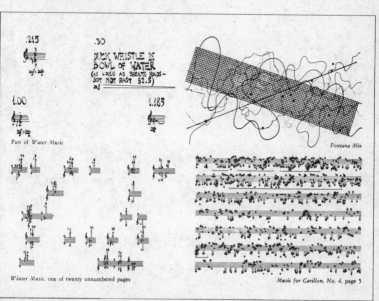

Part of *Water Music*

Fontana Mix

Winter Music. one of twenty unnumbered pages

Music for Carillon, No. 4, page 5

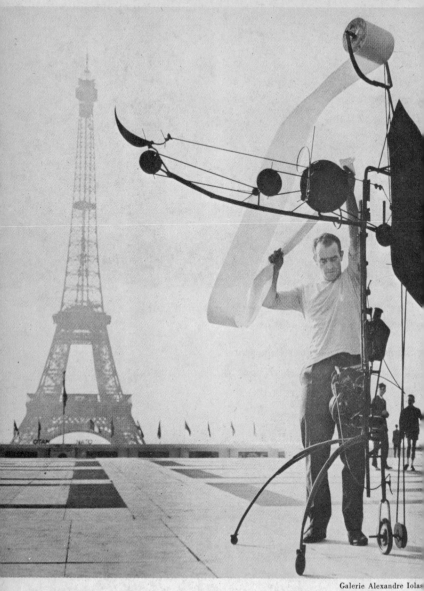

Jean Tinguely and his large "meta-matic" painting machine
at the 1959 Biennale de Paris.

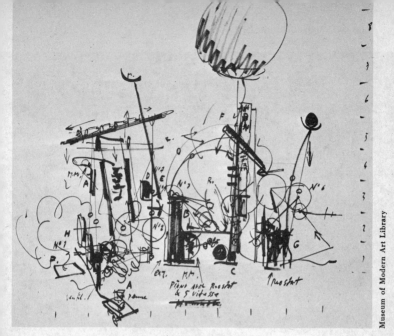

Sketch for *Homage to New York*.

The most interested spectator.

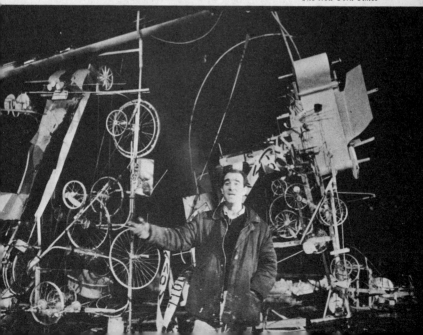

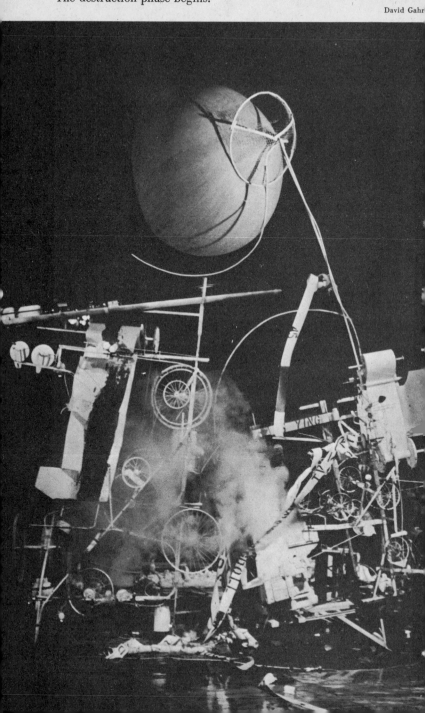

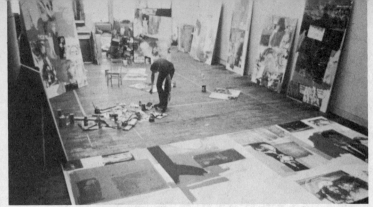

Robert Rauschenberg in his New York studio.

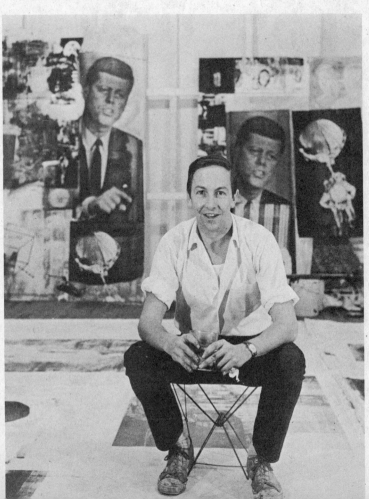

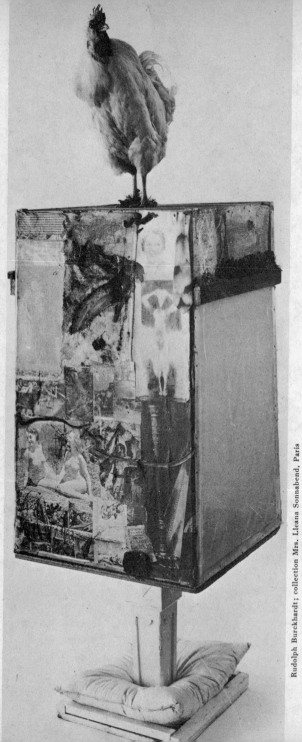

Odalisk (1955

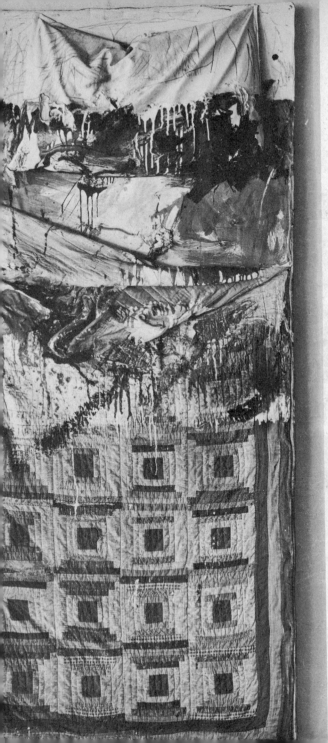

Bed

Rudolph Burckhardt; collection Mr. and Mrs. Leo Castelli, New York City

According to Duchamp, a painting that does not shock is not worth painting. Rauschenberg's undisputed shockers are *Bed* (preceding page) and *Monogram* (below).

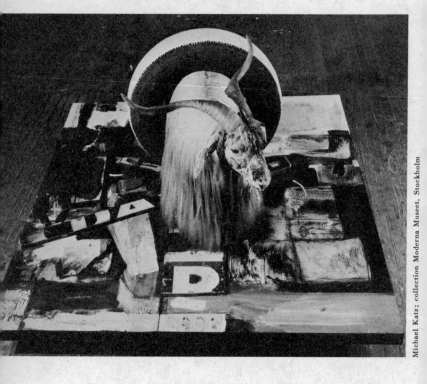

Opposite: Merce Cunningham and Dance Company shown during 1967 performance of *Scramble*.

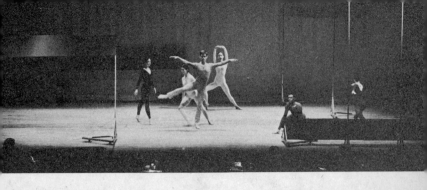

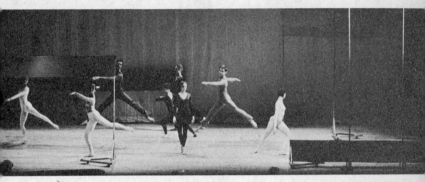

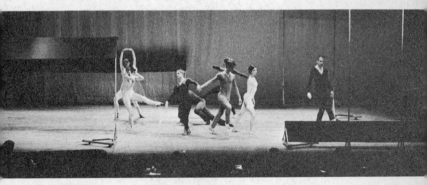

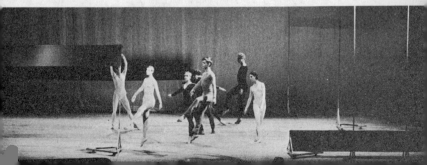

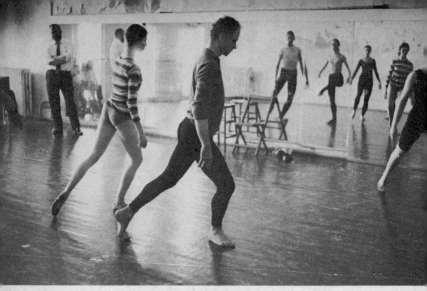

Studio rehearsal: Cunningham with Sandra Neels
(left) and Barbara Lloyd (right).

Cunningham, Carolyn Brown, and Gus Solomons, Jr.

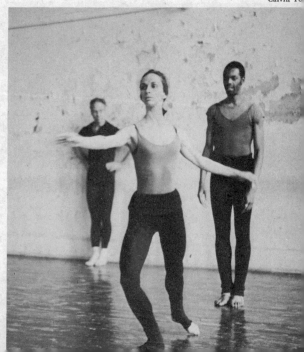

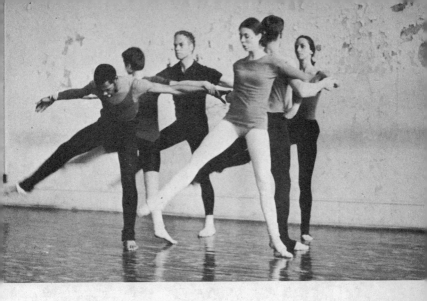

Exploring *Scramble*'s new terrain.

Photos: Calvin Tomkins

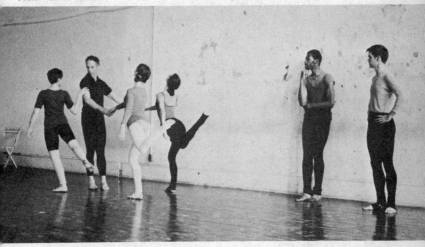

Overleaf: Cunningham's 1968 *Walkaround Time*. The set, supervised by Jasper Johns, is based on the *Large Glass* by Marcel Duchamp.

to dominate the main room with an assembly of objects—
a raincoat, some ancient fur pieces, an artificial leg, pots
and pans—which he suspended from the ceiling. Some
of these hung down to the floor, so that spectators could
not avoid bumping into them, or being bumped into by
them, as they sprang unpredictably into motion for five-
second intervals. Far from being annoyed or frightened or
puzzled by these surprises, the visitors appeared to be
delighted.

When seeing a Tinguely mechanism for the first time,
most people burst out laughing. The laughter may become
somewhat uneasy, but initially it serves to carry the gallery
visitor into Tinguely's world and makes it difficult for him
not to play Tinguely's game. "The machines I make con-
front the public with a new phenomenon," Tinguely says.
"People like them. The spectator is drawn at first by the
novelty—he's never seen anything that crazy. He listens,
they speak to him, and he is enthusiastic. I've seen it—
this contact. It is banal, of course, but it is also very good.
You know, abstract art has become very conformist with-
out ever becoming popular. But in my case, I can honestly
say that I make popular art." The idea that art can be
a game played by artist and spectator is one of Tinguely's
favorite notions. In searching for a parallel to his work,
Tinguely is often moved to compare it to Chinese fireworks.
He considers fireworks a powerful form of artistic ex-
pression, as ephemeral and as free as his own meta-
matics, and some time ago he became eager to stage a
fireworks display of his own. His opportunity arose on the
night of the gala opening of the motion show in Stock-
holm. While the opening-night guests watched from the
island of Skeppsholmen, on which the Modern Museum is
located, Tinguely, who cannot swim, rowed a boat full of

rockets and Roman candles out into the surrounding har-
bor and proceeded to set them off from the boat. In order
to make it an authentic Tinguely spectacle, he had doc-
tored the fireworks to make them less predictably suc-
cessful. Some of the rockets even had strings attached, so
that they would go up a certain distance and then plum-
met anticlimactically. According to several of the specta-
tors, the display turned out to be astonishingly beautiful,
in spite of Tinguely's efforts, and was thus perhaps the
apotheosis of all Tinguely's effects to date—a spectacle
that failed to fail.

It has often been said of Tinguely that all his work is
in some sense a reaction against the discipline, efficiency,
and orderliness of his Swiss background. It is true that
Tinguely has a low opinion of his countrymen, whom he
once described as "suffocating in security and drowning
in comfort," but to see his work as an extended act of
rebellion is to oversimplify it and to ignore the fact that
Tinguely was idiosyncratic, independent, and rebellious
almost from birth. He was born in Fribourg, in 1925,
and three years later his family moved to Basel, where he
grew up. An only child, Tinguely has said that his earliest
memories are of conflicts with his father, who was a fac-
tory worker and a hard, if ineffective, disciplinarian.
Young Tinguely spoke French at home, like his parents,
and German in the street—where, he recalls, he spent most
of his time. At school he skipped classes regularly, hung
out in alleys, and stole for the fun of it. He did visit his
classes often enough to become a passionate reader, with a
special fondness for the lives of men like Alexander, the
Caesars, Napoleon, and Lord Byron. When he was eleven
he discovered that he could assure himself of the privacy

these studies required by going off to a forest just outside
Basel, climbing a tree, and reading there until dark. In this
forest Tinguely, at the age of twelve, spent one whole
weekend turning out his first piece of motion art—a work
he is still inclined to think of as his best. At intervals
along a fast-running stream, he placed some thirty small
water wheels he had made, each fitted with a camshaft
that, when activated by the turning wheel, struck with its
own particular rhythm on a tin can, a bottle, or some other
noise-making object. The sound of this percussive orchestra
was amplified by the natural dome of the trees overhead,
and when the wheels were all going at once, the effect,
Tinguely recalls, was weird and beautiful—a pastoral
symphony played out on the detritus of Basel's back streets.
"It was done with complete innocence," says Tinguely. "I
thought that if someone came walking in the woods he
might hear it, but aside from that I did it just for the sake
of doing it."

Most of Tinguely's ventures at this time were less
successful. When he was fifteen he made a sudden decision
to go to Albania and help that country defend itself against
an impending military attack by Mussolini; he was picked
up by police on the Italian border, clapped in jail for
three days because he refused to give his name, and then
sent home. His father, enraged by the adventure, took
him out of school and got him a job in a Basel department
store—a form of regimentation that Tinguely reacted to
by ripping a time clock off a wall and, not surprisingly,
getting himself fired. On his own, he then got a job in a
rival store as assistant to the chief decorator. His new boss,
impressed by his draftsmanship, suggested that he attend
some evening classes at the Kunstschule. Tinguely did so,
enrolling in the class of a remarkable young teacher

named Julia Ris, who encouraged her students' indepen-
dence and got them into lively arguments about Picasso,
Klee, Kandinsky, Mondrian, and the other painters who
had been altering the image of art in the twentieth century.
Her most popular course was called "material studies,"
in which the students worked with any sort of material at
hand—wood, sand, scrap metal, kitchen pots, old rags—
to make collages that would express such simple physical
states as roughness, smoothness, heat, and cold, or adjec-
tives like "festive" and "floating." The course reflected
Miss Ris's interest in the collages of the Dadaist Kurt
Schwitters, one of the first artists to decide that "found
objects"—that is, junk—were an integral part of the ur-
ban, industrial landscape and could thus be made to serve
as both material and subject matter in the art of an urban,
industrial society.

Tinguely and Miss Ris took to each other immediately.
She remembers him vividly as an exceptionally sharp-
witted, unusually well-read student with an ironic, biting
intelligence. "He was a short youth," she recalls, "not
exactly pretty, but, rather, the darkly pondering type, with
his heavy black eyebrows meeting above his nose, and,
under them, his dark eyes blinking critically. Everything
he did or said was decisive and clear, which made him
seem grown up. He was very much in demand by all the
young ladies—and the youths too—but Janno, as we
called him, took them all for a ride. He was amused by
the ruckus he caused. Once, when I told him to his face
that he treated matters of feeling much too lightly, he
bellowed with laughter and said, 'That's the way I am, I
can't help it.' Moral considerations were not his strong
point."

During the war and immediately afterward Tinguely's

private, or nonartistic, life was one of cheerful chaos. Switzerland, being neutral, attracted political refugees from all over Europe. In Basel, Tinguely fell in with an assortment of young anarchists—including a Polish ex-Communist who had fought in Spain, a German ex-Socialist, and a tubercular American—who met nightly and talked politics until dawn. Their discussions helped fix the paradoxical and irreverent views of the individual and society that are reflected in Tinguely's art and had the incidental effect of destroying, apparently for good, his fondness for reading. In 1949 he surprised his friends by marrying a beautiful copper-haired fellow art student named Eva Appli, who had a four-year-old son by a previous marriage. The three set up a haphazard ménage, almost entirely unencumbered by furniture, in a cheap, multi-room apartment in a run-down building.

At the Kunstschule, Tinguely's work was intense and experimental but by no means haphazard. His deepest interest lay in the material studies, and from his studies with Julia Ris he was also acquiring some knowledge of the problem of motion in art—a problem that has engrossed and puzzled artists ever since cave men depicted running animals by giving them eight legs. Twentieth-century artists, obsessed with the accelerating tempo of modern life, attacked the motion problem with great vigor and ingenuity. Although Cubist art was essentially static, the Futurists in Italy, rebelling against what they considered the academism of Cubism, called for a radically new kind of art, which would put the viewer in the whirling center of pictures that expressed not fixed moments in time but the "universal dynamism" of modern life—"a life of steel, fever, pride, and headlong speed." Similar manifestoes came from the Suprematists, in Russia, and the

Constructivists, in Germany. "We free ourselves from the thousand-year-old error . . . that only static rhythms can be [art's] elements," wrote the constructivist brothers Antoine Pevsner and Naum Gabo in a 1920 manifesto. The Bauhaus school, which accepted the machine as an object worthy of the artist's attention, also embraced the concept of the new kinetic style. "We must put in the place of the static principle of classical art the dynamic principle of universal life," wrote the Bauhaus teacher, sculptor, and architect László Moholy-Nagy in 1922. "The Renaissance painter constructed the scene to be painted from an unchangeable, fixed point following the rules of vanishing-point perspective. But speeding on the roads and circling in the skies has given modern man the opportunity to see more than his Renaissance predecessor. The man at the wheel sees persons and objects in quick succession, in permanent motion." There was also Paul Klee's famous statement that all pictorial art "springs from movement, is itself fixed movement, and is perceived through movement." Tinguely was aware of these currents; he knew, for example, that the Russian Suprematist Vladimir Tatlin had experimented with moving objects in an attempt to "dematerialize" them through speed, as a moving airplane propeller is dematerialized. Thus it was not entirely an anarchistic sense of humor that impelled Tinguely to remove the doors from their hinges in the spare rooms of his apartment and to hang them from the ceilings, where, attached to motors, they could be made to revolve at high speed. He suspended some of his paintings and sculptures in the same fashion and revolved them until they flew to pieces, while he and Eva and their friends took cover behind screens to watch. "It was just like Cape Canaveral," Tinguely says with satisfaction.

In 1951 Tinguely and Eva, leaving her son with his father, hitchhiked to Paris and found a room in a small, shabby hotel on the Rue Pierre Leroux, in the Fifteenth Arrondissement, where they lived for the next two years in what Tinguely has called "agreeable poverty." It was here that their daughter Maria was born in the following year. The Tinguelys fell in readily with the floating, café-centered existence on the Left Bank, and they became totally Gallicized, even to adopting the French pronunciation of their name; in Basel it had been "Tin-GWAY-lee," in Paris it became "Tang-guh-LEE." (The onomatopoetic aptness of the latter to Tinguely's machines has been noted by many critics.) Tinguely took on a series of window-decorating jobs, but most of his time and energy went into his sculpture. He had become obsessed with motion. According to Daniel Spoerri, a Rumanian ex-ballet dancer whom Tinguely had found selling bananas outside the hospital in Basel, and who later followed him to Paris, Tinguely managed to turn almost all conversations into violent arguments about motion, kinetic art, and the approaching death of static, "fixed-image" easel painting.

Tinguely had his first show in 1954 at the tiny Galerie Arnaud on the Left Bank. It consisted of spindly wire sculptures, which, when activated by means of a master cogwheel, moved in a series of jerks and lurches that reduced Eva to helpless laughter whenever she saw them. The mechanisms, she said, were a perfect parody of the Swiss watch. The show also included some of Tinguely's first "reliefs." These were cut-out sheet-metal forms, modeled on the abstract shapes in works by Arp, Kandinsky, and Malevich, which Tinguely painted white and mounted on rods set into a black plywood background; behind the plywood base a system of pulleys and cogwheels operated

by a small motor caused the forms to turn at whatever
speed Tinguely thought appropriate—some whirred furi-
ously, others spun so slowly that the movement was almost
imperceptible. An American woman bought one of the re-
liefs for seventy-five dollars, and several others sold for
forty dollars, which, after deducting the gallery commis-
sion, was about what it cost to make them. The sales came
as a surprise to Tinguely; they were the first evidence of
the popular acceptance he has enjoyed ever since.

In 1955 Tinguely and Eva moved into the Impasse
Ronsin, an artists' colony of dilapidated shacks surround-
ing Brancusi's old studio, in the Vaugirard district. One
of his neighbors in the Impasse, the American painter
Reginald Pollack, says that Tinguely impressed him at the
time as a young man with no doubts about his future. "He
was also," says Pollack, "the world's greatest *je-m'en-
foutiste*. He just didn't give a damn about anything. It
was only his good nature, his sweetness, and the fact that
he really worked like hell that saved him from being un-
bearable. He used to come over every morning at break-
fast time and ask to borrow our coffee grinder, and I'd
say sure, but please get it back before noon, and he would,
and then the next morning there he'd be, with a big smile,
asking to borrow it again. This went on for about a year,
although he was selling by then and could afford to buy
himself one. I finally suggested he take the coffee grinder
and give me something of his in return. He brought over
one of his wire constructions. It had been lying around
on the floor of his studio for months, and everyone who
came in had walked on it, but he said that didn't matter,
it could be any shape at all."

The Tinguelys' marriage was casual, to say the least.
(They are divorced now, and their daughter lives with

Eva and her new husband.) Pollack remembers Eva as "sort of a Swiss beatnik"—tall and very thin and strikingly attractive, although she was never seen in anything but blue jeans. Periodically the Swiss in Eva would come to the surface, and she would push everything to one side—scrap metal, wire rods, motors, Tinguely's acetylene torch, and a tangle of extension cords—and scrub the studio from top to bottom.

Tinguely worked outdoors in warm weather, and neighbors who lived beyond him in the Impasse had to contend with his machines in the lane. He had started building his first meta-matics—mechanical robots that made a great racket, thrashed about, and eventually painted abstract pictures. "Unless you were careful, you could kill yourself on one of those things in the dark," says Pollack. "Once in a while he'd throw a sheet over his stuff, so you wouldn't run into it, but more often he forgot." Whatever money Tinguely made he put right back into materials and motors, which he bought in quantity. The French at that time were all converting their phonographs from 78 r.p.m. to 33 r.p.m., and Tinguely found he could buy up old phonograph motors for very little. At one time he had two hundred and fifty of them on hand. He was working furiously, and his work was attracting admirers. By this time he had graduated from the Galerie Arnaud to the Right Bank gallery of Denise René, then the leading avant-garde dealer in Paris.

Sitting on the roof of K. G. Hultén's apartment house, on the Boulevard Raspail, one rainy spring night in 1955, Tinguely, Hultén, and Robert Breer, a young American painter who had recently gone into abstract film-making, conceived the idea of an exhibition devoted to motion in art. They had no difficulty persuading Denise René to

agree, and the first exhibition of *"Le Mouvement"* took place at her gallery in April. It included mobiles by Calder and some of Duchamp's rotating disks, as well as new works by the regular Denise René group. Victor Vasarely, dean of the Denise René artists, was less than enthusiastic about the show, but he contributed works embodying optical movement—overlapping sheets of Plexiglas covered with black designs that appeared to move when a spectator walked past them. Raphaël-Jesús Soto, a Venezuelan, also used the spectator as the motor for his optical trick pictures. Jacob Agam's pieces consisted of Kandinsky-like shapes that spectators were invited to rearrange at will on a pegboard. The only true motion among the works by the Denise René group was to be found in Tinguely's reliefs and motorized wire sculptures, and in his meta-matic robot that walked about, drew pictures, and jostled neighboring exhibits in a manner that some of the other artists found anything but amusing.

After the motion show Tinguely made twenty new machines, which he exhibited in the avant-garde Galleri Samlaren, in Stockholm. For the next two years he produced nothing at all. While in Stockholm he acted in an experimental film produced by Hultén and Hans Nordenström; it was shot in the streets of the city, and Tinguely managed to get himself jailed for impersonating a policeman, which happened to be the part he was playing. Back in Paris, he spent some months building a racing car with a friend, and some weeks in the hospital after catapulting his Citroën into a ditch.

The event that galvanized him into artistic action again was the opening of Yves Klein's exhibition *"Le Vide"* ("The Void") at the Galerie Iris Clert. Klein spent two days cleaning and whitewashing the one-room gallery to

rid it of the "presences" of other artists who had exhibited there. White and exorcised, it was then presumably filled with the presence of Yves Klein, and nothing else. What the spectators witnessed was merely the pure "atmosphere" of the painter, unaccompanied by such tiresome distractions as paintings or sculptures. Three thousand people were turned away from the opening and spent the evening milling about in the Rue des Beaux Arts. Klein had managed, through an influential relative, to have two Republican Guards, in their crimson and blue uniforms, with cockades, stationed at the door. Klein's Left Bank friends could not believe the Guards were genuine and subjected them to such a barrage of indignities that the pair left in a rage after the first hour. The next morning Klein and Iris Clert were informed that they would be brought to trial for insulting the State. The unpleasantness was disposed of, however, when the commandant of the Guards came around to investigate. He studied *"Le Vide"* with great interest, said he had known many Surrealists and Dadaists in the "good days," and congratulated Klein on a fine show. The *procès* was quashed.

Probably the most enthusiastic viewer of "The Void" was Tinguely, who stayed for three hours and persuaded Klein that the two of them should do a show together. The show, which opened a few months later at the Iris Clert, was called "Pure Speed and Monochrome Stability" and consisted of Klein's blue paintings whirled and "dematerialized" by Tinguely's motors. Some friends of both men have said that Tinguely really succeeded in dematerializing Yves Klein, who did very little of anything for some time afterward. Tinguely, on the other hand, began to work with such intensity that life in the Impasse Ronsin became more than usually difficult for his neighbors. "He'd

be hammering away in there all night," Pollack recalls. "Once, I got up out of bed at four a.m. and went over and banged on his door. I was really sore, and when he opened up I asked what the hell he thought he was doing. He said in a surprised voice, 'Oh, were you already asleep?' " Tinguely himself remembers this period as one in which he was working in a kind of trance. "At night I'd go to sleep and then wake up and start to work again, and then the next morning I'd wake up again and discover that I had done the most amazing things."

Tinguely's amazement and enthusiasm over his work at this period were matched only by those of his admirers, who flocked to his shows in droves. Troubled by this evidence of what he considered a too ready acceptance of his complex creations, Tinguely felt impelled to issue a statement of his artistic ideas. Before the opening of a show of his called "Concert for Seven Pictures," in Düsseldorf, he flew over that city in a small airplane and dropped a hundred and fifty thousand leaflets printed with a manifesto called *"Für Statik"* ("For Statics"). The text read:

Everything moves continuously. Immobility does not exist. Don't be subject to the influence of out-of-date concepts. Forget hours, seconds, and minutes. Accept instability. Live in Time. Be static—with movement. For a static of the present moment. Resist the anxious wish to fix the instantaneous, to kill that which is living.

Stop insisting on "values" which can only break down. Be free, live. Stop painting time. Stop evoking movement and gesture. You *are* movement and gesture. Stop building cathedrals and pyramids which are doomed to fall into ruin. Live in the present; live once more in Time and by Time—for a wonderful and absolute reality.

Not one of the leaflets landed in Düsseldorf; warm air rising from the city whirled them upward and deposited them in the countryside several miles away. This fiasco, an excellent example of instability, continuous movement, and gesture, did not affect the success of the show, which was heavily attended and received considerable attention in the press and on television.

His next exhibition, at the Iris Clert in July 1959, was even more of a sensation. He filled the gallery with meta-matics, which he had developed by then to a formidable state of perfection. The meta-matics represent Tinguely's most inspired application of the functional use of chance. Like Calder's constructions, which they somewhat resemble, they are handsome pieces made up of black metal plates and rods welded together. Each one has a complicated mechanical arm operated by a small motor and fitted with one or more clamps, in which can be placed crayons or inking devices. When the meta-matic is put into operation by the spectator, the arm moves erratically over a clip board holding a sheet of paper. The spectator can stop or start the machine at will, change the colors, and exert some control over the speed at which the arm moves. Some initiates claim that the personality of the operator gets into the painting, and it is certainly true that no two paintings made by the same machine are ever quite alike. Few people can resist trying their luck, and the results, as often as not, are not only distinctly pleasing but uncomfortably close to certain contemporary paintings produced by the unaided human hand.

The meta-matic show drew more than three hundred people a day into Iris Clert's small room, which stayed open until midnight every night to accommodate them.

164 The Bride & the Bachelors

Tinguely organized a meta-matic art contest for the best
picture made on his machines and told a reporter that a
meta-matic was "an anti-abstract machine, because it
proves that anyone can make an abstract picture, even a
machine." The triumph of this show did little to increase
Tinguely's popularity among the Paris abstractionists and
their followers, who tended—and still tend—to look on
him as simply a *fumiste,* or practical joker. A movement
was instigated to keep him out of the huge Biennale de
Paris exhibition scheduled for that October at the Musée
d'Art Moderne, and it succeeded to the extent that Tinguely
was prevented from installing an eight-foot meta-matic,
the biggest yet, in the museum, on the ground that its
gasoline engine would be a hazard to life, limb, and the
other works of art. Tinguely set up his great machine out-
side the museum entrance, where it so fascinated visitors
that some of them never got into the museum at all. The
meta-matic walked, danced, broke down, was repaired
(Tinguely, as usual, was on hand to fix it), mesmerized
children, created some thirty-eight thousand abstract paint-
ings during the two weeks of the Biennale, and was praised
as "a good machine" by André Malraux, the Minister of
Culture. Malraux had the misfortune to be standing in
front of the meta-matic when a balloon attached to the
exhaust pipe exploded in his face, but he later said of the
show, with commendable aplomb, "The State's job is not
to pass judgment; it must only help artists."

During the run of Tinguely's next show, at the Kaplan
Gallery in London, he delivered a remarkable "lecture"
at the Institute of Contemporary Arts. The substance of the
talk was on the general order of the "For Statics" mani-
festo distributed over Düsseldorf, and under other circum-
stances it might have helped to clarify in many minds

Tinguely's somewhat confusing idea that movement itself is static. ("Movement is static because it is the only immutable thing—the only certainty, the only unchangeable.") The trouble was that no one there could understand a word of it. Tinguely sat on the stage in a spotlight while the audience listened to a recorded text that he had taped, in English, before leaving Paris. Constant corrections of his pronunciation and grammar by an English girl were included in the tape; moreover, a duplicate of the tape was played simultaneously but slightly out of phase, thus setting up a chaotic babble that most of the audience found incomprehensible but sidesplitting. During the intermission following the lecture, a Palais Royale *demimondaine*, whom Tinguely had brought from Paris for the occasion, walked up and down the aisles dressed in a short skirt and fish-net stockings, vigorously chewing gum, and grinding out abstract drawings on a small, hand-operated meta-matic, to the loud accompaniment of a Paul Anka recording of "I'm Just a Lonely Boy." Then came the main event. Mounted on the stage with its back to the audience was a *"cyclo-graveur"* meta-matic equipped with a bicycle seat, pedals, handlebars, and a tremendous roll of sturdy wrapping paper. Two young men walked out in white T shirts, each with the word "META-MATIC" stenciled across the front in block letters. An announcer informed the audience that these athletes, both of them cycling-club champions, would compete to see which could cycle away a mile of paper, simultaneously converting it into an abstract painting, in the shorter time. The first contestant mounted the machine and hunched over the handlebars. A starter, dressed in white coat, gloves, and peaked cap with a tassel, fired the starting gun. The cyclist began pedaling madly. The paper shot past the inking devices and sailed

out over the audience in a great parabola, falling in the middle of the seats and inundating the spectators in a lashing torrent of abstract art. The audience was still trying to extricate itself when the second cyclist mounted the machine—which two overalled mechanics had reloaded with a new roll of paper—and buried it a second time. Amid pandemonium the first contestant was declared the winner and presented with a silver cup and a bouquet of flowers. Questions were solicited from the audience and translated for Tinguely, who answered everyone with his usual blend of engaging warmth and *je-m'en-foutisme*.

George Staempfli, a New York gallery owner and art dealer, had met Tinguely in Paris and promised him a New York show, and in January 1960 Tinguely crossed the Atlantic in tourist class on the *Queen Elizabeth* to be on hand for the first exposure of his art in America. During the trip he began drawing up rough sketches for a work that would express some of his complex ideas about New York, a city he had never seen. New York, to Tinguely, had always seemed the place where modern man was in closest contact with his machines. "The skyscraper itself is a kind of machine," he has said. "The American house is a machine. I saw in my mind's eye all those skyscrapers, those monster buildings, all that magnificent accumulation of human power and vitality, all that uneasiness, as though everyone were living on the edge of a precipice, and I thought how nice it would be to make a little machine there that would be conceived, like Chinese fireworks, in total anarchy and freedom." The machine that Tinguely envisioned was to be called *Homage to New York*, and its sole *raison d'être* would be to destroy itself in one act of glorious mechanical freedom. The simplicity,

appropriateness, and grandeur of this vision so impressed Tinguely that he decided at once that the only proper locale for the event was the outdoor sculpture garden of the Museum of Modern Art, and as soon as he landed he set about achieving this almost impossible objective. The fact that he spoke practically no English and that he had few friends and, at best, a tiny reputation in New York seemed small obstacles to him, and he immediately began lining up supporters for his plan. Dore Ashton, an art critic for the *New York Times* who had seen his work in Europe, came down to the pier to meet him, and he showed her the drawings for his machine. "It has to be in the Museum of Modern Art," she remembers his saying. "It has to end up in the garbage cans of the museum." Miss Ashton, who had considerable opportunity to observe Tinguely in action during the next few weeks, was somewhat awed by his talent for getting what he wanted. "He often adopts the manner of a simple peasant when you ask him serious questions," she reports, "but he is certainly not at all simple. He is a very complicated person. If he feels you understand him, you're in; if you don't, he uses you."

One of the people who proved most helpful to Tinguely was Dr. Richard Huelsenbeck, in whose apartment he stayed for the three months he was in New York. Huelsenbeck, the Dadaist turned psychiatrist, had met Tinguely in Paris, admired his work, and enthusiastically proclaimed him a "Meta-Dadaist," who had "fulfilled certain ideas of ours, notably the idea of motion." Dr. Huelsenbeck provided Tinguely's entrée to a group of young innovators in New York that included the painters Robert Rauschenberg and Jasper Johns and the sculptors John Chamberlain and Richard Stankiewicz, and helped him renew his acquaintance with Marcel Duchamp. Duchamp

and Tinguely had met before, in Paris, and were full of
admiration for each other. "I feel with him a closeness
and a rapport that I have felt with few other artists,"
Duchamp has said. "He has this great thing, a sense of
humor—something I have been preaching for artists all
my life. Painters usually think they are the last word in
divinity; they become like *grands prêtres*. I believe in
humor as a thing of great dignity, and so does Tinguely."

The neo-Dada group told Tinguely that the best he
could hope for was to place his self-destroying machine
in some rental assembly hall in Manhattan, or perhaps in
an empty lot. Tinguely, however, would not abandon his
dream. George Staempfli had called a staff member of the
Museum of Modern Art and mentioned Tinguely's scheme
and three days later got word that it would not be possi-
ble. Undaunted, Tinguely got Dore Ashton to broach the
matter to Peter Selz, the museum's young and energetic
Curator of Painting and Sculpture Exhibitions. Selz was
interested. He had been fascinated by Tinguely's big meta-
matic at the Paris Biennale the year before, and he was
receptive to the playful and humorous aspects of Tin-
guely's work. ("Art hasn't been fun for a long time," he
said.) Selz spoke to the museum's director, René d'Har-
noncourt, and this led to a meeting between d'Harnon-
court and Tinguely. D'Harnoncourt asked some searching
questions about the machine and received what Tinguely
refers to as "spiritual explanations." This was followed
by a much longer session between Tinguely and Richard
Koch, the museum's Director of Administration. As Tin-
guely remembers it, "Koch asked me fifty questions, of
which I could answer one or two." Would there be dyna-
mite? Tinguely wasn't sure. Fire? Tinguely didn't know.
How long would it last? Tinguely had no idea. Not sur-

prisingly, Koch wouldn't commit himself. Selz, however, kept exerting pressure from his end, and Tinguely's admirers and allies in the neo-Dada group, some of whom had had their own work shown by the museum, mounted a modest crusade on his behalf.

Tinguely's show of meta-matics and rotating reliefs opened in January at the Staempfli Gallery, to astonished but generally friendly reviews. Feature stories on Tinguely appeared in several national magazines. Shortly afterward the museum reversed its earlier decision, and Tinguely's success was absolute. D'Harnoncourt agreed to let Tinguely set off his doomsday machine in the sculpture garden on the night of March 17, three weeks off, and offered him the use of the temporary Buckminster Fuller geodesic dome, at the far end of the garden, as a workshop; he assured Tinguely that no one would interfere in any way with the great work—a pledge that was faithfully observed.

Tinguely plunged immediately into a wide-ranging search for material. He bought dozens of used motors and a powerful electric fan in secondhand electrical shops on Canal Street. In an Army-surplus store he found a big orange meteorological balloon and some smoke signals. His friends collected enough money for him to buy a quantity of steel tubing, his only major item of expense, and the museum provided him with his indispensable tool, an acetylene torch. All this, however, was only a beginning. Tinguely likes to surround himself with a great mass of material, from which he draws his ideas, and at that moment he felt overpoweringly in need of bicycle wheels—items that no junk dealer in New York City seemed to have in stock. This problem was solved by Billy Klüver, a young Swedish research scientist whom Tinguely had known in

Paris and who was currently working at the Bell Laboratories in New Jersey. Klüver took time off from his work with electron beams and microwave tubes to become Tinguely's assistant, and the first thing he did was to find a bicycle dealer near his home, in Plainfield, New Jersey, who had recently dredged up thirty-five old bicycle wheels from a corner of his lot. "I put them in the back of my car and drove in to the museum about ten o'clock that night," Klüver said later. "When Jean saw them he was like a child; he had expected maybe five or six. His ideas took shape from them. That's how he works. He creates with what comes to hand, and the material shapes the creation. 'I want more wheels,' he said."

The next day Klüver and his wife raided a dump in Summit and loaded up their car with twenty-five more bicycle and baby-carriage wheels, a child's bassinet, and the drum from a derelict washing machine. They passed these over the garden wall to Tinguely, who carried them into the Fuller dome and immediately set to work. Two days later he had finished welding together the first section of his creation. This part centered on a large meta-matic painting machine and included the bassinet and the washing-machine drum as percussion elements. A horizontal roll of paper was to be fed down a sheet-metal trough, where it would be attacked by two large brushes held by an elaborately constructed painting arm. When the paper reached the bottom of the meta-matic it would be blown out toward the audience by the electric fan.

Material was running short again. This time Klüver took Tinguely to a big Newark dump. "I had said that his great machine should be one continuous process—out of the chaos of the dump and back again," Klüver has recalled. "Jean liked that, and when he came out and saw

the dump he fell in love with the place. He wanted to live there. He had the idea that if he could just find the right girl they could live right in the dump, like the bums there did, in a little shack, and he could spend his time building large, involved constructions, and that eventually the bums would become his friends and help him, although the word 'art' was never to be mentioned and his constructions would never be anything but part of the dump." The local inhabitants of the dump did help Tinguely and Klüver find the materials they wanted, including a cable drum, a rusty oilcan, a bedraggled American flag, and a great many more baby-carriage wheels, of which there seemed to be unlimited quantities. The next day Klüver located a dealer who was willing to sell him a workable radio and an antique upright piano for ten dollars. Then Tinguely got the museum to sell him, for two dollars, an ancient Addressograph machine that made an incredible amount of noise.

For the next two weeks Tinguely worked from twelve to sixteen hours a day in the dome, which was damp and ice-cold. The second section of the machine took shape around the piano. Tinguely fashioned ten armatures out of old bicycle parts and mounted them in such a way that they struck the piano keys in sequence, with considerable force. A small meta-matic was attached to the piano, where it would produce a continuous painting that would immediately roll itself up again—*l'art éphémère*. Two pairs of spindles operating at right angles to each other (one vertical, one horizontal) were designed to unroll two written texts and roll *them* up again. The radio, sawed in half but still able to function, was nailed to the piano. The Addressograph machine, with the addition of armatures and a bell, became a percussion instrument. Dozens of

wheels were fitted in place to drive the various moving
parts. Above the whole structure rose a twenty-foot steel
tube supporting the meteorological balloon.

The idea of the machine's destruction had by now begun
to seem of only secondary importance to Tinguely. Origi-
nally he had planned to incorporate into the structure a
number of saws that would attack the metal supports and
cause an ear-splitting din. But an associate of Klüver's at
Bell Laboratories hit on the idea of sawing through the
metal tubing in crucial places beforehand, and holding it
together with joints of soft metal that would melt when an
electrical charge was sent through concealed wire resistors
inside them. Tinguely enthusiastically embraced this new
plan. The joints were never really perfected, according to
Klüver, but Tinguely no longer cared. "He wasn't inter-
ested in perfecting something so that it would be sure to
work," Klüver has said. "He preferred to spend the time
adding new things, new gadgets."

A good many of Tinguely's friends dropped in to lend
a hand at odd times, and nearly every one of them caught
a heavy cold after a few hours in the unheated dome. Tin-
guely, whose somatic reactions are peculiar—he is often
prostrated just before a surge of prodigious labors, as
though, a friend says, he needed "a kind of pain before he
can create"—insists that he was never sick a moment while
working on "Homage." Almost everyone else remembers
that he had a high fever for several days. In any case,
toward the end, he was working almost around the clock,
scarcely bothering to eat or sleep. He made two more
small constructions, self-propelled, and designed to break
off from the main machine as it perished. The first had a
giant motor and a two-foot klaxon mounted on four baby-
carriage wheels. The second, also on wheels, consisted of

the cable drum and the oilcan, from which sprouted a wire with a corner of the American flag attached to it. This was tested in the museum lobby the night before the performance. While Tinguely and Klüver stood in rapt attention, the little cart rolled back and forth across the polished floor with an uncertain, jerky motion, its arm tapping a march rhythm on the oilcan and its bit of flag waving bravely. This oddly appealing mechanism was supposed to roll away from the dying parent machine and drown itself in the reflecting pool of the garden, where Maillol's monumental nude female figure "The River" would preside over its demise.

Because the show was scheduled for early evening Tinguely decided at the last moment to paint the entire construction white, in order to make it more clearly visible. He also confided to Peter Selz that he wanted *Homage* to be very beautiful, so that people watching it would feel dismayed when it began to destroy itself. ("I had no idea how beautiful it was going to be," Selz said later. "You had a real feeling of tragedy that that great white machine couldn't be preserved somehow.") Tinguely worried for fear painting it white might make it *too* beautiful, but he reassured himself that this danger would be averted when the meteorological balloon burst from its overdose of compressed air and descended limply over it. Museum employees and officials pitched in to help with the painting. The excitement of the event had spread to everyone connected with the museum, including Alfred H. Barr, Jr., the Director of Museum Collections, who wrote, in a De Mille—like museum broadside, about Tinguely's "apocalyptic far-out breakthrough, which, it is said, clinks and clanks, tingles and tangles, whirs and buzzes, grinds and creaks, whistles and pops itself into a katabolic Götter-

dämmerung of junk and scrap. Oh, great brotherhood of Jules Verne, Paul Klee, Sandy Calder, Leonardo da Vinci, Rube Goldberg, Marcel Duchamp, Piranesi, Man Ray, Picabia, Filippo Morghen, are you with it?"

Doomsday, a Thursday, dawned gray and wet. The temperature, which had been below freezing for the three weeks that Tinguely had been at work on the machine, rose slightly, and a light snow that had been falling since the previous night turned into a cold rain, which kept up intermittently all day. Over on Fifth Avenue the Saint Patrick's Day parade bravely drummed and blared its way uptown. Hordes of high-school children in green cardboard hats passed the Fifty-fourth Street wall and stopped to look into the garden, where workmen were struggling to move Tinguely's creation from the dome to the central court. The workmen kept slipping and sliding in the wet slush, and there were accidents. The Addressograph machine was damaged. Tinguely became tense. In his black boots, open storm jacket, and two-day-old beard, he looked like a Cuban revolutionary, and for the first time his spirits seemed a trifle subdued.

Robert Rauschenberg showed up at about noon, bringing a device he had made called a "money thrower." Tinguely had suggested to several New York artists that they contribute to the master machine, in a sort of Bauhaus effort, and Rauschenberg, whose "combine paintings" were in some ways even farther out than Tinguely's creations, had promised to add a mascot. This took the form of two heavy springs held in tension by a thin cord, with silver dollars inserted between the coils; when the cord was disintegrated by flash powder, the springs would fly up and scatter the silver dollars. Rauschenberg waited patiently for several hours to have his money thrower con-

JEAN TINGUELY 175

nected. "I felt privileged to be able to hand him a screw-
driver," Rauschenberg has said. "There were so many
different aspects of life involved in the big piece. It was as
real, as interesting, as complicated, as vulnerable, and as
gay as life itself."

After a great deal of searching Klüver had managed
to fill a request of Tinguely's for several bottles full
of powerful chemical stinks. He arrived, carrying them
gingerly, and set them down near the partly assembled
machine. Klüver also brought several containers of ti-
tanium tetrachloride for making smoke, since several
previous methods had proved unsatisfactory. He asked Tin-
guely if it was all right to put the containers in the bassi-
net. Tinguely said it was. Time was running so short that
decisions were being made on the spur of the moment.

Georgine Oeri, a New York art critic and teacher who
had grown up in Tinguely's home town of Basel, came by
to wish him luck. She found him in a state of momentary
despair. He told her he had been trying to explain to the
workmen that they must find a way to paint the snow
black, so it would not detract from his white machine.
The workmen had grown very fond of Tinguely (the day
after the performance he gave a party for all of them in
the boiler room of the museum), but at this point they
were convinced that he had lost his mind. Oddly, although
they spoke no French and Tinguely very little English,
he and they never had the slightest trouble understanding
one another.

Tinguely found that the klaxon on the small carriage
did not work. Robert Breer went off in search of another.
The museum people suddenly became concerned about the
garden's marble flagstones, and everything stopped while
the workmen set wooden blocks under the machine.

Toward five o'clock a sizable crowd began to gather in the
garden, despite the rain. Invitations had gone out to two
hundred people, including Governor and Mrs. Rockefeller,
specifying that "the spectacle will begin at 6:30 and will
take approximately 30 minutes," but many came early,
and many others who had not been invited came too.
The cafeteria facing the garden was full of spectators,
and an NBC camera crew was setting up lights and cam-
eras to film the event. Outside the museum's main en-
trance, on Fifty-third Street, a German sculptor named
Mathias Goeritz was handing out copies of an anti-Tinguely
manifesto: "STOP the aesthetic, so-called 'profound' jokes!
STOP boring us with another sample of egocentric folk art.
. . . We need faith! We need love! We need GOD!"

Tinguely gave up trying to have the snow painted black.
Breer returned with a klaxon that he had bought for a
dollar from a scrap dealer on Tenth Avenue, and Tinguely
substituted it for the defective one. He also checked the
arm of the big meta-matic and adjusted the roller. At one
point Klüver picked up a metal ring from the slush and
asked Tinguely what it was for. Tinguely said he didn't
know. He was calmer now, working steadily but without
haste or tension, and seemingly unaware of the gathering
crowd. At six o'clock Klüver finally got a power line out
to the machine, and they began connecting the circuits.
Breer accidently turned on a fire extinguisher that was
concealed inside the piano but managed to turn it off
before anyone noticed. At six-thirty they were still work-
ing on the machine. The crowd now filled the garden,
standing patiently in slush that was nearly ankle-deep,
under a fitful rain. Apartment dwellers on Fifty-fourth
Street, across from the garden, were waiting at their win-
dows. Some of the spectators were growing restless. David

Sylvester, a British art critic, made a conspicuous departure, saying, "I don't like tuxedo Dada." Two noted Abstract Expressionist painters followed him, muttering angrily. Kenneth Tynan, the theater critic, was asked by a reporter to make a statement. "I'd say it was the end of civilization as we know it," Tynan replied.

The big orange meteorological balloon was inflated and raised to the top of its mast. It looked like the moon rising, and the crowd hushed expectantly. Half an hour more went by while Tinguely and Klüver dashed back and forth between the dome and the machine. At seven-twenty, nearly an hour after the event had been scheduled to begin, Klüver discovered that they had neglected to saw through one leg of the machine. He sawed it quickly. The creation phase was now completed. The machine stood twenty-three feet long and twenty-seven feet high, its white, dripping structure cleanly outlined against the dark evergreens behind it, its eighty bicycle wheels poised for action. The destruction could now begin.

"At seven-thirty I was finished," Klüver wrote in his subsequent log of the event. " 'On va?' 'On va,' said Jean. He looked as calm as if he were about to take a bus. Not once did we go over and check everything. The end of the construction and the beginning of the destruction were indistinguishable." Klüver put in the plug, the machine gave a convulsive shudder, rattled, and immediately broke down. The belt driving the piano mechanism had slipped off its wheel as soon as the motor started up. Klüver tried frantically to fix it, his fingers numb with cold. "Laisse-moi faire, Billy!" Tinguely called out. A blown fuse was replaced. The piano started to play again, but other belts had jumped off and only three notes were working.

The big meta-matic clanked into operation. Instead of

rolling down past the paintbrushes, though, the paper
rolled itself up the wrong way and flapped derisively
atop the machine; Tinguely had accidently reversed the
belt when he was attaching it to the painting arm. When
he saw what had happened he grabbed Klüver's arm and
pointed, doubling up with laughter. From that moment on
it was clear that the machine would proceed about its de-
struction in its own way, but the audience, unaware that
Tinguely's machines hardly ever worked as they were sup-
posed to, gave a collective groan.

What happened next was pure, vintage Tinguely.
Thick, yellow, strong-smelling smoke billowed from the
baby's bassinet, where Klüver had put the titanium tetra-
chloride, and was caught by the blast from the powerful
fan that had been supposed to blow the meta-matic paint-
ing toward the audience. Having waited an hour and a
half to see the show, the spectators now found themselves
enveloped in a choking cloud that completely obscured
their view of the machine. They could hear it, though.
Most of the percussion elements were working splendidly,
and the din was tremendous.

When the smoke finally cleared, the machine could be
seen shaking and quivering in all its members. Smoke and
flames began to emerge from inside the piano, which con-
tinued to sound its melancholy three-note dirge; a can of
gasoline had been set to overturn onto a burning candle
there. The radio turned itself on, but nobody could hear it.
Rauschenberg's money thrower went off with a brilliant
flash. An arm began to beat in sepulchral rhythm on the
washing-machine drum. At this point the bottles of strong-
smelling liquids were supposed to slide down from their
rack and break, but the strings holding them failed to

snap. The meteorological balloon refused to burst—there was not enough compressed air in the bottle.

The second meta-matic worked perfectly, producing a long black painting that immediately wound itself up again. The two texts unrolled, but the horizontal one began to sag instead of winding itself up. "Do you remember that little ring you picked up and asked about?" Tinguely shouted to Klüver. "It was to hold the paper roll up!" The vertical text had finished unrolling, and its loose end hung teasingly over the burning piano. Tinguely was beside himself with wonder and delight. Each element of his machine was having its chance to be, as he said later, "a poem in itself." A photographer took his picture standing in front of the machine, arms outspread, smiling, with the words "Ying Is Yang" on the horizontal text just above his head.

The piano was really blazing now. "There is something very odd about seeing a piano burn," George Staempfli has since said. "All your ideas about music are somehow involved." For the museum authorities, a good deal more than ideas about music was involved. They had not anticipated a fire and were understandably sensitive on that subject in view of the museum's second-floor fire the year before, which had destroyed almost two hundred thousand dollars' worth of paintings. The concealed fire extinguisher was supposed to go off at the eighteenth minute, but the flames had spread through the whole piano and burned out a vital connection. Black smoke poured from the machine. With a limping, eccentric motion, the small suicide carriage broke away from the main machine, its flag waving. Then it stopped. Tinguely helped it along tenderly toward the pool, but its motor was too weak, and

it never got there. The Addressograph machine started up, thrashing and clattering. It had been too badly damaged in transit, though, and it fell over after a minute or so, stone dead. Brilliant yellow smoke flashes now began going off all over the machine.

Some twenty minutes after the start of the destruction the resistors in the sawed-through supports began to melt the joints. The mechanism sagged but did not collapse entirely, because some crossbars at the bottom stubbornly refused to give way. The other small carriage suddenly shot out from under the piano, its klaxon shrieking, and smoke and flames pouring from its rear end. It headed straight for the audience, caromed off a photographer's bag, and rammed into a ladder on which a correspondent for *Paris-Match* was standing; he courageously descended, turned it around, and sent it scuttling into the NBC sound equipment. Tinguely suddenly began to worry for fear the fire extinguisher in the piano would explode from the heat, and he wanted firemen to put out the blaze. Klüver found a fireman in attendance, who seemed to be enjoying the show. He listened to Klüver's pleading and then, with apparent reluctance, signaled to two museum guards, who ran out with small extinguishers and applied them to the piano fire. The audience booed the men angrily, assuming that they were spoiling the show. A *Times* photographer who went inside the museum a few minutes later overheard the fireman talking to headquarters on the telephone. "There are these machines, see," he was saying, "and one of them is on fire, but they tell me it's a work of art, see, and then this guy tells me *himself* to put it out, see, and the crowd yells 'No! No!' "

One of the guards ran into the museum and returned trundling a big extinguisher, with which he doused the

piano and the surrounding machinery. He was furiously booed. The audience had seen everything go wrong, and now, it seemed, it was to be denied the machine's climactic act of self-destruction. More boos, interspersed with a few cheers, attended the final anticlimax as the fireman and the two guards attacked the sagging machine with axes, knocking down the piano, the big meta-matic, and the mast that held the balloon. At the end, though, there was a rousing cheer for the dying monster. The crowd descended on the debris for souvenirs and managed to add to the general discomfort by breaking every one of the stink bottles. But if the audience felt frustrated, the museum authorities were in a state approaching shock; some of them were so angry about the fire that they refused to attend a reception held at George Staempfli's following the event. As Philip Johnson, a trustee, said later, "It was not a good joke."

Not everyone agreed with Johnson. The newspaper reviews were mixed, most of them treating it as a crazy stunt that failed to come off. There were so few downright hostile reactions that the *Nation* was moved to comment sourly, "This is what social protest has fallen to in our day—a garden party." The only critic (aside from Dore Ashton, in a later article) to write about *Homage* at any length was the *Times'* John Canaday. Although he called the show a "fiasco," he saw the machine as "an object of bizarre attraction, if not of classical beauty," and "a legitimate work of art as social expression, even if it pooped a bit." Returning to the subject in a Sunday column, he said that the machine was at least honest in its destructiveness, and that Tinguely himself "deserved a nod of recognition for an elaborate witticism on a subject of deadly seriousness, man's loss of faith."

That sort of interpretation was fine with Tinguely, and so were all the others. To him, the machine was anything that anyone said it was—social protest, joke, abomination, satire—but, in addition, it was a machine that had rejected itself in order to become humor and poetry. It was the opposite of the skyscrapers, the opposite of the Pyramids, the opposite of the fixed, petrified work of art, and thus the best solution he had yet found to the problem of making something that would be as free, as ephemeral, and as vulnerable as life itself. It had evolved, after all, "in total anarchy and freedom," and he had been as surprised as any other spectator by this evolution. All the unforeseen accidents and failures delighted Tinguely. The fact that only three notes of the piano worked moved him deeply. As he said afterward, "It was very beautiful, I thought, and absolutely unplanned that one part of the piano should continue to play for almost fifteen minutes while the rest was being consumed by fire—those three notes still playing on the midst of the fire, calmly, sadly, monotonously, just those three. Many people told me afterward that for them it was a terrible thing. One woman told me later that she had wept, she found it so sad. It *was* sad, in many respects. It was also funny. I laughed a great deal while it was happening. I was the best spectator. I had never seen anything like that."

Whatever else it achieved, *Homage to New York* had a profoundly liberating effect on Jean Tinguely. The technical knowledge gained in building the machine and the excitement of working for (and with) a large audience had, in a sense, opened up to him a whole new career as a *régisseur*—a stage director for spectacles in which the crowd was as important to the total effect as the absurd

antics of his liberated machines. In his post-*Homage* mood of exhilaration, ideas for new projects poured out of him. He would create a machine to destroy museums. He would make two huge machines, one black and one white, and set them to destroying each other. He would make a meta-matic vehicle that would go along a highway (Klüver suggested the Los Angeles Freeway) painting a continuous abstract picture, and another machine that would come along behind washing it off. He would take three windows in a department store and install three machines to destroy products sold inside the store; in the first window there would be a machine slashing dresses, in the second window a machine rending straw hats, and in the third window a machine smashing teacups. Across all three windows there would be a sign reading, "Come In and Buy Before Jean Tinguely Destroys Everything!"

In the ensuing months Tinguely carried out a number of new ideas. For a show called *"L'Art Fonctionnel"* at the Quatre-Saisons Gallery, in Paris, that spring, he made six large machines, one of which sawed sculptures in half. Another actually made sculptures when the spectator sat on top and turned a barrel with his feet, thus setting in motion a hammer that beat on a chisel that chipped away at a block of stone. For a group show at the Haus Lange Museum, in Krefeld, Germany—a gallery designed by Mies van der Rohe—Tinguely managed to install his machine "to destroy museums." It stood in the garden outside, tearing up grass with its feet and beating furiously but in vain against the museum wall with its upper assembly. Tinguely also experimented with a new kind of self-destroying machine, in which joints made of plaster were disintegrated by the explosion of powerful fireworks. One of these caused a minor scandal in Copenhagen in

the fall of 1961 when it was discovered that the wreckage of the machine contained a dead dove. Tinguely claimed that the dove, which was supposed to fly up in beauty and freedom as the imprisoning sculpture collapsed, had been suffering from a malady and had "died in its basket before the fireworks"; Danish nature lovers were not pleased, however, and the Copenhagen papers ran front-page pictures of the martyred bird.

In April 1961 twenty-five of Tinguely's "junk-mobiles" —moving constructions of various sizes whose motors are clearly visible as part of the sculpture—were shown at Staempfli's. Motion enthusiasts of all ages crowded in daily to turn them on and off and watch in fascination as they shook, shimmied, thrashed, and plunged headlong into the task of doing nothing. The simplest and most immediately popular of them was a bamboo curtain that did the Charleston; the most unsettling was a three-foot nightmare of splayed springs and tangled wire that performed a thumping, mechanico-erotic tribal dance and was appropriately titled *La Sorcière*. Most of the junk-mobiles were sold, including *IBM*, a small, saturnine fragment of an electrical circuit, with one red wire turning slyly upon its own axis, which Staempfli bought for himself. Tinguely, who never stays long with the same dealer, has subsequently exhibited at the Leo Castelli and Iolas galleries in New York and in group shows throughout Europe, and in the summer of 1964 he was actually commissioned by the Swiss government to make a large sculpture for the Lausanne Fair. So far, however, he has done nothing so stirringly apocalyptical as *Homage to New York*.

Naturally enough, there are some people—particularly those whom Tinguely has wittingly or unwittingly offended —who consider his work nothing more than the jokes of

a master charlatan. "He is just amusing himself," says his ex-dealer Iris Clert, who feels that she put Tinguely on the art map. "And he is too destructive. The moment he makes something, he has to smash it." For Tinguely, though, the idea of destruction has become, as he says, a sort of "refuge" in a personal artistic crisis. When he is asked by a stranger to comment on something he has made, Tinguely usually says whatever comes into his head at the moment or replies with a good-humored shrug. When he discusses his work with his friends, though, which he does often, it is difficult for a listener to escape the feeling that the struggle with motion is for him an immensely serious matter, and that all the random or incidental elements of his art—theatricality, humor, satire, practical jokes, mistakes, willful destructiveness—do not conceal the fact that he has caught a philosophical devil by the tail and is hanging on for dear, kinetic life.

Tinguely has said that in his pursuit of total freedom of movement he sometimes feels that he is being pursued and overtaken by its opposite, by what he calls "the monster of stability," and this depresses him profoundly. Some of his admirers believe that his recent work has been touched by the hot breath of this monster and that Tinguely himself is now suffering from a sort of "Michelangelo complex," a desire to create something that will last indefinitely. The difficulty of combining such a desire for permanence with the creation of machines that move and break down is obvious, and Tinguely's inner struggle with this problem, so far unresolved, has led to a marked decrease in his activity in the last few years.

"It may be that I've been a maniac for a long time," Tinguely has conceded, "and for a long time I've been so drowned in my means of expression that I really can't

discuss it, I can only make words around it. It's perfectly true that what I'm trying to do may be impossible. But maybe not. Maybe it *is* possible to make things that are so close to life that they exist as simply and changeably and permanently as a cat jumping, or a child playing, or a truck going by outside, and if so I would very much like to make them. Life *is* play, movement, continual change. Only the fear of death makes us want to stop life, to 'fix' it impossibly forever. The moment life is fixed, it is no longer true; it is dead, and therefore uninteresting. But now it's as though this monster of stability were pushing me, pushing me toward a certain point in myself where I will have to end all these experiments and experiences—or, rather, where the experiences I've had will have to be reconciled as one and the same. I feel that in a way I am almost condemned to be myself, integrally and totally, and this sometimes fills me with despair. It's as though I had not much more time to look into things.

"I would prefer, of course, to stay as long as possible in the field of experiment—that is, I would like to go much further. But I can feel the time approaching when this will no longer be possible, when I will have to be simply myself, doing what men like Giacometti do. Giacometti, with his little pile of clay in front of him, working every day, all the time, doing what he has to do without even knowing why or how, magnificently unconscious—I have a great admiration for Giacometti, because I can feel his strength of expression, but I would really like to avoid becoming like that.

"Everyone laughs, I know. It is strangely easy to laugh, it is certainly necessary to laugh. But I find I laugh less all the time. Once I spent all day trying to make a machine, bending, soldering, struggling with the material. I forgot

to eat. I finished about eight in the evening. It was dark
and cold, and I started the thing going to see what sort of
sound it made. Sound interests me enormously; it is an-
other kind of material to me. I studied the sound, reg-
ulated it, changed it. I changed the motor and replaced it
with one that was more powerful, but that didn't satisfy
me either, so I took the whole machine apart and changed
its shape. And suddenly, at about ten o'clock, I discovered
that this machine terrified me, actually made me afraid.
It was like some monster crouching ready to spring. I
went to bed and forgot about it. And then, months later,
I saw someone standing in front of it at an exhibition and
laughing his head off. I had been completely demoralized
by that machine. For me it was a horrible machine, but
it was what I had wanted to make. And here was someone
looking at it and laughing."

Robert Rauschenberg

Unlike many of the other young painters active on the New York art scene, Robert Rauschenberg often feels personally responsible when his work is misunderstood. This is an appealing trait, but one that can lead him into difficult situations, as it did at the opening of a major retrospective exhibition of his work at the Jewish Museum, on upper Fifth Avenue, in the spring of 1963. Opening night was restricted to the museum's regular membership—a rather different group of people from the large and enthusiastic art crowd that had come to a preview the evening before—and some of the members were totally unprepared for the kind of art they found on the walls of their venerable institution. In the first room, for example, the visitor was greeted by an immense work, in seven panels, entitled *White Painting*, upon which no image—in fact, no mark of any kind—could be detected. Next to this were two entries,

189

each called *Black Painting,* one consisting of black pig-
ment uniformly applied to canvas, the other (in three
panels) of black pigment unevenly applied over a base of
torn and crumpled newspapers. Passing on, the viewer was
confronted by an enormous red painting (*Charlene*),
whose surface was enlivened with mirrors, bits of cloth
and wood, part of a man's undershirt, a flattened parasol,
postcards, comic strips, drugstore reproductions of Old
Master paintings, and even its own source of light, in the
form of an unfrosted electric-light bulb that flashed off and
on. In the far corner of the room hung the painting that is
usually thought to be the most shocking of Rauschenberg's
works—a real quilt and a real pillow, liberally daubed
with oil paint and matter-of-factly entitled *Bed*—while in
the middle of the floor stood *Monogram,* one of what he
calls his "combines"; its central feature is a stuffed Angora
goat encircled at midriff by an automobile tire. The re-
actions of the Jewish Museum members to all this were
varied and intense. Some left the premises precipitately,
others walked about looking dazed, and several brought
their dismay to the attention of the artist, an ex-
tremely friendly, responsive, and clean-cut young South-
erner of medium height and maximum charm, who made
earnest efforts to get to the bottom of their complaints.

One such conversation he remembers in detail. A mid-
dle-aged woman came up to him midway through the
evening and asked why he was interested only in ugly
things. "She really wanted to know," Rauschenberg re-
calls. "You could see that she wasn't just being hostile.
Well, I had to find out first of all what she meant by
'ugly,' and so we talked about that for a while, and it
seemed that what bothered her was the materials I'd
chosen to use and the way they were put together. To her,

all my decisions seemed absolutely arbitrary—as though I could just as well have selected anything at all—and therefore there was no meaning, and that made it ugly. So I told her that if I were to describe the way she was dressed, it might sound very much like what she'd been saying. For instance, she had feathers on her head. And she had this enamel brooch with a picture of *The Blue Boy* on it pinned to her breast. And around her neck she had on what she would call mink but what could also be described as the skin of a dead animal. Well, at first she was a little offended by this, I think, but then later she came back and said she was beginning to understand. She was really serious about it, and intelligent. The thing was, she just hadn't been able to *look* at the pictures until somebody helped her."

Although many people still find Rauschenberg's work distasteful, and even disturbing, to look at, a substantial number of collectors, museum officials, dealers, and even art critics have come around to seeing things his way— enough of them, in any case, to establish his reputation as an extremely influential artist. What's more, he shows signs of becoming a phenomenally popular one. The 1964 Rauschenberg retrospective at the Whitechapel Gallery in London drew the largest crowds ever seen at the gallery and thoroughly dazzled the local press. The *Times* of London called it "the most exhilarating art exhibition in London," and the *Sunday Telegraph* described Rauschenberg as "the most important American artist since Jackson Pollock." These superlatives were confirmed three months later when Rauschenberg walked off with the international grand prize for painting at the Venice Biennale—the top award in international art competition, which had never before in the Biennale's sixty-nine-year history been given

to an American painter. For a young man whose work had until fairly recently been viewed as a rather bad joke, this sort of recognition was highly gratifying and also somewhat alarming—too easy acceptance, he sometimes fears, can result from misunderstanding as readily as can no acceptance at all.

Together with Jasper Johns, who is five years younger, Rauschenberg has often been referred to as the co-founder (or co-perpetrator, depending on one's point of view) of the Pop Art school, which has blithely turned its back on the Abstract Expressionist painting that made New York the center of the postwar international art world, and which takes its highly realistic subject matter from commercial advertising, comic strips, and mass-produced commodities. There is some justification for describing Rauschenberg as "the Old Master" of the new painting—a phrase first applied to him by Dr. Alan Solomon, the Jewish Museum's director at that time. He was certainly one of the first artists to involve himself seriously with subject matter of this kind, and in the course of his protean development since 1948, as Dr. Solomon's retrospective exhibition made amply clear, he has either foreshadowed or grappled directly with most of the ideas, attitudes, and techniques that the Pop artists have now adopted. At the same time, it has become increasingly evident that Rauschenberg's course is uniquely his own, and that he really has no more in common with the Pop artists than he has with the Abstract Expressionists of the preceding artistic generation. For one thing, he almost never repeats himself. While many of the Pop practitioners tend to play endless variations on the same theme, Rauschenberg's only consistent trait as an artist has been to move on, once he has explored an area, into fresh and often astounding new terrain. One of the few

"accidents" in a painting that he will not accept, in fact, is an unplanned resemblance to something that he (or some other artist) has done before; when this happens he paints it out. Rauschenberg prefers to be unfamiliar with what he is doing, and he often feels that what really motivates him as a painter is curiosity—"to see what makes a picture." "Bob has always been able to see beyond what others have decided should be the limits of art," Jack Tworkov, one of Rauschenberg's relatively few admirers among the older generation of Abstract Expressionist painters, said not long ago. "Twentieth-century art has been a constant expansion of these limits, of course—people once thought that Cézanne had gone as far as you could go. But Bob always wants to go still further. Look at what he did with collage. If it was all right to make pictures with bits of pasted paper or metal or wood, he asked, then why couldn't you use a bed, or even a goat with a tire? He keeps asking the question—and it's a terrific question philosophically, whether or not the results are great art—and his asking it has influenced a whole generation of artists."

In a rather cryptic statement that has been widely quoted, Rauschenberg once said, "Painting relates to both art and life. Neither can be made. I try to act in the gap between the two." Whatever this statement means to Rauschenberg (its interpretations are legion), it does serve to suggest the brash, nervy balancing act that characterizes his best work, and also his preoccupation with two of the big questions of twentieth-century art: what is the nature of art itself, and what is the nature of reality? "I don't want a picture to look like something it isn't," he said some time ago. "I want it to look like something it is. And I think a picture is more like the real world when

it's made out of the real world." Because he spent most of his formative years living and working in sections of lower Manhattan that are not noted for their elegance—first in loft buildings on Fulton, Pearl, and Front Streets, then on Broadway near Twelfth Street—the objects, images, and sensations of his real world have tended to be somewhat inelegant, particularly since Rauschenberg until about 1959 was making no money to speak of and depended for his materials partly on what he came across in the course of the day's activity. Toward all these materials, however, his attitude has always been one of cheerful and nearly total acceptance. He is unfailingly surprised when someone regards an object in one of his works as ugly. He never thinks that anything he uses is ugly at all, and sometimes he finds his salvaged objects strikingly beautiful. "I really feel sorry for people who think things like soap dishes or mirrors or Coke bottles are ugly, because they're surrounded by things like that all day long, and it must make them miserable," he said once. Whenever he uses such objects as these in a "combine," Rauschenberg always respects their integrity, never altering their appearance to the point where they function merely as formal shapes in the composition and never allowing them to serve merely symbolic ends. The objects and fragments come through relatively intact, with strong overtones of their life in the real world before they embarked upon their present life in art. And in his best works they seem to belong, to be miraculously *right*, in the context of the painting.

In 1962 Rauschenberg abandoned the use of concrete objects in favor of a technique involving the use of silk-screened images applied to canvas. The silk screens are very expensive, and the new technique thus reflects Rau-

schenberg's current affluence; having managed for most of his career to get along on almost no money at all, he is now one of the small group of American painters whose new work is usually sold even before it reaches their dealers, at prices ranging from five thousand to fifty thousand dollars a painting. If success has enlarged the field of possibilities open to him, however, few of his friends see much indication that it has altered his style of living. "He worries more now over what people are saying about him," one somewhat disgruntled fellow artist has claimed, "and he devotes a lot of thought to what he won't wear when he goes out socially." On the whole, though, Rauschenberg's zest for exploration seems unimpaired, and his attitude toward painting and toward life in general is pretty much the same as it always has been—one of sheer delight.

The origins of this attitude are somewhat perplexing. Artists have, of course, come from every conceivable sort of background, but not many have grown up in an environment that would appear to be less conducive to aesthetic development than the small Gulf Coast refinery town of Port Arthur, Texas, where Rauschenberg spent his first eighteen years. (His grandfather, a Berlin doctor, had settled in Texas and married a full-blooded Cherokee.) "It wasn't until I left Texas to go into the Navy that I realized there was such a thing as an artist," Rauschenberg has said. "When I was a child it was very easy to grow up in Port Arthur without ever seeing a painting." The Rauschenbergs lived modestly—his father worked for a local utility company—and the major social occasions were family get-togethers (there were a great many aunts and uncles) and regular attendance at the Church of

Christ, an austere denomination that frowned on social dancing.

Rauschenberg seems to have spent a large part of his highly independent childhood collecting and caring for a variety of pets, and for a while his ambition was to be a veterinarian. His younger sister Janet, now Mrs. Byron Begneaud of Lafayette, Louisiana, recalls that "when he was eight years old the following animals were his pets all at one time: a horned toad, a nanny goat, a banny rooster, some goldfish, and two hunting dogs that had a family of nine puppies."

He had always done a lot of drawing in school, to the detriment of his grades, but he saw nothing unusual in this until he got to the Navy boot camp in Farragut, Idaho, in 1942, where he found, to his great surprise, that his ability to make recognizable pencil sketches of fellow recruits was looked upon as a highly enviable skill. The first real paintings he ever saw were in the Henry E. Huntington Art Gallery in San Marino, California. He had been sent from boot camp to the Navy Hospital Corps School in San Diego, and on one of his first liberties he went to the gallery, where he had heard there was some great art. The experience left him "pretty shook up," he recalls. Three pictures in particular stuck in his mind: "There was Reynolds' portrait of Mrs. Siddons as the Tragic Muse—an enormous brown thing—and then there was *The Blue Boy* and *Pinkie* [Sir Thomas Lawrence's portrait of the young Sarah Moulton-Barrett], which I remembered having seen on the backs of some playing cards. I just looked at them with a kind of fascination and awe." Painting suddenly began to seem to Rauschenberg like something that it was possible to do, although it was

some time before he seriously thought of it as something
that *he* could do.

In 1946, after three years as a neuropsychiatric tech-
nician in naval hospitals in California, Rauschenberg re-
ceived his discharge and went home to Port Arthur—or,
rather, to what he thought was home; his family had
moved to Lafayette, Louisiana, in the meanwhile, and, as
Rauschenberg puts it, "none of us were ever much good
at writing letters." Rauschenberg found his family a day
later, but the reunion was a brief one, since he stayed
only a few weeks. "I was so restless and so changed," he
says. "Everybody felt that way, I guess. Anyway, by then
I thought I knew more about Los Angeles than anyplace
else, so I went back there." Being a civilian in Los
Angeles, he soon found, was not quite the same as being
a sailor on leave, and when a Kansas City girl he met
suggested that he study at the Kansas City Art Institute
under the GI Bill of Rights, he instantly agreed.

Although he was very excited about going to art school,
Rauschenberg was too naïve to get much out of it; he
actually learned more from some outside jobs he took to
help support himself, doing advertising and display work
for local merchants. "I'd also found that in order to be an
artist you had to go to Paris, and I was saving up for
that," he said. "I took all those jokes very seriously then."
In the fall of 1947, after a year in Kansas City, he had
enough money for his passage and came east for the first
time, to board one of the converted troopships that ferried
students to Europe in those days.

In 1947 Paris was still recovering from the war, and
Rauschenberg found it depressing. He enrolled at the Aca-
démie Julian, but he got little benefit from his studies.

"The criticism was once a week in French, and I didn't understand any French. The other students were hung up on whether their stuff should look like Matisse or Picasso. I saw my first Matisses and Picassos in Paris, but they didn't really make much sense to me. I simply wanted to learn to paint." The one tangible result of his brief attendance at the Académie was his meeting with Sue Weil, a young New York art student with whom he immediately fell in love. The couple soon stopped going to classes and took to painting what they saw in the streets of Paris—in Rauschenberg's case, portraits and some rather Expressionistic cityscapes. They did a lot of their painting in the dingy front room of their *pension*, just off the Boulevard Raspail. "We were scared of the *concierge*," Rauschenberg has recalled, "and whenever one of us spilled a drop of paint on the grimy old Oriental rug we'd go around and carefully put a drop of the same color in several other places, to equalize it. After a while the room began to seem brighter and brighter."

Although Rauschenberg found sheer sensual joy in the act of painting, he eventually came to the conclusion that if he was ever to move forward he would have to have discipline. One day in mid-August of 1948 he picked up a copy of *Time* and read that "the greatest disciplinarian in the United States" was Josef Albers, then head of the Fine Arts Department of Black Mountain College, in North Carolina. As it happened, Sue Weil was getting ready to go home and enter Black Mountain herself, and as soon as he had managed to save up enough money for his return passage Rauschenberg joined her there, entering college midway through the fall term of 1948.

It is generally agreed that the two greatest art teachers of the present day are Hans Hofmann and Josef Albers.

Albers, with his Bauhaus background and his geometrical purity of style, would appear to represent the polar opposite of the loose, free-swinging kind of painting that Rauschenberg has come to exemplify, and Rauschenberg himself has defined the basic difference between them: "Albers' rule is to make order. As for me, I consider myself successful only when I do something that resembles the lack of order I sense." Nevertheless, there is no doubt that Albers' teaching was a crucial element in Rauschenberg's development, and no one is more aware of this than Rauschenberg. "Albers was a beautiful teacher and an impossible person," he has said. "He wasn't easy to talk to, and I found his criticism so excruciating and so devastating that I never asked for it. Years later, though, I'm still learning what he taught me, because what he taught had to do with the entire visual world. He didn't teach you how to 'do art.' The focus was always on your personal sense of looking. When he taught water color, for example, he taught the specific properties of water color—not how to make a good water-color picture. When he taught drawing, he taught the efficient functioning of line. Color was about the flexibilities and the complex relationships that colors have with one another. I consider Albers the most important teacher I've ever had, and I'm sure he considered me one of his poorest students. Coming from Paris, entering in the middle of the term, and showing all that wildness and naïveté and hunger, I must have seemed not serious to him, and I don't think he ever realized that it was his discipline that I came for. Besides, my response to what I learned from him was just the opposite of what he intended. When Albers showed me that one color was as good as another and that you were just expressing a personal preference if you thought a

certain color would be better, I found that I couldn't decide
to *use* one color instead of another, because I really wasn't
interested in taste. I was so involved with the materials
separately that I didn't want painting to be simply an act
of employing one color to do something to another color,
like using red to intensify green, because that would imply
some subordination of red. I was very hesitant about arbi-
trarily designing forms and selecting colors that would
achieve some predetermined result, because I didn't have
any ideas to support that sort of thing—I didn't want
color to serve me, in other words. That's why I ended up
doing the all-white and the all-black paintings—one of the
reasons, anyway."

It took several more years for Rauschenberg to reach
the austerity of all white and all black, but he was clearly
moving in that direction when he left North Carolina in
the summer of 1949. For the next three years he was in
New York, studying intermittently at the Art Students
League (first under Vaclav Vytlacil and then under Morris
Kantor), living as cheaply as possible, and supporting
himself by odd jobs. He also continued to see a lot of
Sue Weil, and in the spring of 1950 they were married.
That summer, which they spent at the Weil family house
on Outer Island, off the coast of Connecticut, Rauschenberg
and his wife began experimenting with blueprint paper,
placing various objects on sheets of it and exposing them
to sunlight, in much the same way that Man Ray had made
his early "rayograms" on photographic paper. (Rauschen-
berg had become interested in photography while at
Black Mountain, and he was represented in the Museum
of Modern Art's photographic collection long before the
museum ever gave him serious recognition as a painter.)
The results of the blueprint experiments pleased them so

much that they kept on experimenting that fall, when they got back to New York and moved into a tiny ground-floor apartment in the West Nineties. Now that Rauschenberg was married and a prospective father (Christopher Rauschenberg was born in 1951), the idea of making some money occurred to him; he took some of the blueprints to *Life*, which bought them and ran a "Speaking of Pictures" department on the Rauschenbergs in April 1951. Not long afterward he managed to sell the idea to the display director of Bonwit Teller, Gene Moore, who used the blueprints to decorate the store's windows later in the year.

That same winter Rauschenberg bundled up a group of his paintings and took them along to Betty Parsons, in her Fifty-seventh Street gallery. "I just went up to see her with a bunch of paintings under my arm," he has said. "I didn't know how you were supposed to do those things. She asked me, in her low voice, did I want criticism? I said no, I didn't. The pictures were finished. It's hard to say what I did want—just a response of some kind. Betty Parsons' was then the liveliest gallery around, and I just wanted to see what would happen. She asked me if I wanted a show. That really hadn't even been in my mind; nothing in my experience had led me to think in those terms. 'If you want a show,' she said, 'you can't have one before May, because everything is booked.' So I had a show at the Betty Parsons in the spring."

Recalling this first meeting, Mrs. Parsons says that Rauschenberg struck her then as being incredibly naïve. "It had snowed the night before, and he was very excited about that. He was just full of enthusiasm. I was instantly fascinated by his work. Oils mostly, and predominantly white. I could see right away that he was on his own tan-

gent—that he wasn't influenced by anyone else." Rau-
schenberg's work at that period was semi-abstract—or,
rather, abstract with figurative signs and symbols, such as
black arrows and hands and flowerlike sequences of forms.
His technique, thanks to Albers, was quietly controlled, and
his palette was almost exclusively black and white. A few
months later, when Mrs. Parsons went to Rauschenberg's
studio to select pictures for the show, she found that he
had painted over most of the canvases she had seen earlier.
"Today I wouldn't do that," Rauschenberg says. "I'd know
that an early picture might be better than something I was
working on right now. But then I just thought, Oh, the
next thing will be much better!" There was more than
enough work for a show, in any event, because Rauschen-
berg, whose energy has always been prodigious, was then
painting five pictures a day. The exhibition opened on
May 14; it was received with bare civility by the critics
("stylish doodles in black and white," wrote the *Times*'
Stuart Preston) and ignored by the public. Only one pic-
ture from this period has survived—a painting consisting
entirely of numbers penciled into a white ground—and it
hangs in Rauschenberg's studio. The others were destroyed
in a fire at the Weils' summer home on Outer Island.

Right after the Betty Parsons show Rauschenberg's
pictures started to go black—"night plants," as he has
described them—with forms emerging mysteriously from
darkness. He rubbed dirt into white pigment to make
rough-textured grays, and he used some red lead, but no
other colors. He was still reacting to Albers' being such a
good teacher and to his own unwillingness to make color
"serve" him. These somewhat somber experiments led
directly to the extraordinary series of paintings that he did
in the summer of 1952 at Black Mountain College, to

which he had returned, uninvited, as a sort of painter-in-residence. Albers had by then left to teach at Yale, but Rauschenberg still looked upon Black Mountain as a kind of second home.

All sorts of interpretations have been advanced for the all-white and all-black paintings of that summer, which is hardly surprising. The white paintings are blank canvases, painted flat white, on which the "picture" is continuously being created by elements outside it—by the shadows of people passing back and forth, by light and shade, by countless tiny reflections. Far from echoing Malevich's famous *White on White*, Rauschenberg's white paintings have been seen as the purest possible statement of the idea that life (that is to say, environment) can enter directly into art; they have also been seen as definitive proof of the impossibility of creating a void (one might have thought science had already proved this, but art takes nothing for granted); they have even been seen as clarion manifestoes of the right of the artist in our chaotic era to choose to do nothing at all; and, of course, they have been seen as practical jokes—anti-art gestures, mere provocations. Rauschenberg does not consider them jokes or gestures of any kind. Moreover, he makes it plain that nothing he has done has ever started with an *idea*. "I always thought of the white paintings as being not passive but very—well, hypersensitive," he told an interviewer in 1963. "So that one could look at them and almost see how many people were in the room by the shadows cast, or what time of day it was."

In his black paintings Rauschenberg began by pasting torn and crumpled newspaper to the canvas, "to make a lively ground, so that whatever I did would be in addition to something that was already there, so that even the first

stroke in the painting would have its position in a gray
map of words." Although some of the paintings appear at
first glance to be entirely black, closer examination re-
veals the newspaper type showing through in places, and
also reveals many gradations of tone. "With the black ones
I was interested in getting complexity without their reveal-
ing much—in the fact that there was much to see but not
much showing. I wanted to show that a painting could
have the dignity of not calling attention to itself. In both
the blacks and the whites there was none of the familiar
aggressiveness of art that says, 'Well, here it is, whether
you like it or not.'"

What Rauschenberg was getting at was a kind of paint-
ing in which the artist—his personality, his emotions, his
ideas, his taste—would not be the controlling element. He
was thus moving in a direction contrary to the highly
subjective art of the New York Abstract Expressionists—
the so-called "action painters," who have sought to make
their own encounter with paint and canvas the subject of
their art. "I don't want a painting to be just an expression
of my personality," Rauschenberg has said. "I feel it
ought to be much better than that. And I'm opposed to the
whole idea of conception-execution—of getting an idea for
a picture and then carrying it out. I've always felt as
though, whatever I've used and whatever I've done, the
method was always closer to a *collaboration* with ma-
terials than to any kind of conscious manipulation and
control."

In his groping toward an art that was not guided by
personal taste or self-expression, Rauschenberg found a
powerful ally that summer. John Cage, who is twelve years
Rauschenberg's senior, was also at Black Mountain, work-

ing on his first major composition for magnetic tape. The two men had already met in New York, and Cage even owned a painting from Rauschenberg's show at the Betty Parsons. (This would have been a second survivor from the show if Rauschenberg had not wandered into Cage's apartment one day in 1953 and, finding no one home, proceeded to paint a black composition on top of it, thinking that Cage would like the new one more.) It was at Black Mountain, though, that they got to know each other well and discovered a remarkable affinity in their attitudes. In a sense they approached their respective arts from diametrically opposed points of view. Cage, an intellectual if ever there was one, not only had worked his way through the theories of Arnold Schönberg, Edgard Varèse, Anton Webern, and the other pioneers of modern music, but had also steeped himself in Hindu and Buddhist philosophy, including Zen, and his music was a kind of distillation of many arduous mental journeys. Rauschenberg, never much of a reader, has always been guided primarily by instinct and direct apprehension. And yet, starting from these opposite poles, they have often reached strikingly similar conclusions. Cage's famous "silent" piece for piano, in which the pianist sits at the keyboard for four minutes and thirty-three seconds without striking a note or making any other sound, is a kind of musical counterpart of Rauschenberg's white paintings, which Cage once described, in a poetic essay on Rauschenberg, as "airports for the lights, shadows, and particles."

It was inevitable, of course, that the spirit behind the white paintings and the silent piano piece would be attacked as irresponsible and anti-art, particularly by the more sobersided artists. Cage, having been exposed to accusations of this sort for a good deal longer than

Rauschenberg, had learned how to ignore them, and al-
though he himself has pointed out that he never taught
Rauschenberg anything or influenced his way of working
—"What Bob is, what he does, all comes out of himself,"
Cage has said—there is no question that he was able to
give the younger man a great deal of welcome encourage-
ment at a critical point in his career. Nor was Cage the
only one to do so. Jack Tworkov, the Abstract Expres-
sionist who had come down to teach at Black Mountain
that summer, was immediately attracted to Rauschenberg's
work.

In spite of this encouragement from people whose opin-
ions he valued, the summer was a painful one for Rau-
schenberg. His marriage was breaking up, and that fall he
and his wife were divorced. Despondent and uncertain, he
went to Rome with a friend, and then, when he was nearly
out of money, struck off alone for North Africa, where he
had heard that Americans could make a lot of money
working at United States military installations. Having
used his last fifty dollars to fly to Casablanca, he presented
himself at the employment office of a large construction
company and confidently announced that he was willing
to do any sort of work. This was the wrong approach. "It
turned out you had to apply for a specific grade of job
and have papers and references to prove you were quali-
fied." Having received a flat turndown, he sat on a bench
outside the office to ponder his next move, and there
struck up a conversation with a girl from the installation's
personnel department, who proved to be keenly interested
in art. The upshot of this chance meeting was that the girl
went inside and returned with a sheaf of papers and
references belonging to a previous applicant for the job
of shopkeeper. Rauschenberg spent a few hours memo-

rizing the pertinent facts and went back for another inter-
view. Neither he nor his benefactress had considered the
possibility that he might draw the same interviewer, but
this, of course, was exactly what happened. As Rauschen-
berg describes it, "The man leafed through the papers,
asked me a few questions, and then said, without the
slightest indication that he saw anything fishy, 'Why didn't
you tell me all this before?'" Rauschenberg got the job,
at three hundred and fifty dollars a week.

Three months later, when he had saved up a thousand
dollars, he quit and began wandering around North Africa.
He took a bus as far south as he could go, to the edge of
the Sahara, and then made his way by slow stages to
Spanish Morocco. He had decided arbitrarily to do no
painting in North Africa, but the need to do *something*
led him to construct a variety of strange, fetishlike objects
—lengths of rope, for instance, in which bones, painted
sticks, and other oddments were tied and tangled, and
rough wooden boxes with stones or other found materials
inside. On his return to Rome after five months, he met
the owner of the Galleria dell'Obelisco—the only Roman
gallery then showing work by such contemporary Italians
as Burri and Afro—and, much to his amazement, the gal-
lery owner offered to exhibit the North African objects.
The dealer labeled them *"scatole contemplative"* (thought
boxes) and obviously considered them a great joke. A
surprising number of the objects were sold, and another
avant-garde gallery, in Florence, asked to exhibit them.
Rauschenberg went up to Florence for the opening. An
eminent Florentine critic reviewed the show, which he
called, as a starter, "a great psychological mess." His
conclusion, eloquently expressed several columns later,
was that all of Rauschenberg's works should be thrown

into the river. Rauschenberg was considerably impressed
by the suggestion. "I'd made enough money from sales
to buy my passage, and I was leaving for home in a few
days, but I had packing problems. I thought to myself,
What a wonderful idea!" Putting aside a few *scatole con-
templative* as gifts for friends, he gathered up all the rest
of his works, went out before dawn on a quiet Sunday
morning, found a secluded spot along the Arno, and threw
them in. Then he wrote the critic a letter saying, "I took
your advice."

On his return to New York in the summer of 1953
Rauschenberg found lodging in an old loft building on
Fulton Street, not far from the fish market. Lower Man-
hattan appealed to him not only because it was cheap, but
because the city there has the look and feel of a seaport,
which it quickly loses uptown. For many months he slept
on fish boxes salvaged from the market and lived on a
strict food budget of fifteen cents a day, supplementing his
meager diet with green bananas that he picked up from
the wharves. In the hot weather he rose early, worked
until the air in the loft became stifling, and then took the
ferry to Staten Island, where he spent the rest of the day
on the beach. He would come back late in the afternoon,
usually carrying some bit of flotsam he had picked up on
the beach, and work until late at night. He was experi-
menting with sculpture then, using whatever materials he
could find—rocks dug up on his block by Consolidated
Edison workmen, pieces of lumber ("Con Edison's lumber
is full of knotholes"), scrap metal. In his bottomless
curiosity to see "what is a picture and what isn't," he
even tried making pictures out of dirt, which he packed
into boxlike frames. Later, when some birdseed that had
accidentally fallen into a dirt painting began to sprout, he

got the idea of making a "living" picture, with real grass and moss. Most of these curious works were presented to the public that September at the Stable Gallery, a former riding establishment at Seventh Avenue and Fifty-eighth Street. The show established Rauschenberg as the *enfant terrible* of the New York art world.

Eleanor Ward, who had opened the Stable the year before, had been on the lookout for promising avant-garde painters. She had come down to Fulton Street one day and had seen and liked Rauschenberg's black paintings. The show, which also featured black-and-white abstractions by Cy Twombly, was something of an upheaval. "One well-known critic was so horrified that he came out literally clutching his forehead," Mrs. Ward has recalled. "I lost friends over that show. A great many people really thought it was immoral. In those days you could still shock people, remember, and some of the people it shocked the most were other artists. Nothing sold, of course, and I had to remove the guestbook, because so many awful things were being written in it."

At this time, and for several years afterward, Rauschenberg received very little sympathy from other painters. His only real encouragement, in fact, came from the little group of avant-garde musicians and dancers around John Cage and Merce Cunningham. Cage, for example, commissioned Rauschenberg to design the program for a week of Cunningham dance concerts at the Theatre de Lys. (Cage rejected the design but paid him anyway.) Another composer, Earle Brown, bought a black painting for the odd sum of $26.30, which represented a refund he had received that day from the Telephone Company. Rauschenberg knew most of the New York painters by this time. He went regularly to the Artists' Club—that informal,

freewheeling seminar in a loft on Ninth Street where for
several years artists met weekly to discuss, usually with
great heat, the new art they were forging—even though
he usually had to walk all the way uptown and back to
save the subway fare. But he felt somewhat isolated from
the main current of Abstract Expressionist painting, and
he had trouble with the language being used. "The kind
of talk you heard then in the art world was so hard to
take," he has recalled. "It was all about suffering and
self-expression and the State of Things. I just wasn't in-
terested in that, and I certainly didn't have any interest
in trying to improve the world through painting."

All this may have had some bearing on his rather
bizarre decision that winter to erase a drawing by Willem
de Kooning, the most revered of the Abstract Expres-
sionists. Rauschenberg has stoutly denied that this was
merely a gesture and has defended it on purely aesthetic
grounds. "I had been working for some time at erasing,
with the idea that I wanted to create a work of art by that
method. Not just by deleting certain lines, you understand,
but by erasing the whole thing. Using my own work wasn't
satisfactory. If it was my own work being erased, then
the erasing would only be half the process, and I wanted
it to be the whole. Anyway, I realized that it had to be
something by someone who everybody agreed was great,
and the most logical person for that was de Kooning. I
actually had a de Kooning drawing that I'd stolen from
him once, but that wouldn't do—the act required the
artist's participation. So I went to his studio and explained
to him just what I had in mind. I remember that the idea
of destruction kept coming into the conversation, and I
kept trying to show that it wouldn't *be* destruction, al-
though there was always the chance that if it didn't work

out there would be a terrible waste. At first, he didn't like
the notion much, but he understood, and after a while he
agreed. He took out a portfolio of his drawings and began
thumbing through it. He pulled out one drawing, looked
at it, and said, 'No, I'm not going to make it easy for
you. It has to be something I'd miss.' Then he took out
another portfolio and looked through that, and finally he
gave me a drawing, and I took it home. It wasn't easy, by
any means. The drawing was done with a hard line, and
it was greasy too, so I had to work very hard on it, using
every sort of eraser. But in the end it really worked. I
liked the result. I felt it was a legitimate work of art,
created by the technique of erasing. So the problem was
solved, and I didn't have to do it again." The erased de
Kooning, framed, now hangs in Rauschenberg's studio,
the faint, ghostly shadow of its original lines just de-
tectable on the white paper. The inscription underneath
reads:

<div align="center">

ERASED DE KOONING DRAWING

ROBERT RAUSCHENBERG

1953

</div>

It has always been rather difficult for anyone to dislike
Rauschenberg personally. His exuberance, energy, and
high spirits are infectious, and his spontaneous enthusiasm
for work by other artists, even when it is very different
from his own, is especially winning. Some of the older
Abstract Expressionists who welcomed his company got
around the aesthetic problem posed by his work by writing
him down as basically non-serious. (Some still do. "Bob is
a limited kind of artist with limited goals," a prominent
critic observed not long ago. "He's not out to hit the jack-
pot, by which I mean he's not out to create a masterpiece

that will change the course of painting"—a statement
with which Rauschenberg would probably agree.) Jack
Tworkov, on the other hand, continued to give him full,
active, and generous support, and in 1954 talked his own
dealer, Charles Egan, into going down to Fulton Street
to see Rauschenberg's new work. The result was that
Rauschenberg joined the Egan Gallery—which then had
Franz Kline, Philip Guston, and several more of the top
Abstract Expressionists on its roster—and exhibited there
in December of that year.

The new paintings were predominantly red and de-
cidedly aggressive. "I'd heard so much criticism of the
black paintings," Rauschenberg has explained, "and so
many accusations of my being anti-art and of 'Well, if
he hates it all that much, why does he paint?' that I
thought I'd better find out whether there was any truth
in them. The black paintings and the white ones had mis-
represented themselves, and I had already had *that* ex-
perience. So the next move was obviously to try some other
color, and I picked the color I found the hardest to work
with, which was red." The red paintings were very red,
very large, and thickly populated with elements of collage.
They culminated in *Charlene*, the huge work that was in-
cluded in the 1963 Jewish Museum retrospective. The
Egan show opened shortly before Christmas (Egan called
it "Joyeux Noël") and was extended through January of
1955. Leo Castelli, Rauschenberg's dealer since 1958,
recalls it vividly. "It was an astonishing event—some-
thing like Coney Island, with umbrellas turning and lights
flashing. It seemed altogether new and unprecedented, not
related in any way to anything else." Two pictures were
sold, and there were even a few favorable reviews. As
usual, though, the public and most artists reacted to it

with hostility, and Rauschenberg's claim to the title of *enfant terrible* began to appear incontestable.

Soon after the Egan show Rauschenberg moved to a loft studio on Pearl Street, and there came in contact with Jasper Johns, who had a studio in the same building. Johns, whose work was to strike some observers as even stranger than Rauschenberg's, was unknown at the time. He had not had a New York exhibition, and he had met very few artists. It was his implacably logical idea that since the surface of a canvas is flat, nothing should be painted on it but flat objects. He did not care to produce an illusion with perspective, or, indeed, to produce an illusion of any kind; it was the fact, the reality, that interested him. This led him to paint such things as flags, targets, and numbers (an especially clear example—one cannot paint an "image" of the number 7, say; one can only paint a 7), which took on, as a result of his striking and "painterly" talent, an intensity and power that many people have found somewhat ominous. For the next five years Johns and Rauschenberg saw each other's work daily and gave each other, as Rauschenberg has put it, "the permission to do what we wanted." In order to understand this statement it is necessary to realize that the Abstract Expressionist school was at this time becoming widely recognized as the first native American style of painting to exert a profound international influence. The "action painters" had made New York, not Paris, the center of the postwar art world, and the pull in the direction of Abstract Expressionism was so powerful that anyone who wanted to work in a different direction had, as Rauschenberg has said, "to start every day moving out from Pollock and de Kooning, which is sort of a long way to have to go to start from." Although Rauschenberg

and Johns both had their roots in the Abstract Expressionist style, they *were* moving out in a different direction, for they had both largely rejected the notion that self-expression in any form—including that of action painting —should be the basis of their art. The daily stimulus of seeing each other's work almost certainly saved them both a great deal of self-doubt.

In spite of their close association, their work is not at all alike. The differences involve not only technique— Johns' being precise, elegant, orderly, and Rauschenberg's rough, casual, slapdash—but general attitude as well. Johns' work seems rather cerebral in comparison with Rauschenberg's pictorial outbursts. If Johns can be said to have influenced the Pop artists who now paint deadpan representations of soup cans and comic strips, Rauschenberg's influence is to be seen in the more hazardous creations of Jim Dine and Claes Oldenburg, where a precarious balance between ugliness and beauty is often attempted and sometimes achieved. The fundamental difference in their attitude shows up in an anecdote told by John Cage. "When they moved from Pearl to Front Street, I offered to help and brought over my station wagon. Bob's attitude was that if any of his work was damaged en route it wouldn't concern him at all—it would just be part of the painting's natural life. Jasper's attitude was that if something happened to one of his paintings he would have to work on it—not just repair the damage, but work on the whole painting, since any change would reopen the aesthetic problem for him."

Charlene was the last of Rauschenberg's red paintings. "I'd begun to notice that when you were walking down the street, or were in a theater or in any group of people, the

mass, no matter how colorful, never looked *tonal*. Some-
body might be wearing a bright red tie or green shoes, but
somehow such things were absorbed, and all you saw was
a general no-color, in which no tone stood out. I began
trying to put this quality of pedestrian color into my
paintings." He also discovered a new way to get beyond his
own taste. In hardware stores on Canal Street he found
that he could buy, at a discount, cans of paint whose labels
had come off, so that there was no way of knowing what
color he was going to use until he got a can home and
pried off the lid. The major painting of this new series
was *Rebus*, in which he got exactly the quality of lean,
unprogrammed, nondescript color that he was after. *Rebus*
was painted on cheap dropcloths, which were all that
Rauschenberg could afford at the time; it has since been
remounted on canvas. Some critics consider it one of the
most important pictures of the decade. It is owned by the
artist and is on extended loan to the Metropolitan Mu-
seum.

Another work that belongs to this period is the notori-
ous *Bed*, whose quality very few viewers would describe
as nondescript or pedestrian. Rauschenberg insists that
he had no intention of shocking anyone with *Bed*. He
simply woke up one May morning with the desire to paint
but nothing to paint on and no money to buy canvas. His
eye fell on the quilt at the foot of his bed. The quilt
had come up from Black Mountain with him, and he had
slept under it for several winters. The weather was getting
warm, though, and next winter seemed a long way off.
He made a stretcher for the quilt, just as though it were
canvas, and started to paint. Something was wrong, though;
the quilt pattern was too self-assertive. Rauschenberg
added his pillow. "That solved everything—the quilt

stopped insisting on itself, and the pillow gave me a nice white area to paint on." The finished work not only has caused a great many people intense discomfort (more than one viewer has said that it looks like a bed in which an ax murder has been committed), but has figured prominently in an international cultural *crise*. In 1958, at the first Festival of Two Worlds in Spoleto, Italy, *Bed* was part of an exhibition of work by twelve young American artists. The whole exhibition so outraged the Italian authorities at the Festival that they refused to hang it. Eventually, however, after much transatlantic wrangling and an anticensorship appeal to the International Association of Art Critics, the American contributions *were* hung—with the sole exception of *Bed*, which was sequestered in a back room.

Rauschenberg is perplexed by such reactions. "I think of *Bed* as one of the friendliest pictures I've ever painted. My fear has always been that someone would want to crawl into it." On the other hand Rauschenberg has never believed that the function of art should be to make the beholder feel relaxed or uplifted, and he is not at all displeased to think that his own pictures make people restless. "If you don't change your mind about something when you confront a picture you've not seen before," he once said, "either you're a stubborn fool or the painting is not very good."

In the middle and late 1950s Rauschenberg's work took on more and more of a restless, try-anything quality that was guaranteed to keep viewers from feeling relaxed. He had begun to think of his work as a kind of reporting, and action photographs from magazines and newspapers —struggling athletes, dancers in motion, violent street incidents—were cropping up again and again in his com-

positions. Even his titles began to function in a new and
active way, as something added to the painting; titles like
Rebus, Satellite, Curfew, or *Talisman,* rather than em-
phasizing one aspect of the work, seem to add another
dimension and expand the frame of reference. Rauschen-
berg's increasing assurance also encouraged him to use
larger and larger objects as collage elements. The doors
that open, the street signs, the assorted stuffed livestock—
chickens, a pheasant, an eagle with wings outspread—that
appear in certain pictures of this period did not make his
work any more acceptable to the uninitiated viewer; they
could, however, be seen as a logical development of the col-
lage technique that began with the Cubist collages of
Picasso and Braque. Western art until that time had
sought, by means of the Renaissance discovery of van-
ishing-point perspective, to lead the viewer's eye into the
illusionistic space of the painting. The Cubists abandoned
perspective to paint "flat," and in the Picasso-Braque col-
lages of 1911–1912 the surface of the picture actually be-
gan to extend outward, toward the viewer. The implications
of this revolutionary step have been explored in various
ways by a great many subsequent painters, all of whom
have embraced collage as a method of incorporating
"reality" into the picture without imitating it. As usual,
Rauschenberg was willing to push the whole idea a lot fur-
ther. If a painting could be made with boards, string, or
scrap metal, as Tworkov put it, then why not with a
chicken? Rauschenberg's stuffed birds, which he picked
up from taxidermists' shops or received as gifts from
friends, are usually attached somewhere outside the picture
surface, perching atop the frame or looming out from
beneath it. "There wasn't any special idea behind this,"
he says. "I just liked working with these things as objects,

and I liked the fact that a picture could come out into the room."

Strolling along Seventh Avenue one day, Rauschenberg paused to look in the window of a store that sold office furniture. Gazing morosely back at him was one of the strangest creatures he had ever seen—a large stuffed Angora goat with curving backswept horns and a thick, curly fleece that hung almost to the floor. He immediately went inside and asked the price. The store owner was somewhat reluctant to sell the trophy, which he had bought sight unseen at a railroad auction (it had been in a crate with some other unclaimed merchandise), but Rauschenberg talked him into letting it go for thirty-five dollars—fifteen down and twenty on account. When he got the goat home he saw that the long, ropelike fleece was thick with dirt and that the animal's muzzle had been badly bashed in. He set to work with rug shampoo and scrubbed away at the fleece until it was several dozen shades lighter. Then he turned his attention to the damaged muzzle. After hours of painstaking plastic surgery it still looked discolored and uneven on one side. Rauschenberg decided to conceal this defect with paint, which he applied in a thick impasto to the goat's cheeks. "So many people ask me why I put all that awful paint on his face," Rauschenberg said once. "It's what seems to bother people the most. But, you see, I know exactly why I did it!"

The next problem was how to use such an extraordinary object in a picture. "I'd never used anything as large as that, and for a long time I couldn't make it fit—couldn't make it look as though it belonged there." He worked on the goat, off and on, for three years, and its present version was preceded by two others. "In the first version I had it resting on a high shelf in the painting—flat

against it, with light bulbs set underneath. That was no good, because there was only one side of him showing, and I felt it was a terrible shame not to be able to see all of him. Next I tried mounting him with his rear end to the canvas, but that was awful—it looked as though he was *pulling* it." It was at this point that he had the inspiration of placing an automobile tire around the goat's middle. The tire, whose treads he painted white, seemed to him to be "something as unavoidable as the goat"—something that could function as powerfully as the goat in the plastic sense but that had an everyday reality that tended to balance the goat's extremely exotic look. The third, and final, version was such a simple and obvious solution that he was amazed it had not struck him sooner. He made an "environment" for the goat—a flat, horizontal wooden platform on which it could stand. The platform was painted and collaged in Rauschenberg's customary manner, with such random objects as a tennis ball, a rubber heel, a shirt sleeve, and numerous action photographs from magazines and newspapers. Standing thoughtfully among these images, the goat, with its painted face and its encircling tire, looked oddly at home. Since it was a freestanding object and could not be hung on a wall, it could hardly be called a painting, even under the most elastic definition. Nor was it sculpture, since painting figured importantly in it. As a result of this ambiguity Rauschenberg decided to call it a "combine." It has probably been his most famous single work. Entitled *Monogram* (both the goat and the tire seem to Rauschenberg to function as succinctly as initials, hence the title), it has traveled extensively in Europe and the United States and has been subjected to all sorts of praise and considerable abuse. Once, in Milan, it collapsed under the weight of an

Italian art lover who sat on its back so that his wife could
take his picture; Rauschenberg was obliged to have its
right front leg repaired by an expert at the Musuem of
Natural History. The artist has so far resisted all offers to
buy it.

In the early 1950s, while continuing to work with un-
diminished energy on his paintings and combines, Rau-
schenberg became increasingly involved with avant-garde
music and dance activities in New York. He designed cos-
tumes and sets for Merce Cunningham's troupe and also
collaborated on several occasions with Paul Taylor, a
gifted former protégé of Martha Graham. Taylor's dance
ideas used to be a good deal more experimental than they
are now, and in 1954 he put on, with Rauschenberg's as-
sistance and (one suspects) under Rauschenberg's in-
fluence, a recital at Hunter College that was the scandal of
the season. The program consisted of seven dances. The
"music" for the first was in the form of a tape recording
of the telephone voice that announces the time of day over
and over. Another number, called *Duet,* was a static piece;
the curtain went up on Taylor and his female partner, who
held the same pose without moving until the curtain went
down again. The *pièce de résistance,* however, was a dance
called *Resemblance.* Rauschenberg's "set" for this work
was a dog, of medium size and indeterminate breed, which
was rented from a professional trainer and was thus the
only paid member of the company. The dog's function
was to come onstage and sit down, which would be the cue
for the dance to begin; when he got up and went off the
dance would stop. During rehearsals, though, the dog ap-
parently took an immediate and violent dislike to John
Cage's *Water Music,* which was being used as the score.
(It is full of loud and unexpected sounds.) "He kept

whining and running off into the wings at every loud noise,"
Taylor has recalled. "As a result, his trainer filled him so
full of tranquilizers just before the performance that the
poor animal didn't know what he was doing. He wandered
onstage, but instead of sitting down he just ambled out
front and took a good, long look at the audience. The effect
was marvelous; you couldn't have choreographed anything
better. Then he turned around and went offstage. It was
really superb. We only had to pay half his fee too, be-
cause he hadn't done what he was supposed to do." The
critics present were thoroughly outraged, however, and
Taylor, though he recalls the incident fondly, has since
moved in a somewhat more traditional direction.

Although Rauschenberg's own work did not really begin
to sell until 1959, his standard of living took a sharp turn
for the better in 1955. During that year he and Jasper
Johns suddenly discovered that they could support them-
selves comfortably by doing occasional commercial jobs
for Gene Moore, who was then in charge of window dis-
plays for both Bonwit Teller and Tiffany. The painters
collaborated on these jobs, using a fictitious name (Matson
Jones) to rule out any possible connection with their seri-
ous painting. What they did, for the most part, was to
make astonishingly realistic, meticulously executed "nat-
ural" settings for the jewelry to be displayed in Tiffany's
windows: a miniature highway, complete with white line
and telephone poles, over which a diamond bracelet was
negligently draped; a sinister, murky-looking swamp, with
tree trunks rising from slimy water and a few emeralds
glittering like snakes' eyes in the mud; a wintry forest
on the morning after an ice storm, with snow on the
ground and real diamonds looking as though they had
just fallen in showers from the icy branches. From time to

time Moore would place one or two of their serious paint-
ings in a Bonwit window, not because he liked the work
(he didn't), but because he felt that it was part of his job
as a display director to show what was going on in New
York. He got a lot of complaints from customers about
Rauschenberg's pictures and relatively few about Johns'.

There is no question that the public has responded more
readily to Johns' work than to Rauschenberg's. It was not
until 1958, though—nearly ten years after Rauschenberg's
first show at the Betty Parsons—that Johns had a major
one-man exhibition in New York, at the Leo Castelli Gal-
lery. The show was spectacularly successful. Alfred Barr,
the Museum of Modern Art's highly respected Director of
Collections, was so enthusiastic that he bought three pic-
tures for the museum and urged all his friends to see the
show. *Art News* put a Johns target on its cover. Almost
overnight, Johns acquired an international reputation and
a market. A Rauschenberg show three months later was
equally sensational—it included *Rebus, Bed,* and a chick-
en-bearing combine called *Odalisk*—but, as usual, there
were few sales. A woman who bought a relatively inoffen-
sive Rauschenberg from this show later sold it back to
Castelli, explaining that she had been keeping it in a
closet because the delivery boys all laughed when they saw
it hanging on the wall. Rauschenberg was still the *enfant
terrible.* Characteristically, though, he was overjoyed by
Johns' success.

Even Rauschenberg's detractors concede that he has al-
ways been exceptionally generous toward other artists. He
has been stanchly loyal to John Cage, Merce Cunning-
ham, and his other friends in the music and dance world,
in which there has been nothing to compare with the current

boom in the art market. In 1958 Rauschenberg, Johns, and a volatile entrepreneur named Emile de Antonio pooled their talents and their funds to sponsor a major New York concert of Cage's music at Town Hall, and several large paintings donated by Rauschenberg were sold for the benefit of the Foundation for Contemporary Performance Arts, an organization dedicated to getting engagements for experimental music, dance, and theater groups. He has also been warmly sympathetic to much of the new work being done by painters younger than himself. "Bob made me see my own work differently," says Jim Dine, one of the best of the Pop artists. "He was really enthusiastic about it, and he talked about it to other people, and I'll never forget that."

Early in 1959 Rauschenberg started to work on a series of thirty-four illustrations for Dante's "Inferno," a project that was to occupy almost all his time for the next two years. He had been wanting for some time to do a series of drawings, and that winter he hit on a technique that allowed him to incorporate fragments of the "real world" into work on a small, intimate scale. The technique, in its present stage of refinement, involves wetting a piece of drawing paper with lighter fluid (the most satisfactory as well as the most convenient medium), placing on it, face down, a photograph from a magazine (*Time, Life,* and *Newsweek* are excellent for this purpose; *Look,* for some reason, is not), and rubbing over the back of the photograph with the nib of a dry ball-point pen. The image thus transferred functions, like collage, as a fragment of life and is used with other such fragments in the drawing that is then done on the paper, which may include water

color, shading, erasing, washes, and even old-fashioned
line drawing, which Rauschenberg can do very effectively
when so inclined.

Rauschenberg made a number of transfer drawings in
this manner, but he found that one did not lead to an-
other, as was the case with his paintings. "I really wanted
to make a whole lot of drawings, though, so I began look-
ing around for a vehicle, something to keep them going."
The idea of using Dante's poem came into his head at this
point, although he is not exactly sure why. He had never
read the poem. He *had* seen one or two of the Botticelli
drawings for *The Divine Comedy* in a volume of reproduc-
tions and had liked their intimate quality—a quality he
considers essential in a drawing. He had also seen the
Gustave Doré illustrations and had hated them. In any
case, having decided to use the "Inferno" as a vehicle, he
made up his mind that he would not attempt to pick out
highlights to illustrate, because that would smack too
much of personal taste and imply a certain lack of respect
for the poet by distorting his emphasis and thus encourag-
ing distortion in reading. Rather, he would illustrate all
thirty-four cantos with one drawing apiece, proceeding
in strict chronological order and not reading ahead to the
next canto until he had finished illustrating the present
one. He bought several translations of the poem in paper-
back. The version by John Ciardi suited him best, and it
was this one that he used primarily. When he had illus-
trated the first six cantos he realized that the project was
going to take at least a year to complete. In order to con-
centrate on it exclusively he needed money. It occurred
to him to apply for a Guggenheim grant. "I thought Dante
might make my project seem respectable enough," he said.
With his application Rauschenberg sent in six of the Dante

drawings, another large transfer drawing, and only one painting, which he considered "embarrassingly lyrical." He also sent some photographs of his work, having learned that a photograph, lacking the physical presence of large and unwieldy objects, often made the work more acceptable in certain quarters. On the day of the official judging of applications, a secretary of the Guggenheim selection committee telephoned to say that the committee was favorably disposed toward his application. They wanted, though, to see a little more of his work—in the original. "I knew right then I was cooked," Rauschenberg has said. "It was like being asked to do myself in." After combing the studio for something that would be least likely to upset the authorities, he reluctantly sent in two more paintings. The next day he was informed that his application had been turned down.

Fortunately one or two collectors were becoming interested in Rauschenberg about this time, so there was enough money coming in from sales to keep him going on the Dante project. Keep going he did, for the next eighteen months, although the strain of working on such a small scale was so intense that he had to break out from time to time and do a large painting or a construction. Not surprisingly, the objects he used in these works were bigger and more aggressive than ever.

The Dante drawings, which were first shown at Leo Castelli's in December of 1960, are a remarkable distillation of Rauschenberg's complex art. Although the images are all of the present day (taken mostly from magazines), they show a sustained inventive power and an inner consistency that are entirely relevant to the spirit of the poem. Just as Dante used public figures to people his Hell, so does Rauschenberg; Kennedy, Nixon, and Adlai Stevenson

turn up here and there (Stevenson as Virgil, the guide),
along with such other modern souls in torment as
struggling athletes and soldiers in gas masks. Hellish rock-
ets and other armaments appear frequently, along with the
racing cars that seem to represent for Rauschenberg the
demons of the nether world. Dante, the earthly witness, is
shown throughout as a kind of nondescript, ordinary man
with a towel wrapped around his waist. He appears in
nearly every drawing, and he came from an advertisement
for golf clubs in *Sports Illustrated*. (Rauschenberg ran out
of copies of the magazine but managed to get more by mail
from a somewhat perplexed back-date-magazine dealer in
New Jersey, who obligingly looked up the issues that had
run the ad.) The original drawings were purchased by an
anonymous patron and donated to the Museum of Modern
Art, and the whole series has been published by Harry N.
Abrams in a limited edition priced at three hundred dollars
a copy.

Rauschenberg's reputation as a serious artist was greatly
strengthened by the Dante drawings. Although he had first
received official recognition in 1959, when the Museum
of Modern Art included him in its important group show
called "Sixteen Americans," it was only now, and rather
suddenly, that the art world began to see him as something
more than an *enfant terrible*. The obvious next step was a
one-man show in Paris, and this was held in the spring of
1961 at the influential Galerie Daniel Cordier. Rauschen-
berg went over for the opening. His work stunned the Paris
artists, who had seen nothing even remotely comparable to
Monogram, Odalisk, and *Pilgrim*—the last a recent and
colorful canvas to which Rauschenberg had casually at-
tached a plain wooden chair. (When the canvas was in his
Front Street studio, visitors coming to look at his works

would often pile their hats and coats on the chair—to their
discomfiture when it came time to view the *œuvre*.) The
show was an enormous success. Even more useful, from the
point of view of Rauschenberg's reputation abroad, was
an interview he had with André Parinaud, the editor of the
Paris weekly *Arts*. Ileana Sonnabend, Rauschenberg's close
friend and current Paris dealer (she was formerly Mrs.
Leo Castelli), served as interpreter, and she says that
Parinaud's opening questions convinced her that he
planned to use Rauschenberg as an example of all that
was sick, materialistic, and degraded in American society.
Rauschenberg's replies, however, were disconcertingly
candid. When Parinaud asked him, for example, "If some-
one proposed that you become President of the United
States or president of General Motors, would you stop
being a painter?" Rauschenberg's thoughtful answer was,
"Those are good jobs. I'd think seriously about it." Mid-
way through the interview Parinaud called in his own
interpreter, to make sure that Mrs. Sonnabend was trans-
lating accurately. Rauschenberg continued to answer all
the questions with lucid candor, revealing a consistent at-
titude toward his work that Parinaud apparently found af-
fecting and sincere. "I don't want to reform the world,"
Rauschenberg protested at one point. "I just want to live
in it!" By the end of the session Parinaud was completely
won over. The interview was given a full page in *Arts* and
was received with great enthusiasm by the Paris artists.
"Rauschenberg became a hero to them," Mrs. Sonnabend
explained later. "He took them out of painting, you see,
and into something else—life, maybe."

While in Paris, Rauschenberg also renewed his ac-
quaintance with Jean Tinguely, whom he had met in the
garden of the Museum of Modern Art the year before,

when Tinguely set off his huge, self-destroying construction called *Homage to New York*. The two artists got along splendidly, even though neither could speak very much of the other's language. They found that they had a great deal in common—boundless energy, irreverent humor, and a basic desire to avoid in their work the fixed, static quality of so-called "high art." Tinguely's sculptures, which spring into furious motion when activated by small motors, can even be seen as aesthetic counterparts of the Rauschenberg combines, in which the ambiguous, dynamic irresolution of all elements keeps the eye in continuous motion over the surface. Both men liked the idea of collaboration between artists, and that spring they joined forces with several other avant-garde talents to put on a rather bizarre performance in the little theater that is part of the American Embassy. This spectacle presented simultaneously a motorized Tinguely sculpture that went back and forth across the stage doing a strip-tease; a performance, in and around the piano, of John Cage's *Variations II* by David Tudor; a picture-shoot by Niki de Saint-Phalle, who creates her works by firing a .22 rifle at papier-mâché and plaster constructions in which plastic bags of paint are embedded; and the onstage creation of a painting by Rauschenberg, whose brushstrokes, hammer blows, and other sound effects were amplified by contact microphones attached to the canvas. Only the back of the painting was visible to the audience, which expected to see the finished work at the end but was denied that pleasure. Jasper Johns, who was also having a show in Paris, contributed a painted sign reading "Entr' Acte" and a target made of flowers. The performance drew a large and enthusiastic audience, although the Embassy,

uncertain what to expect, had forbidden any advance pub-
licity.

Rauschenberg, Tinguely, and Niki de Saint-Phalle were
so exhilarated by the experience that they collaborated on
an even more peculiar theatrical event the following spring
in New York. This took place at the Maidman Playhouse,
on Forty-second Street, and was entitled "The Construc-
tion of Boston." It had a script by Kenneth Koch, the
poet, which no one followed. No one, in fact, could quite
agree on what each would do. Tinguely originally planned
to act the part of a lady architect (he finds American
career women hilarious) building a "rubber city" by
pumping up huge balloons onstage; as he pumped up
one, the others would slowly deflate. Then, at the last
minute, he decided instead to build a cinder-block wall
between the performers and the audience. Rauschenberg
constructed a set resembling a furnished apartment and
had two dancers from the Merce Cunningham company—
Viola Farber and Steve Paxton—go through the routines
of an "ordinary day," which included being rained on
by an elaborate Rauschenberg rainmaker, until Tinguely's
wall sealed them from view. A number of other confusing
actions took place, but the collaborators had not been able
to resolve their differences of opinion, and the event,
Rauschenberg feels, was not as interesting as it might
have been.

Rauschenberg admits to having been stagestruck since
early childhood (he insisted on getting into all the school
plays, although he could never remember his lines), and
he has found an outlet for this theatrical urge in his work
with the Cunningham and other dance companies, for which
he handles lighting in addition to concocting costumes and

sets. He has even turned his hand to choreography. During
the 1963 Pop Art Festival in Washington, sponsored by
the Washington Gallery of Modern Art, a large audience
gathered in a roller-skating arena for a dance concert that
included the première (and so far only) performance of
Rauschenberg's *Pelican,* in which Rauschenberg himself
and the Swedish sculptor P. O. Ultvedt, wearing roller
skates and huge, spoked sails made from parachutes,
swooped and wheeled about the arena with Carolyn Brown,
one of the Cunningham dancers, who miraculously sur-
vived the experience and actually claims to have enjoyed
it. Rauschenberg would like to see modern dancers move
toward a more spontaneous, unplanned sort of choreog
raphy, letting the specific environment in which they find
themselves dictate what they do at each performance.
Cunningham has been taking steps in this direction lately,
and the future evolution of his company is being watched
with great interest in the dance world.

During the last few years Rauschenberg has moved con-
sistently in the direction of even greater freedom and
spontaneity in his work. The large post-1957 combines
are full of brilliant, uninhibited color, laid on in luscious
impasto and swift washes, flowing and fusing with the
collage objects and drawing them inextricably into the
precarious balance of the picture as a whole. Any object,
it seems, is grist for his art-life mill, and he has used an
astonishing variety of objects—clocks, neckties, street
signs, radios (in a combine called *Broadcast,* where he
was exploring "the relation of sound to seeing"), electric
fans, and even a reliquary allegedly containing the tooth
of an obscure Catholic saint. He has also shown an un-
diminished zest for upsetting aesthetic applecarts and dis-

proving fashionable art clichés. Bored and irritated by people who look at a picture and say, "It's perfect; it couldn't have been any other way," he did four pictures using exactly the same materials—the same colors, the same amount of each color, the same collage elements, all carefully measured out. The pictures are called *Summer Rental (Versions I-IV)*, and they are strikingly dissimilar. Conversely, he set out to make two pictures called *Factum* as nearly identical as possible, right down to the "accidents" of running or dripping paint in both. The fact that they *are* nearly identical is a wry comment on the whole idea of chance in art. "I don't believe in chance any more than I believe in anything else," Rauschenberg said once. "With me, it's much more a matter of just accepting whatever happens, accepting all these elements from the outside and then trying to work with them in a sort of free collaboration. That's what makes painting an adventure, which is what it is for me."

Oddly, though, as Rauschenberg's work has grown in freedom and assurance, his goal of an art beyond self-expression or personal taste seems to have steadily receded. This has had nothing to do with success or reputation; the fact that he is an artist whose work is now in great demand by collectors and museums in many countries and whose influence on current art trends is constantly assessed in art journals does not appear to have had the slightest effect on his attitude or on his way of working. What is very evident, though, is that everything he has done since the 1952 black paintings bears the unmistakable stamp of his own particular talent and sensibility. No one could mistake a Rauschenberg for the work of anyone else. It can thus be argued that his personal taste must be the guiding force in all his work, and that what his paintings

really express, in defiance of his wishes in the matter, is
his own unique view of life. Jackson Pollock was once
asked by a friend whether he felt that anything at all he
did with paint was all right. "No," said Pollock. "Not
if I lose contact." The contact he had in mind was prob-
ably the same sort of intensity and inner discipline that
enables Rauschenberg to accept whatever comes to hand,
to transform his bizarre materials, and to keep them,
somehow, in balance. Every now and then Rauschenberg
says something that suggests he is aware of the paradox in
his situation. "I'd really like to think that the artist could
be just another kind of material in the picture, working
in collaboration with all the other materials," he said one
day not long ago. "But of course I know this isn't possible,
really. I know that the artist can't help exercising his con-
trol to a degree and that he makes all the decisions finally.
But if I can just throw enough obstacles in the way of my
own personal taste, then maybe it won't be *all*-controlling,
and maybe the picture will turn out to be more interesting
as a result."

In the early 1960s Rauschenberg began to notice that
more and more collage was turning up in the art galleries
—work in which the collage technique was the whole
point rather than just a means to an end. This disturbed
him and gave impetus to an urge he had been feeling for
some time to paint "flat." A large 1962 canvas called
Ace showed the transition; it was basically a flat painting,
whose relatively few collage elements were easily absorbed
into the composition. After *Ace*, Rauschenberg abandoned
collage altogether and turned to silk-screen painting, which
he adapted (freely, to say the least) from commercial
art. The images he wanted he took from magazines, news-
papers, and such sources, and he had a commercial firm

transfer them by a photographic process—in any size he
ordered—to silk screens. Then, placing a screen over a
canvas, he poured paint over it and forced the paint
through the porous silk design with a squeegee. Next he
worked directly on the surface of the canvas with brush,
palette knife, fingers, turpentine-soaked rags, or anything
else. He started only with black-and-white silk screens,
"because I'm such a pushover for color and I didn't want
that to interfere with what I was trying to work out." The
black-and-white series culminated in the tremendous,
thirty-two-foot *Barge*, which dominated one room of the
Jewish Museum retrospective. After that he felt free to
explore the greater complexities of the four-color separa-
tion process.

The new technique has not made painting any less of
an adventure for him. "It's as much like Christmas for
me as using objects I pick up in the street," he said one
day in 1963, to a visitor who had dropped in at his loft
studio on lower Broadway to watch him work. "There's
that same quality of surprise and freshness that I have
when using objects. When I get the screens back from the
manufacturer the images on them look different from the
way they did in the original photographs, because of the
change in scale, so that's one surprise right there. Then,
they look different again when I transfer them to canvas,
so there's another surprise. And they keep on suggesting
different things when they're juxtaposed with other images
on the canvas, so there's the same kind of interaction that
goes on in the combines and the same possibilities of
collaboration and discovery."

Four big canvases were resting against the long wall
of the hundred-foot, whitewashed loft, and Rauschenberg
was working on all of them simultaneously. Certain silk-

screened images appeared on all four of the canvases—
the Sistine Chapel in the Vatican, an engineer's diagram
of a large clock, four stop-motion shots of a small bird in
flight—but never in the same places, and sometimes only a
part of the image was showing. Rauschenberg moved from
one canvas to another, jauntily brushing in areas of white.
"I like to work on several at a time this way because you're
not so likely to get hung up on one, or to work schemingly,"
he said. "You keep moving. When you come back to one
and it hasn't moved automatically while you were away,
suggesting something new, you just go on to the next." He
worked steadily through the afternoon talking of this and
that, commenting on the surprises that cropped up in the
pictures ("*That* was a good stroke!") and occasionally step-
ping back to scrutinize his progress. From time to time
he paused to replenish a tall glass of vodka and orange
juice. The four paintings progressed at about the same
rate but not in the same direction. One of them, in which
a signpost marking the intersection of Nassau and Pine
Streets figured prominently, began to take on an extra-
ordinary denseness and complexity, while the others stayed
looser and less well organized, with more empty spaces.
After a while Rauschenberg became totally and exclu-
sively absorbed, for an hour or more, in the signpost
picture. There was always, he said, a point at which a
painting "shook loose" for him, and then it went very
fast. He broke away from it finally and turned his atten-
tion to its neighbor. He placed that canvas flat on the
floor and proceeded to lay in the image of the clock
diagram precisely in the middle of the shot of the Sistine
Chapel. The result delighted him. "It makes a modern
painting out of *The Last Judgment*," he said happily.

Toward six-thirty Rauschenberg stopped painting and

spent forty minutes or so cleaning his silk screens with solvent. After that he sat down and talked about some of the things he would be doing in the weeks to come. He had been commissioned, along with several other young artists, to do a large work for the exterior of Philip Johnson's New York State Pavilion at the 1964 World's Fair, and he was thinking of doing something in neon tubing, a material he had never tried before. Also, he was working on the layout for the limited edition of his Dante drawings, each copy of which would include a Rauschenberg lithograph (he recently became interested in the lithography process and has worked several stones in the Long Island studio of Tatyana Grossman, one of the leaders in a movement to establish a tradition of fine printmaking in America). And in five weeks he was due to go on tour with the Cunningham company. The thought of these overlapping commitments seemed to exhilarate him. "I like to do all sorts of things that aren't painting," he said. "You see, I have this feeling that I'm never not working, that whatever I do is just—well, part of what I'm doing. Do you know what I mean? It's something that appeals to me so much in some of those old painters —Leonardo, for example. God knows I'm aware how enormous his talent was, and this sounds presumptuous, but what really appeals to me about Leonardo is his attitude—his being interested in all those things *other* than painting, doing those theater pieces and pageants, designing fantastic engines, when everybody kept telling him he should stick to painting. And his painting too— I don't think any other picture has ever hit me so hard as his *Annunciation,* in Florence. Everything in it—every detail—is of equal importance. He gave as much attention to the grass and the trees and the rocks as he did to

the Virgin. I couldn't get over that. More and more I've
found that what I don't like is the kind of Mickey Mousing
you see in painters like El Greco and Soutine and van
Gogh, and even in Giotto—you know, the mouth drawn
down to show sorrow and the tear trembling in the eye.
But then I really don't think much about past art, I guess.
Duchamp, of course. I find his life and work a constant
inspiration. I don't think Duchamp meant any of his
things to be just gestures, any more than I meant the
erased de Kooning to be a gesture. His *Bicycle Wheel*
has always struck me as one of the most beautiful pieces
of sculpture I've ever seen."

After a while he continued, "It has never bothered me
a bit when people say that what I'm doing is not art. I
don't think of myself as making art. I do what I do be-
cause I want to, because painting is the best way I've
found to get along with myself. And it's always the mo-
ment of doing it that counts. When a painting is finished
it's already something I've done, no longer something I'm
doing, and it's not so interesting any more. I think I can
keep on playing this game indefinitely. And it *is* a game—
everything I do seems to have some of that in it. The
point is, I just paint in order to learn something new
about painting, and everything I learn always resolves
itself into two or three pictures."

He broke off, smiling thoughtfully. After a moment or so
he got up and crossed the room and stood in front of the
painting with the signpost and contemplated it for some
time. There was something about it that bothered him. He
had put in three red-and-white stop signs near the bottom
of the canvas, and they were somehow refusing to work
with the other images. He picked up a rag, poured tur-
pentine over it, and started to scrub away at an area of

red near the center. A few drops of turpentine dribbled down the canvas, passing through one of the four bird-in-flight images. Rauschenberg shifted his attention to the bird, rubbing it with the rag until it was blurred and indistinct. He went over to a worktable and found a can of white paint and quickly painted in the area around another of the birds, making it stand out more sharply. Then he stepped back, still with a thoughtful smile on his face. "Look at that," he marveled, more or less to himself. "The birds have freed the stop signs." And he went on painting.

Merce Cunningham

The first rehearsal of *Scramble* took place at Merce Cunningham's Manhattan studio one spring afternoon in 1967, during the interval between two scheduled dance classes. Only three of his eight regular dancers were on hand that day, but Cunningham had decided to start work on the new dance anyway. "I learned long ago that if I waited until everyone was available to rehearse, I'd never finish anything," he said later. "So I just evolved this system of choreographing for whoever's there." Carolyn Brown, the principal female dancer in the Cunningham company, had been teaching the intermediate class in the studio—a large room, thirty by forty-five feet, on the fourth floor of a dingy loft building in the East Thirties, with a high ceiling, worn linoleum on the floor, and windows at one end overlooking Third Avenue—and two other Cunningham dancers, Sandra Neels and Yseult Riopelle, had been in the class, along with

a dozen other students; the three girls had stayed on afterward, exercising to keep their muscles limber, until Cunningham arrived, shortly after three o'clock.

Nodding cheerfully to the dancers, Cunningham took a position near a long mirror that runs the length of the studio's south wall and did a series of rapid, loose-jointed movements, turning and changing direction, breaking off abruptly, finishing the phrase with a hand gesture, and then going into another experimental sequence. As he approaches fifty, Cunningham still moves like no other dancer. He cannot jump as high or as far as he used to, but the years have not diminished his uncanny speed and elasticity or his fluid, restless animal grace. An inch over six feet tall, long in the torso but not particularly so in the legs, he has a physical presence that is oddly deceptive. Offstage, in ordinary clothes, he looks thin to the point of frailty; performing, or even moving about the studio in a drab green shirt and sweat pants, he is a powerful and supple athlete, a dominating figure. His face is endlessly expressive—gaunt, furrowed, large-featured, with arching brows and a high forehead framed by tight, archaic curls that are now touched with gray. The features convey a force that is not readily apparent offstage, where most people find him unfailingly courteous, informal, and yet somewhat withdrawn.

After ten minutes of self-absorbed experimentation, Cunningham signaled by softly clapping his hands that he was ready to start working on the new dance, which had not yet been named. He began with Carolyn Brown, his most accomplished dancer, a lean, dark-haired girl, who was wearing black woolen tights and a black sleeveless top. She watched him attentively, hovering a few steps behind him as he demonstrated in front of the mirror the rapid phrase that he had been sketching out by himself a few minutes

before. She moved with him, picking up some of the motion as she went along, and when he demonstrated it a second time, she was able to follow him almost step for step. Her arms were wrong, though, and Cunningham stopped to show her what he wanted—a flowing, wavelike motion back from each shoulder, slower in tempo than the leg movements. Cunningham watched her try it out several times, nodded approvingly, and turned to Sandra Neels. Sandra, a long-legged brunette, wearing a white leotard with a blue velours overblouse, was to come in from the wings, pause, then spring vertically into the air three times, her arms rising and falling in countermotion to the jumps, the third jump bringing her to a point just behind where Carolyn Brown would be at the end of her phrase. When Sandra had mastered this, Cunningham proceeded to give Yseult Riopelle, the company's nineteen-year-old apprentice, a relatively simple walking-and-turning step that would bring her on from the other side of the stage and position her slightly behind and to one side of Sandra.

The three girls responded very differently to Cunningham's instructions. Carolyn Brown, a perfectionist, a brilliant and mature dancer at the peak of her career, seemed to want to understand every aspect of the movement that had been given to her, to have all the details clear in her mind, before she put them together. She practiced the arm motion over and over while Cunningham worked with the two others, watching herself critically in the mirror until she had it just right. When she did the whole phrase, though, the quality that she gave to it was her own and not Cunningham's; it was precise, poised, and under strict control. Sandra Neels, who is about the same height as Carolyn Brown but looks taller because of the length of her legs, preferred to absorb the phrase in its entirety; she tended to

make her jumps a little more graceful and less emphatic
than Cunningham wanted, but she responded with alacrity
to his corrections. Yseult Riopelle moved more stiffly, count-
ing to herself and trying hard to remember the steps. There
was no music to support the dancers. The only sounds in the
room were the friction of bare feet on the linoleum floor,
hard breathing, and the muffled sounds of traffic on Third
Avenue.

After about twenty minutes, Cunningham went on to the
next phrase, which the three girls were to do in unison. It
was a sort of grotesque walk—a swinging of the legs out
sidewise from the hips while the torso shifted from side to
side and the head wagged in a stiff articulation, like a
marionette on strings. The movement had a quality often
found in Cunningham's work—a physical awkwardness that
is disturbing at first glance but later, in the context of the
dance, beautiful. It took the girls some time to get this, with
Cunningham demonstrating over and over—teaching with
his body rather than verbally. Very few words were ex-
changed throughout the session. In the time remaining that
afternoon, Cunningham gave them two more phrases. The
first was made up of very slow movements—extended turns
and deep knee bends made while each dancer poised,
heronlike, on one leg. They danced it together, in a circle,
but not in unison, and at intervals one dancer would break
into a swift measure and then return to the slow, turning
motion. The other phrase was a strict-unison movement that
involved large, space-devouring strides and ended with each
girl bringing her arms forward over her head as she glided
offstage. Since a phrase to be done in unison requires exact
timing, Cunningham gave them a strong, steady beat by
clapping his hands. Later, when they had learned the move-

ment, they would do without the beat—just as they would do without the support of music throughout the dance.

No aspect of Cunningham's choreography—which, during the last decade, has been the most influential (and controversial) development in the world of modern dance—dismays lovers of traditional choreography so much as his complete dissociation of dance and music. Cunningham is not the only choreographer to dispense with storytelling and mimed emotion—the underpinnings of classical ballet and of most modern dance as well—but until fairly recently he was the only one to treat music and dance as distinct and wholly independent activities that simply occur in a common time and place. Most people tend to assume that there is a natural link between dance and rhythmic accompaniment of some sort, and a great many dancers consider Cunningham's denial of that link both arbitrary and self-defeating. Music can support a dancer—help him to jump higher and to move with greater precision—so why dispense with this useful and ancient relationship? Actually, as the ethnomusicologist Curt Sachs pointed out in his *World History of the Dance*, there is evidence that primitive man may very well have started dancing in response to certain inner promptings long before he danced to audible rhythms, and the supposed unity of music and dance may not be "natural" at all. In any case, Cunningham firmly believes that the independence of the dance from the music offers to both a higher degree of expressive freedom. "The result is that the dance is free to act as it chooses, as is the music," he wrote in a 1953 magazine article. "The music doesn't have to work itself to death trying to underline the dance, or the dance create havoc in trying to be as flashy as the music."

In Cunningham's work, the dissociation dates from the beginning of his professional association with the composer John Cage, who has served for the last twenty-five years as musical director of the Cunningham dance company. Cunningham and Cage met in the 1930s at the Cornish School, an arts-centered institution in Seattle, where Cunningham was a student and Cage was on the faculty. They met again in New York in the 1940s, while Cunningham was dancing with the Martha Graham company. Cage had already evolved a method of composing music based on units of time, a method that afforded a complete break with the traditional theme-and-variation melodic structure of composition. Cunningham responded enthusiastically to this structural notion of Cage's, because it fitted in precisely with his own artistic leanings. "I never could stand the modern-dance idea of structure in terms of theme and variations," Cunningham said recently. "That sort of A-B-A business based on emotional or psychological meanings just seemed ridiculous to me." From the start of their association, Cage and Cunningham have simply agreed on a certain time structure—for example, eight parts of two minutes each—and then gone off independently to compose the music and the dance.

In the spring of 1944, Cunningham and Cage gave their first joint New York recital, at the Humphrey-Weidman studio theater. Cage played his own compositions on a "prepared" piano (nuts, bolts, bits of rubber, and other objects were inserted between the strings, thus converting the instrument into a sort of percussion orchestra) while Cunningham danced to rhythms that sometimes coincided with what Cage was playing and sometimes did not. "A lot of modern-dance people in the audience liked one of my dances on that program—the one called *Root of an Unfocus*—be-

cause it seemed to them to be tied to an emotional mean-
ing," Cunningham recalled not long ago. "They thought it
had to do with fear. It had nothing directly to do with
fear as far as I was concerned. The main thing about it—
and the thing everybody missed—was that its structure was
based on time, in the same sense that a radio show is. It was
divided into time units, and the dance and the music would
come together at the beginning and the end of each unit,
but in between they would be independent of each other.
This was the beginning of the idea that music and dance
could be dissociated, and from this point on the dissociation
in our work just got wider and wider."

In the years since 1944, Cunningham has commissioned
or composed dances to scores by many of the leading avant-
garde composers in this country and Europe, including
Pierre Boulez, Bo Nilsson, Morton Feldman, Christian
Wolff, Earle Brown (who is Carolyn's husband), and, of
course, Cage. As the new dance started to take shape in the
spring of 1967, he decided to approach Toshi Ichiyanagi, a
young Japanese composer who four years earlier had done
the score for Cunningham's *Story* and was then working in
New York under a grant from the JDR 3rd (or John D.
Rockefeller III) Fund. Ichiyanagi readily agreed to do a
new score for Cunningham. He even came to several re-
hearsals, to get an idea of what the dance was going to be
like—something he had not done in the case of *Story*. His
score was not completed until shortly before the première,
however, and the first time the dancers heard it was during
their initial performance of the dance onstage.

Having begun with Carolyn Brown, Sandra Neels, and
Yseult Riopelle, Cunningham continued to work with them
exclusively for the rest of that week, at the end of which he
went to California for a teaching engagement at Mills Col-

lege. Several of the other dancers in the company had begun
to wonder whether they would be in the piece at all.
"They're all wondering about the new dance," Cunning-
ham said wryly. "But then, so am I." He had no clear idea
of what the piece might become, except for a vague feeling
that it would be a fairly long work—thirty minutes or longer
—and quite complex. "I don't have ideas, exactly," he ex-
plained to a friend the afternoon before he left for Cali-
fornia. "There's no thinking involved in my choreography. I
work alone for a couple of hours every morning in the
studio. I just try things out. And my eye catches something
in the mirror, or the body catches something that looks in-
teresting, and then I work on that. Of course, I know that
when I give it to the dancers it's going to look different,
just because their bodies are not the same as mine. But
there's a point of balance—a point of tension—to any move-
ment, and, with luck, I can transfer that to someone else.
Sometimes it's not transferrable—either their bodies won't
do it or I can't translate it for them. But it's all in terms of
the body, you see. I don't work through images or ideas—I
work through the body. And I don't ever want a dancer to
start thinking that a movement *means* something. That was
what I really didn't like about working with Martha Gra-
ham—the idea that was always being given to you that a
particular movement meant something specific. I thought
that was nonsense. And, you know, I really think Martha
felt it was, too. Once, when we were rehearsing *Appa-
lachian Spring*, I had a passage that Martha said had to do
with fear, or maybe with ecstasy—she wasn't sure which—
and she said why didn't I go and work on it and see what
I came up with. I did, and she was delighted; she even said
it had solved some of her other problems. It's always seemed
to me that Martha's followers make her ideas much more

rigid and specific than they really are with her, and that Martha herself has a basic respect for the ambiguity in all dance movement. At least, that's my opinion. The ambiguity is always the interesting part for me, the getting to know each other in a new terrain—what we're doing now in this new piece."

The ambiguity in Cunningham's work has led some critics to call his dances abstract. This term is somewhat misleading, for—unlike the Alwin Nikolais dancers, who wear elaborate and enveloping costumes—Cunningham's dancers are never merely symbolic or decorative. "My feeling is very strongly that we are human beings engaged in certain situations," Cunningham has said. These situations may not be familar, or even recognizable, but the dancers, whose simple costumes never conceal the body and whose movements are all based on the body's natural expressivity, are never more or less than human. Cunningham is often asked just what it is, in a dance that tells no story and delineates no psychological or emotional state of mind, that is being expressed. His reply is that he does not set out to express anything specifically. There is no "statement," no underlying idea or meaning. At the same time, he does believe that each of his dances produces a unique atmosphere, and, like many twentieth-century artists, he invites the spectator to interpret that atmosphere in any way he wishes. Even a specific interpretation is all right with Cunningham. He wrote some years ago, "If the dancer dances—which is not the same as having theories about dancing or wishing to dance or trying to dance or remembering in his body someone else's dance—but if the dancer *dances*, everything is there. The meaning is there if that's what you want."

With a small company such as Cunningham's, in which everyone is to some degree a soloist, the look of each dance

changes markedly as the company itself changes. Several
dancers have left the group since the spring of 1967, and
others have joined it, bringing their own individual quality.
Cunningham welcomes and uses all such variations. He
wants each of his dancers to develop and project a uniquely
personal style, not a style that would be a mere reflection
of his own. His training, which depends upon a natural and
free use of the whole body, has the effect, he once said, of
letting "the individual quality of each of the dancers ap-
pear, naked, powerful, and unafraid."

After attending a few rehearsals, one begins to under-
stand what Cunningham means by this individual quality.
It has very little to do with "personality" in the commonly
accepted sense, and nothing at all to do with the stage
mannerisms of an actor or actress. Rather, it is tied up
with a particular way of moving, which, in turn, bears a
direct relation to the physical proportions of the dancer.
Barbara Lloyd, who seemed the most naturally gifted of
Cunningham's eight dancers that spring, has a small, deli-
cate body that is rather attenuated from the hips down; she
moves with a childlike spontaneity, a sort of casual brio.
Gus Solomons, Jr., a Negro, who is six feet four inches tall
and whose legs are very long in relation to his torso, has a
relaxed, springy buoyancy that is in striking contrast to the
controlled precision of Albert Reid, a much more com-
pactly built dancer. The personal quality of each dancer
may be emphasized by the length of the neck, the way the
head is carried, the relation of the arms to the torso. Valda
Setterfield, who apprenticed briefly with José Limón be-
fore joining Cunningham in 1965, has an aristocratic
hauteur that can change in a twinkling to its own comic
parody. Peter Saul, trained in both ballet and modern
dance, moves with an intensity that becomes even stronger

during the stillnesses between movements. Yseult Riopelle is still working out her individual style.

What the dancers have in common is a firm commitment to Cunningham's dance aesthetic; some of them have done or will do choreography of their own, but none would consider dancing regularly in any other company. Carolyn Brown, the daughter of a dance teacher who had performed with the Denishawn troupe, claims that she tried hard *not* to become a dancer. She had been accepted as a graduate student in philosophy at Columbia in 1953 when she started taking Cunningham's classes, and that was that. Gus Solomons had a somewhat similar experience: he was finishing up the requirements for his architectural degree at MIT when he saw the Cunningham dancers perform; he got his degree and then put it aside and joined the company in 1965, after brief stints with Martha Graham and Donald McKayle. In the case of Sandra Neels, the commitment was made before she ever saw the Cunningham company dance. On the strength of a Cunningham statement on dance that was published in a paperback anthology, which she happened to read one day in the bathtub, Sandra came East from Seattle in 1961 with the sole ambition of becoming a Cunningham dancer. She took all the Cunningham classes she could afford for two years, apprenticed with the company on a European tour, became a regular performer, and, sometime in 1965, made the breakthrough into her own personal style. "I saw it start to happen," Cunningham said recently, recalling the event. "I just caught something out of the corner of my eye, and said to myself, 'Well, now, that's beginning to be interesting.' Sometimes, you see, when a dancer works as hard as Sandra does, and has great concentration, she goes through everything and gets to this particular thing, this personal character that comes through the

dance—not in spite of it but through it. For a long time, Sandra didn't have that, and people didn't notice her much. All you saw were those long legs and the short torso. Now it's all come together, and what you notice is herself. That's what makes watching dancers so fascinating."

Just before Cunningham went out to Mills College, he gave Sandra a solo to do in the new dance. Characteristically he did not tell her that it was to be a solo, and she did not know until some time later that she would be alone onstage when she performed it. She practiced the movement constantly, in spare moments between classes and during rehearsals. It was a slow phrase, with frequent changes of tempo and many points of stillness. (In Cunningham's dances, stillness is not just a pause between movements; like the negative volumes in a Henry Moore sculpture, Cunningham's still points have a distinct expressive power of their own.) Cunningham told Sandra to make the changes in tempo very clear, but he offered no other suggestions, and she was not at all sure that she was doing what he wanted. Soon after his return from California, she did the movement in rehearsal and heard him say, more or less to himself, "Oh, yes, it's going to work." But she had no idea precisely what she was doing to draw forth this comment. The dancers all learn not to expect direct praise from Cunningham, or anything very specific in the way of verbal direction. Sandra feels that without Carolyn Brown's help she could never have learned the repertory. "In spite of his being such a marvelous teacher, Merce is never completely precise about things," she explained once. "When he does something, you can see the whole shape of it beautifully, but often you're not quite sure about the direction—about whether you're supposed to face front or diagonally, or whether the back is supposed to be straight or curved." For

his part, Cunningham maintains that he is too impatient to be able to enjoy teaching. He has said that the only sort of teaching he would find congenial is the teaching of the Japanese Zen masters, "who just go on doing what they do."

The individual quality of Cunningham's own dancing defies brief analysis. Any movement, he has said, can become part of a dance, and there are times during a performance when a movement of his looks so unstylized and natural or, conversely, so eccentric that he does not appear to be dancing at all. He frequently starts a phrase with no sense of preparation, no visible "attack"; he simply moves, as an animal moves, effortlessly and without tension, lending an impromptu, experimental character to the most complicated passages. In almost everything he does, there is a delicate balance between feral grace and awkwardness—the pleasing awkwardness of something done expertly but for the first time. "I think dance only comes alive when it gets awkward again," Cunningham once said. "I remember the only time I saw Ulanova. She was dancing *Giselle*, that old chestnut, and yet she managed to make it seem awkward and fresh again. That's what I admire." The critic Peter Yates has described as essential to the quality of Cunningham's dancing "the sensation of release, the prevailing relaxation, however elaborate or difficult the movement." Certainly the release is there, taking the forms, in astonishing variety, of wit, intelligence, strength, guile, tenderness, menace, and playful, openhearted curiosity. "I think basically it comes down to an appetite for motion," Cunningham said recently of his own dancing. "Once, years ago, a student came to me and said she understood why I wanted to invent all these new kinds of movement but she didn't understand why I wanted to do them fast. My answer was 'Appetite.' It's as though you were going to get up and walk over to that door

over there." He pointed to the door of the studio, through which students were just then entering for an advanced class. "You do it the normal way. Then you wonder how it would be if there were an obstacle in the way that you had to go around and still arrive in the same amount of time. And you do it with a lot more steps, and with fewer steps, and then you add some turning and jumping—all these other possibilities. You just have to be interested in motion for its own sake."

Merce Cunningham was born and brought up in Centralia, Washington, a small town fifty miles south of Tacoma. His father practiced law in Centralia, and his two brothers live there today—one practices law, and the other is a judge. Cunningham might conceivably have followed the same course if he had not started, at the age of twelve and by his own request, to attend private dance classes offered by Mrs. J. W. Barrett, a former vaudeville performer and circus bareback rider who imparted a rare theatrical zest to the Centralia social scene. Mrs. Barrett soon recognized that her new pupil was a naturally gifted dancer, with an extraordinary sense of rhythm. She accordingly arranged a dance program at the local Grange hall for Cunningham and her daughter Marjorie, who was about the same age, and the event was so successful that when summer came around she took them both on what she called a "vaudeville tour" to California and back. Cunningham still treasures the memory of one night during that tour, when the makeup bag got lost. He and Marjorie huddled in a broom closet, which served as the dressing room for the night club they were to perform in, while Mrs. Barrett searched for the missing bag. Suddenly Mrs. Barrett flung open the closet door, took one look at their forlorn expressions, and burst

out laughing. "There's no makeup," she said, "so bite your
lips and pinch your cheeks, and you're on!" Her spirit is
something that Cunningham likes to recall during difficult
moments on tour with his company.

Cunningham planned to become an actor when, after
graduation from high school in Centralia, he went away to
the Cornish School in Seattle in 1937. But he soon found
himself getting more and more deeply involved in the dance
department at Cornish. The head of the department was
Bonnie Bird, a modern dancer who had worked with Mar-
tha Graham. At the end of his second year at Cornish, Miss
Bird and John Cage, who played the piano for dance
classes in addition to his other duties on the Cornish faculty,
encouraged Cunningham to enroll in a summer program at
Mills College in Oakland, where the Bennington School of
the Dance and a number of prominent figures in American
modern dance—including Martha Graham, Doris Hum-
phrey, Charles Weidman, and Hanya Holm—were to be in
residence. Miss Graham saw Cunningham dance in a stu-
dent program, and immediately afterward she suggested
that he come to New York and work with her. Cunningham
managed, not without difficulty, to persuade his parents,
and two weeks later, in September 1939, he arrived in New
York and presented himself at the Graham studio. "Oh,"
said Miss Graham. "I didn't think you'd come." But she at
once gave him an important solo part in the new dance
she was then working on, called *Every Soul Is a Circus*,
Cunningham was thus a soloist from the start of his
professional career.

Martha Graham's immense and revolutionary contribu-
tion to the expressive language of dance was based, to a
certain extent, upon a new relationship between the
dancer's body and the floor. To the gravity-defying illusion

conveyed by the ballet dancer *en pointe* Miss Graham opposed the sculptural dignity of a body drawing its strength and its expressive power from its contact with the solid ground. Her dancing, accordingly, possessed a monolithic quality, a heaviness of movement and gesture. It struck some people as odd that she should become enthusiastic about a dancer like Cunningham, whose natural gifts— bounce and lightness, and astonishing speed—seemed almost the exact opposite of her needs. Cunningham's own explanation is that Miss Graham's choreography was just then in the process of changing. "I think she had begun to be interested in the possibility of lightness," he said recently. "And, of course, she would always use the things that a dancer could do." In any event, Cunningham drew high praise from the critics for his athletic performance as the Acrobat in *Every Soul Is a Circus*, and for the next five years he was, with Erick Hawkins, one of the featured male soloists with the Graham troupe.

By the end of his first season with Miss Graham, Cunningham had started to wonder what else there was to do in the field of dance. He had been to see a great many dance recitals and performances in New York that winter, and had found himself increasingly drawn to the ballet. "What appealed to me was the technical demands of ballet," he said. "Martha made great demands, of course, but not so much technically. Ballet's demands interested me: dexterity in the legs, speed, and, of course, air—jumping up and down." In spite of the deep and rather bitter schism dividing ballet and modern dance at that time—there was practically no communication between devotees of the two—Cunningham managed, with Miss Graham's help and encouragement, to enroll in the School of American Ballet, which had been founded in 1933 by Lincoln Kirstein and Edward M. M.

Warburg, and of which George Balanchine was the director. Cunningham studied there for two years, on and off, while continuing to perform with the Graham troupe, and the training, he feels, was invaluable. It was certainly as important an influence as Miss Graham's in the development of his own style.

Cunningham also had a brief flirtation with the Broadway stage at about this time. Agnes de Mille, Valerie Bettis, and a few other modern dancers were just starting then to break into the musical-comedy field, displacing the one-two-three-kick chorines of yore, and in 1943 Miss de Mille offered Cunningham a dancing role in *Oklahoma!*, for which she was doing the choreography. Cunningham turned it down. Six months later, though, he did accept a solo dancing part in another show that Miss de Mille choreographed, *One Touch of Venus*. He rehearsed and performed with the show for a week in Boston, and felt so ridiculous that he withdrew before the opening in New York, offering the somewhat lame excuse that Martha Graham needed him to rehearse for a tour that was about to begin. The Broadway musical stage has given employment to many modern dancers since then— it is still the only place they can earn what non-dancers would consider a decent living—but Cunningham was never tempted by Broadway again.

By this time, Cunningham had started to withdraw from the powerful influence of Martha Graham. Although he continued until 1945 to dance in certain works of hers and to tour with the company, he stopped taking her classes and spent most of his time working by himself, in a small loft studio on Seventeenth Street near Union Square. He lived on the money he made touring with Miss Graham, augmented by an occasional check from his parents, but in time he also started to teach a little. "I was just trying out

everything I could think of," he has said of this period.
"Probably the idea of having my own company was in my
head, but I didn't really think in those terms. I'd always
wanted to make dances, and I was just experimenting with
different types of movement." The joint Cunningham-
Cage recital at the Humphrey-Weidman studio in April
1944 gave New Yorkers an opportunity to see the results
of his experiments. Edwin Denby, in his review of the re-
cital for the *Herald Tribune*, wrote of Cunningham, "His
build resembles that of the juvenile 'saltimbanques' of the
early Picasso canvases. As a dancer, his instep and his knees
are extraordinarily elastic and quick; his steps, runs, knee
bends, and leaps are brilliant in lightness and speed. His
torso can turn on its vertical axis with great sensitivity, his
shoulders are held lightly free, and his head poises intelli-
gently. The arms are light and long, they float but do not
have an active look. These are all merits particularly suited
to lyric expression. The effect of them is one of excessively
elegant and irreproachable sensuality." Of the program it-
self, Denby wrote, "I have never seen a first recital that
combined such impeccable taste, intellectually and decora-
tively, such originality of dance material, and so sure a
manner of presentation."

There has never been any question about Cunningham's
natural gifts. Ever since 1944, though, there has been no end
of dispute over the uses to which he has put these gifts, and
the directions in which his explorations have led him. Some
of Cunningham's dances—*Nocturnes*, for example, and the
much acclaimed *Summerspace*—have been as lyrical, as
elegant, and as irreproachably sensual as Denby or anyone
else could have wished. Other dances have put lyricism very
distinctly aside, however, in favor of grotesque distortions
and eccentricities whose effect seems primarily comic,

though in a few works, such as *Winterbranch* and the more recent *Place*, the whole purpose seems to be to create an atmosphere of grim devastation. Certainly the most amazing aspect of his work over the years has been its variety— its kaleidoscopic changes of tone and mood, not only from one dance to another but often within a single dance. As the London *Observer* noted in 1964, after the Cunningham troupe had had an extraordinary triumph in London, his dances "are so full of invention that they will be a mine for imitators for years."

Following the 1944 recital, Cunningham and Cage gave annual New York presentations of their new works. Their recitals, at the YMHA, the Hunter College Playhouse, and elsewhere, were attended mostly by painters and poets— rarely, in the early years, by musicians and dancers—and it took most of the next year for Cage and Cunningham to pay off the modest debts they had incurred for each recital, so they began casting about for performance opportunities outside New York. They found them by writing to colleges and universities, and from 1947 until fairly recently they rarely performed anywhere else. Their travels were sometimes complicated by Cunningham's rather sketchy sense of geography—he once booked them to perform in Phoenix and Seattle on the same day, thinking somehow that the difference in time zones would make the connection possible—but they covered a lot of territory and perplexed a sizable number of students. Confronted for the first time by prepared-piano music that incorporated many non-musical sounds and long silences, and by dancing that was neither interpretive nor programmatic, the audiences in the small colleges that Cunningham and Cage visited were usually dumfounded. "People didn't yell or scream," Cunningham has said, "but there was a lot of nervous laugh-

ter, and, of course, a great many people walked out. If they happened to know anything about the modern dance—Graham and José Limón and people like that—they didn't like us at all."

The majority of established modern dancers did not look with much favor upon what Cunningham was doing, either, and it is worthy of note that his first major commission came from the rival world of ballet. Early in 1947, the newly formed Ballet Society in New York, which had grown out of Balanchine's School of American Ballet and was soon to become the New York City Ballet, commissioned Cunningham and Cage to create a work for its company of brilliant young dancers. Cage composed a score for an orchestra of forty conventional instruments. Cunningham worked independently with the dancers, among whom was the future star Tanaquil Le Clercq. Most of the dancers, Cunningham discovered, were much disturbed at first when they found themselves rehearsing without music, but then they caught on and did it beautifully. Isamu Noguchi designed the sets for the new work, which was called *The Seasons*, and which had its première at the Ziegfeld Theatre in May 1947. Cunningham returned to the School of American Ballet in 1948 for two years, this time as a teacher, and in the summer of 1949 he put together a recital in Paris with Tanaquil Le Clercq and Betty Nichols, another young dancer from Ballet Society, whom he had happened to meet outside the American Express office. The recital took place in the atelier of the painter Jean Hélion, before a rather distinguished audience of artists and literati. Alice B. Toklas sat in the front row, and afterward she told Cunningham that she liked his dancing, "because it's so pagan. " Cunningham has always enjoyed working with ballet-trained dancers, and as recently as the fall of 1967 he accepted an

invitation to re-create his *Summerspace* for the Cullberg
Ballet Company in Stockholm. By 1949, though, he had be-
gun to think more and more seriously of forming his own
company.

"Forming a company," Cunningham said once, "means
simply that you decide you want to do a piece with some
other people instead of alone, and so you start to look
around." He had already made a few pieces in which his
students at the Seventeenth Street studio danced, but in
those days his students were mostly dancers who had re-
ceived their fundamental training elsewhere, and their
physical and intellectual attributes did not always satisfy
Cunningham's requirements. Following his return from
Europe in 1949, he began to get a number of pupils with
little or no previous training. The most talented of these stu-
dents—Marianne Preger, Remy Charlip, Jo Anne Melsher,
Carolyn Brown, Viola Farber, Paul Taylor, and, later on,
Judith Dunn, Marilyn Wood, and Steve Paxton—became
the nucleus of an informal company. Performance opportu-
nities were rare. Leonard Bernstein invited them to dance at
the Brandeis University Festival of the Performing Arts in
1952, and in 1953 they appeared at the Alvin Theatre in
New York, in a program with the Martha Graham and José
Limón companies. The Cunningham group did not really
begin to function as a unit, however, until the summer of
1953, when it was invited to Black Mountain College in
North Carolina. Cunningham and Cage had been going to
this militantly experimental institution since 1947, to per-
form and to teach; the faculty and the students were hos-
pitable to their work, and the previous summer they had
put on Cage's *Theatre Piece #1*, a mixture of dancing,
music, poetry, motion pictures, slide projections, and other
activities, planned and unplanned, that is now generally

considered to have been the real beginning of the trend in
this country toward Happenings and multi-media shows of
all kinds. In 1953 the Cunningham dancers were in resi-
dence at Black Mountain for six weeks. They worked to-
gether every day and acquired a repertory of new Cun-
ningham dances that included *Collage* and *Suite by Chance*
—the latter having an electronic score, the first of its kind
written for a dance, by the young American composer Chris-
tian Wolff.

Like Cage in his music, Cunningham at this time was ex-
perimenting with various chance methods of composition, in
an effort to go beyond his personal taste and his own physi-
cal memory of dance motions. He drew up elaborate charts
for different aspects of the dance—tempo, direction of
movement, kind of movement (leaping, running, turning,
and so on), single or group movement—and then tossed
coins to determine the order in which these would go to-
gether. For one dance, *Untitled Solo*, Cunningham drew up
charts for specific movements of his head, back, shoulders,
arms, hands, legs, and feet; to his great surprise, the dance
turned out to be intensely dramatic. Unlike Cage, whose
interest in chance was in part a reflection of an interest in
Oriental religions and in recent developments in mathe-
matics and science, Cunningham considered chance simply
a tool for practical use—one method among others. "If you
use chance, all sorts of things happen that wouldn't other-
wise," he said once. "I found my dances becoming richer
and more interesting, so I continued using chance methods.
That's the only reason." Cunningham is a far more tradi-
tional artist than Cage in some ways; he will use chance
when he thinks it may be useful, but he also depends on his
own powers of conscious invention, his personal taste, and
at times his memory, and he refuses to be bound by any

system, even one of his own devising. At Black Mountain in that summer of 1953, for example, he abrogated the dissociation of music and dance long enough to choreograph a work, which he called *Septet*, for a particular piece of music—the *Three Pieces in the Form of a Pear*, by Erik Satie. It was because Cunningham liked the music so much that he decided to make a dance to go with it—though there was not the strict, beat-for-beat relationship that ballet-lovers would recognize. He did the same thing three years later with Satie's *Nocturnes*.

The Cunningham dancers had their first major New York engagement in December 1953—a one-week stand at the off-Broadway Theatre de Lys. They performed all the new works they had rehearsed that summer, played to a full house each night, and were totally ignored by the press. "But we had started to be a company, and that was something," Cunningham has recalled. "My idea was just to go on making pieces, and I felt it was silly to make a piece and then wait for an opportunity to do it, so I continued writing letters all the time to colleges and universities. We got a few dates. I remember once, at Notre Dame, there was a prom the same night and the only people in the audience were priests and nuns. But that's the way it happened—the company just sort of evolved."

The Cunningham company continued to evolve for the next decade, in spite of the desperate economics of the modern dance. In 1965 the Rockefeller Panel Report on the Performing Arts estimated that the total public for dance of all kinds in this country was less than one million regular attendants, and pointed out that, for economic reasons, even Martha Graham "has not toured in her own country for fifteen years." Although the Cunningham company traveled light—for several years they managed to get everything, in-

cluding costumes and sets, into Cage's Volkswagen Microbus—the expense of transporting and feeding even a small company of dancers usually exceeded the modest fees that colleges could offer them, and, as a result, Cunningham could rarely pay his dancers anything at all beyond their expenses. The dancers supported themselves between engagements, usually by teaching, and considered themselves well rewarded simply to be associated with Cunningham. Naturally, some dropped out. Paul Taylor, a brilliantly gifted dancer, left in 1954 to form his own company, and several of the girls stopped dancing to get married or to have babies. By and large, though, that first "classic" Cunningham troupe functioned, far more than most repertory companies, as a tightly knit family. Its members all got along, in spite of the cramped quarters and the other recurrent miseries of the touring life. They saw a great deal of each other in New York between engagements, they shared the same ideas and interests, and they approached their work in the same state of intense stimulation, as a result of Cunningham's creative vision. Judith Dunn, who left Cunningham's company in 1963 to create dances of her own, has recalled that once, when the dancers trooped into a roadside diner after traveling all day, a waitress asked if they were members of some religious group. This spirit carried over into their dancing and helped to create the strong impression of unity and physical interrelatedness that in Cunningham's dances takes the place of the precise correlation of music and dance in the formal ballet.

Like the other members of the company, Cunningham supported himself mainly by teaching. Although he rarely performed in New York, young dancers heard about him and came to study with him, drawn by the belief that he was breaking new ground in the dance. The followers of

Martha Graham, generally speaking, were continuing to work the psychological-symbolic vein that she had first mined thirty years earlier. Cunningham's work had less in common with the modern-dance choreography of Graham and José Limón than it had with the dazzling neoclassicism of George Balanchine, who had made the New York City Ballet into the most advanced and most exciting ballet company in the world. Both Cunningham and Balanchine have always been interested in movement for its own sake, and Balanchine's ballets are often as plotless as Cunningham's pieces. The movement, however, is fundamentally different. Out of the so-called contraction-and-release technique of Martha Graham, Cunningham developed an articulation of the back and torso that is large and free—something not found in the ballet, where the torso is held relatively rigid at all times. Nor is it found in the Graham choreography, with its tense and dramatically contorted bodies. Cunningham's students are taught that the body operates from a central point of balance in the lower region of the spine; once this center of balance is fully recognized, he has written, the spine "acts not just as a source for the arms and legs, but in itself can coil and explode like a spring, can grow taut or loose, can turn on its own axis or project into space directions." Cunningham took "dexterity in the legs" from ballet technique and transformed it into a means of spatial expression. Instead of moving primarily up and down and in long leaps, as ballet dancers do, the Cunningham dancers tend to make large lateral movements; they cover a great deal of stage space, and make frequent use of everyday, non-stylized motions, such as walking and running. The difference between the Balanchine and the Cunningham companies became very clear in 1966, when, at Balanchine's invitation, Cunningham restaged his *Summer-*

space for the New York City Ballet. Marvelously trained as
Balanchine's dancers were, they found it extraordinarily
difficult to move in the large, sweeping manner that is
natural to the Cunningham company, and they could not
do everyday things like running without making them seem
slightly artificial. The New York City Ballet's performance
of *Summerspace* struck most of the critics as interesting but
not quite successful (when Viola Farber, then one of Cun-
ningham's dancers, saw it she burst into tears), and Balan-
chine has not kept the work in the company's active reper-
tory.

Many of the young dancers who sought out Cunningham
were interested in doing choreography themselves. A class
in experimental music and dance composition at the Cun-
ningham studio in 1960, conducted by Robert Dunn, with
Cunningham's cooperation, and made up almost entirely of
Cunningham students, led directly to the formation of a new
dance avant-garde that became associated with the Judson
Memorial Church on Washington Square. Taking as their
starting point Cunningham's idea that any movement can
be part of a dance, Yvonne Rainer, Judith Dunn, Steve Pax-
ton, and other members of the Judson group arrived at a
sort of non-dance aesthetic that could dispense with such
rudimentary requirements as dance training and physical
technique. Cunningham himself has never been willing to
dispense with technique, and as a result he is looked upon
by some of his former disciples with a respect that is slightly
tinged with condescension. He has remained firmly com-
mitted to dance as dance, although he acknowledges that
the concept is difficult to define. "I think it has to do with
amplification, with enlargement," he said recently. "Danc-
ing provides something—an amplification of energy—that
is not provided any other way, and that's what interests

me." It might be added that in Cunningham's case an innate and nearly infallible sense of theatre underlies all his experiments, and makes the final result interesting whether or not one is aware of the aesthetic that produced it.

Cunningham's ideas have always had much in common with those of his contemporaries in the visual arts, and for this reason some of his most loyal admirers and supporters have been painters and sculptors. His dances have been compared to the canvases of Jackson Pollock, in which there is no fixed center but, rather, an all-over relatedness of shifting movement. His feeling that any movement can be part of a dance has its echo in the assemblages and combines of Robert Rauschenberg, among others. Both Rauschenberg and Jasper Johns, the two most influential artists of the post-Pollock generation, have been associated directly with the Cunningham company—Rauschenberg for several years was its costume and stage designer, and Johns in 1967 became its artistic adviser. Rauschenberg was at Black Mountain during the summer of 1952, and he took part in *Theatre Piece #1*, projecting slides of his paintings onto a screen and playing a wind-up Victrola. For ten years, starting in 1954, he designed the costumes and sets for virtually all the new Cunningham dances, and from 1961 to 1964, having taught himself the rudiments of theatrical lighting, he traveled with the group as its lighting designer and stage manager. Rauschenberg's fertile imagination contributed to some of the most striking works in the repertory: *Summerspace*, for which he and Johns painted a huge pointillist backdrop that the dancers, who wear costumes of the same pointillist pattern, seem to disappear into whenever they stop moving; *Antic Meet*, a marvelously loony piece that at one point has Carolyn Brown, in a nightgown Rauschenberg found in a thrift shop, step through an onstage door

and sit down in a chair strapped to Cunningham's back; *Story*, the indeterminate work for which Rauschenberg devised costumes and props out of whatever he found backstage on the day of the performance; and *Winterbranch*, a dark and powerful work that has been variously interpreted as being "about" nuclear war, concentration camps, Vietnam, and a shipwreck (as a sea captain's wife once suggested).

The collaboration of Cage, Cunningham, and Rauschenberg was an immensely stimulating experience for all three, and it also attracted the attention of people who might not normally have interested themselves in modern dance. In the late 1950s, Cunningham began to receive more and more invitations to perform abroad, in Europe and even in the Far East—invitations that had to be turned down in most cases, because he lacked the money to get there. Cunningham did perform in Europe in 1958 and 1960, together with Cage, David Tudor, and Carolyn Brown, who had by this time become his principal dancer; in order for him to take the entire company along, someone would have had to put up the money for air transportation. The State Department, which regularly sends performing groups on foreign tours, considered Cunningham's work "controversial" and consistently withheld its support.

Early in 1964, the company received a number of invitations to perform at European summer music festivals, and at the same time the wealthy family of Gita Sarabhai, an Indian musician who had studied with Cage, renewed an offer it had made once before to arrange a series of performances in India. The State Department refused to pay any travel costs, as usual, but this time Cunningham's admirers among New York artists came to the rescue. In 1962 a number of artists had contributed paintings to a benefit

sale at the Allan Stone Gallery, which had been organized
by the Foundation for Contemporary Performance Arts in
order to make it possible for the Cunningham company to
have a one-week "season" in a Broadway theater. The
Broadway season had not come about, for various reasons,
so now the entire proceeds of the sale—slightly more than
seventeen thousand dollars—were made available to Cun-
ningham for travel expenses around the world. A grant of
twenty thousand dollars for payroll expenses while in the
Far East was subsequently obtained from the JDR 3rd
Fund, and this, together with some additional grants from
private sources, plus the sales of a sculpture by Richard
Lippold and a painting by Rauschenberg, seemed to pro-
vide nearly sufficient funds for the undertaking. In June
1964, therefore, the Cunningham dance company, with its
various assisting artists and attendants (eighteen people in
all, including ten dancers and Barbara Lloyd's two-year-
old son), embarked on a world tour.

The tour lasted six months. The company gave seventy
performances, starting in Strasbourg and Paris, where its
reception was mixed, moving on to Venice, Vienna, and
London, where it caused such a sensation that a one-week
engagement at Sadler's Wells was extended by three more
sold-out weeks at the Phoenix, and then going on to Scandi-
navia, Czechoslovakia, and Poland, and eventually to India,
Thailand, and Japan. There were some casualties en route.
Shareen Blair, a very pretty blond dancer, married an ad-
mirer in London and left the company forthwith. Viola Far-
ber, who shared feature billing with Carolyn Brown, strained
the Achilles' tendon in her left heel during a performance
in Paris but continued to dance throughout the tour, despite
medical warnings, and aggravated the injury to such a de-
gree that she was obliged to withdraw from professional

dancing soon after the company returned to the United
States. (The loss was keenly felt. "She was unlike any other
dancer I've ever seen," Cunningham said not long ago. "She
always looked as though she were off balance, but she was
always *on*. We used to do a duet called *Paired*, in which
we'd come out at one point with our hands smeared with
paint from cans we kept in the wings and daub it on each
other; a certain color gave the cue for a certain kind of
movement, and the movements were extremely hazardous.
I don't think I could have done it with anyone but Viola.
And that body! At Connecticut College once, a friend of
mine in the audience heard a lady say, 'If that blond girl
were my daughter, I'd snatch her right off the stage!' ")
Also, to everyone's sorrow, friction arose between Cunning-
ham and Rauschenberg during the tour and led to Rausch-
enberg's severing his ties with the company that fall.
Rauschenberg had won the grand international prize for
painting at the Venice Biennale in June, and this made him
the most publicized painter in Europe; the friction, friends
of both men believe, was a matter of artistic temperaments
and was almost certainly unavoidable.

Although the company came home heavily in debt, the
world tour proved to be a watershed in its development.
The London success was a large factor. Dance critics, theater
and film directors, painters, musicians, and young aesthetes
of all kinds had flocked to see the Cunningham dancers in
London and had been enchanted by their ability to com-
bine freedom of movement with classical precision. Being
taken seriously in London, it seemed, was the key to being
taken seriously in New York. The company was scheduled
to dance twice at the Hunter College Playhouse that fall,
and the demand for tickets was so great that a third per-
formance was added. Appearances followed at the New York

State Theatre, at the Brooklyn Academy of Music, and, in 1965, at Philharmonic Hall, where the Cunningham-Cage *Variations V* had its première. This is a multi-media work in which radio antennas mounted about the stage respond to the motion of the dancers' bodies, thus creating an electronic score anew each time, while in the background a huge screen shows fragmented images from television and movie films by Stan VanDerBeek; the piece ends with Cunningham riding a bicycle onstage.

Invitations also came in from other parts of the country. In the fall of 1965 the company gave a week of performances at the Harper Theatre Dance Festival in Chicago, during which they presented the latest Cunningham-Cage work, called *How to Pass, Kick, Fall, and Run*. This immediately became the company's most popular offering—an irresistible combination of joyous athletics by the dancers, who wear bright sweaters and white ankle socks, and a "score" made up of droll stories read, one a minute, by Cage, who sits at a table at one side of the stage and sips champagne while reading. For this and other numbers, the company could now count on a lively reception everywhere it went, and Cunningham's reputation grew rapidly. He had been discovered by a new and predominantly youthful audience, which had perhaps not been previously interested in dance and responded to Cunningham's dances as a new form of theater. But when the Cunningham company was invited to represent America at the highly esteemed Paris International Dance Festival in November 1966, the State Department once again refused to put up any funds, arguing that, as one government official blandly put it, "there was not much interest in Cunningham's kind of thing in Europe." The Cunningham dancers made the trip anyway, thanks largely to the generosity of the Spanish painter Joan Miró,

who had seen them dance two years before, and who donated a painting to be sold for the purpose of paying their travel costs. In Paris, where they were in competition with state-subsidized dance companies from Cuba, the Soviet Union, and other countries, Cunningham took the major prize—the golden star for choreography. The award was received in Cunningham's absence (he had already flown home) by a United States Embassy official, who then refused to turn it over to Cunningham's business administrator, explaining that he preferred to send it to Washington; the award reached Cunningham in New York two weeks later, by mail, in a package on which there was forty cents' postage due.

For a modern-dance company, international success can be ruinous. Cunningham's debts, covering the accumulated losses of two foreign tours, the costs of moving to his new studio, on Third Avenue, and a sizable sum in back taxes due the government, amounted to something in excess of seventeen thousand dollars by the time he started to work on *Scramble*. He did not seem to be seriously troubled by this burden, which is a fairly typical one for a small dance company in America. "I try not to think about money any more," he confided to a friend at the time. "If I think about it at all, I get too nervous." Some practical thinking about the problem *was* being done, however—by Judith Blinken, the booking agent for the company, and by the directors of the Cunningham Dance Foundation, a tax-exempt organization formed in 1964 to cope with the economic consequences of Cunningham's expanded activities in various fields. Mrs. Blinken, an attractive and resourceful young woman who also serves as Cunningham's business representative, and Wilder Green, a curator of the Museum of Modern Art, had

organized a benefit for the Cunningham company to be held on June 3, 1967, at the estate of the architect Philip Johnson, in Connecticut. They hoped to raise enough money this way to pay off at least a portion of the debt. In addition to working on the new dance, therefore, Cunningham was preparing a one-hour dance program for the company to present at the benefit. They would be dancing outdoors, and Cunningham planned to use sections from several of his dances, including the new one.

When Cunningham got back from his week of teaching at Mills College, he scheduled daily rehearsals for the entire company. With the exception of Peter Saul, who had injured his back during a performance earlier in the season, everybody would be dancing in the new piece. Saul came to the studio now and then to watch the rehearsals, which were sandwiched between two afternoon classes. Valda Setterfield and Barbara Lloyd frequently brought their small sons, who played together, sometimes quite noisily, during rehearsals. Gus Solomons, Albert Reid, and Barbara Lloyd all had outside teaching commitments that obliged them to miss some rehearsals, and on those occasions Cunningham tried to work on parts of the dance in which they did not appear. By this time he had pretty well decided to call the new dance *Scramble*—a word that suggested to him the kind of coming together and breaking apart in interweaving movements that he was working out for it. Cunningham likes ambiguity in his titles, and in this case, he has said, he also had in mind the "scrambling" of codes and messages, the Air Force slang expression for getting planes off the ground in a hurry, and, prosaically enough, the method of cooking eggs.

Scramble took shape slowly at first, and by June 3, the day of the benefit at Philip Johnson's, the dancers had

learned only about six minutes of the new material. They
danced this much of it at the very end of the one-hour pro-
gram, which also included portions of *Field Dances, Varia-
tions V, Rune, Suite for Five, Nocturnes,* and *How to Pass,
Kick, Fall, and Run.* They performed on a specially con-
structed outdoor stage, before a large and fashionable audi-
ence seated in a meadow, to the accompaniment of a largely
electronic score created spontaneously by John Cage, David
Tudor, Gordon Mumma, and Toshi Ichiyanagi. It had been
Cage's idea to make of the occasion a sort of aural "picnic,"
with each musician bringing whatever sounds and sound-
producing equipment he favored, and the rural welkin was
rent by the amplified sounds of creaking automobile doors,
engines, windshield wipers, and radios; a giant amplified
tam-tam; a small Audubon birdcall (also amplified); a
French horn; and a good deal of miscellaneous electronic
feedback. Usually, the Cunningham dancers say, they are so
absorbed in the movement that they do not really hear the
music being played, but this time the sheer volume com-
manded attention. Carolyn Brown complained later that the
noise had affected her inner ear and, consequently, her
balance, so that for a moment during the performance she
came close to fainting. The company danced superbly nev-
ertheless, and the six minutes of *Scramble* at the end im-
pressed the audience as particularly brilliant. Dusk was
falling over the meadow by this time, and Miss Beverly Em-
mons, the company's lighting designer and stage manager,
had turned on some improvised stage lights—two spots
mounted on a pole, plus the headlights of a Ford ranch
wagon. During Carolyn Brown's first solo, a lovely sequence
in which her undulating arm movements suggest a swimmer
under water, one of several big helium balloons that had
been tethered behind the stage was cut loose from its moor-

ings; it rose swiftly above the trees and into a violet sky, where it cut across the white vapor trail of a passing jet—an effect that seemed perfectly in keeping with the atmosphere of the dance.

The Johnson benefit was a phenomenal success. Nearly four hundred invited guests—far more than had been expected—paid seventy-five dollars apiece to attend, and they stayed on after the performance for an elegant picnic supper, provided by Mr. and Mrs. John de Menil, who were co-sponsors of the event with Philip Johnson. The party ended somewhat abruptly at eleven-thirty, when a local policeman, acting on complaints from neighbors, silenced the Velvet Underground rock group just as it and the more enthusiastic amateur dancers among the guests were getting into action on the outdoor stage. No one seemed to feel particularly ill used, however, and Judith Blinken had excellent news to report at the next board meeting of the Cunningham Dance Foundation. The benefit receipts, after all expenses were subtracted, came to nearly twenty-four thousand dollars—enough to wipe out the debt and leave a surplus for future activities.

After a day off to recover from the benefit, Cunningham and his dancers began to work intensively on *Scramble*. The summer schedule went into effect at the studio on the same day, June 5, which meant a considerable increase in the number of students attending classes. There were three classes every day, starting at ten-forty-five in the morning, and more than a hundred students. Cunningham taught five classes a week—three advanced, and two repertory classes for students who wanted to go further and master a specific Cunningham work (in this case *Rune*). Carolyn Brown and Sandra Neels taught the intermediate and elementary classes, and Albert Reid taught a new class in fundamentals

for beginners (the dancers called this the zoo class). Lewis
Lloyd, Barbara's former husband, who had been working
part time as an all-purpose business-and-office manager, was
hired on a full-time basis by the Cunningham Dance Foun-
dation early in June, and this freed Cunningham from a
number of managerial chores and enabled him to devote
most of his time and attention to the new dance.

As *Scramble* progressed, it made increasing demands on
the dancers. It was clearly going to be "a real *dance* dance,"
as Gus Solomons put it—full of active, strenuous movement.
Carolyn Brown, Sandra Neels, and Yseult Riopelle had been
given a very fast and intricate passage in which they wove
in and out of an interlocking, constantly shifting circle; the
passage required perfect timing, and for several days they
collided with each other every now and then, and dissolved
in laughter each time it happened. There was also a se-
quence in which all the dancers ran the length of the room
four times, leaping and pirouetting as they ran, and trotted
back each time to start off in a different order. The con-
tinuity of the dance had not yet been established. Cunning-
ham often uses chance operations—coin tossing—to deter-
mine such factors as the sequence of movements in a dance.
So far, though, it appeared that deliberate choice had been
a far more important factor than chance in the evolution
of *Scramble*. Cunningham carefully gave each dancer the
steps and the body movements that he had worked out in
advance, and these figures became the raw material of the
dance. He would change the movement if it did not seem
to work well, or if the dancer felt uncomfortable doing it,
and sometimes he would see something unexpected that he
liked and would incorporate it—pausing to jot the new
movement down in a spiral notebook that provided a rough,
partly verbal and partly visual shorthand record of the

choreography. Cunningham watched his dancers closely, alert for any new shape or movement that he might use. With *Scramble*, though, every movement, once accepted, was scrupulously plotted and rehearsed.

The whole question of chance in Cunningham's work is frequently misunderstood, even by some of his most ardent admirers. Chance sometimes (but not always) enters the choreographic process as a means of determining the kinds of movements used, the order of the movements, the tempi, and other specific aspects of the dance; Cunningham uses it to arrive at certain decisions, which are then permanent. Indeterminacy, a wholly different concept, enters when the dancers are allowed to make certain choices of their own *during* the performance. One occasionally hears people in the audience at a Cunningham recital say knowingly that the dancers "do whatever they like" onstage—a feat that, in view of the complexity and intricate timing of the choreography, would be astonishing indeed. Actually, there is only one piece in the current repertory, *Field Dances*, that allows the dancers any freedom of choice during performance. *Field Dances*, which dates from 1963, was designed to be performed by any number of dancers, in any space, over any length of time. Cunningham's method was to devise and give to the dancers a series of relatively simple movements, some of which could be done solo and others in conjunction with one or more people. Each dancer has a different gamut of movements, and each is free to do these in any order and in any part of the performing area, and the dancers are also free to leave the stage at any time. *Field Dances* is performed to Cage's *Variations IV*—a collage of recorded sounds—and the dancers simply stop when the music stops. The dance changes from performance to performance and is thus "indeterminate," but the degree of indeter-

minacy is confined within strict limits. The same used to be true of *Story*, in which the range of movements was somewhat more complicated. Cunningham sometimes talks of experimenting further in the direction of indeterminacy, but he worries about injuries that might result from dancers colliding with one another at high speed, and he also suspects that more indeterminacy might turn out to be less interesting. "The trouble is, we all tend to fall back on our old habits," he said one afternoon in his studio. "Dancing is very tiring, and when you're tired you're likely to just do the easy thing, the thing you know. Whereas when you know what you have to do, you can usually jump the fatigue, go beyond it." Several of Cunningham's dancers tend to question his basic tolerance for any degree of indeterminacy at all. "Every time we did *Story*, Merce was furious with us afterward," Sandra Neels said once. "He always said, 'We're never going to perform *that* again.' " Finally he did drop it from the repertory.

Scramble was certainly not indeterminate, nor did chance play much of a role in its creation. Cunningham kept experimenting with the order of its various parts. By the middle of June, he had blocked out three main sections of the dance. There would be four sections in all, and his idea was that each one would be complete in itself. The longest section was the one that began with the whole company running four times across the stage. The fourth time across, Sandra Neels and Gus Solomons fell to the floor and remained there while the others went off; then, rising slowly, they began a sinuous, erotic duet, which led into Sandra's solo. This section also included the Carolyn Brown solo with the swimming movement and a Brown-Cunningham duet, which began with her taking extended positions while he scrambled (literally) under her outstretched arm or leg.

The duet then erupted into a very active series of rapid
leaps and pirouettes, crisscrossing the stage and ending
when she made a startling head-first leap into the wings,
where she was caught by Gus Solomons and Albert Reid.
One of the other sections centered on an athletic male trio,
somewhat violent at times, for Cunningham, Solomons, and
Reid. Cunningham was currently devoting his attention to
the third section, which began with six of the dancers
locked in a tight huddle that kept shifting as they changed
positions, while Cunningham hovered on the periphery; the
whole group then moved crablike across the floor and sud-
denly disintegrated as the dancers broke free and scattered,
regrouped in pairs or threes, and went running and leaping
across the floor in recurrent flurries of activity. Because the
movement was so complex and so strenuous, the dancers
were exhausted at the end of each rehearsal. During the brief
breaks, they would collapse on the floor, or lie propped
against the wall with their legs above their heads. They all
downed vast quantities of vitamin pills, and taped and re-
taped their bare insteps against floor burns. The weather
had grown warm and humid, and the sweat poured off
them; wherever a dancer's body touched the floor a damp
patch remained. Cunningham said that the new dance had
started to take its own shape and life, and that his job from
now on was to avoid interfering with it. He hoped to have
it finished in time for their next engagement—a two-day
appearance, on July 24 and 25, at the Ravinia Music Festi-
val in Illinois—but he was not committing himself to that.

As the pressure increased, so did the emotional intensity
of the dancers. One day Cunningham was working on a
new, extremely complicated phrase, to be done by all the
dancers in unison, that occurred in the fourth section. Bar-
bara Lloyd, who teaches a dance class at the Fine Arts

Workshop in Carnegie Hall twice a week, had missed
the previous rehearsal, at which Cunningham had taught
them the new phrase. Sandra Neels coached her while the
others waited for Cunningham to start the rehearsal, but the
movement was too difficult to learn in a few minutes.
When the company rehearsed it, Barbara could not keep
up; each time they reached a certain point, she dropped out
and stood against the wall. Cunningham asked her to try it
alone. She got about halfway through the phrase, lost it,
and walked back to the wall with her head down, fighting
tears. Sandra hurried over to reassure her, and Cunningham
went on to rehearse the men's trio. Later, he returned to the
difficult unison phrase and rehearsed it over and over while
Barbara watched from the sidelines. By the end of the re-
hearsal, everyone was gasping with exhaustion. Sandra, who
had developed new uncertainties of her own about the diffi-
cult phrase, began to question Carolyn Brown; when Car-
olyn replied irritably, Sandra burst into tears. Later, though,
in an East Village bar where the dancers gathered, they all
seemed relaxed and in good spirits again. For half an hour
after the rehearsal, Cunningham had worked alone with
Barbara Lloyd, coaching her in the new phrase.

No one at this point had a clear idea of what Cunning-
ham himself would be doing in *Scramble*. There were a few
passages—his duet with Carolyn Brown, the male trio, the
"huddle" of six—that he danced with the others in rehearsal,
but until the end of June he concentrated for the most part
on what the others did and simply sketched in his own
movements, taking a few steps and then indicating the rest
with hand motions. As a result, the whole shape of the
dance was never apparent. "Merce never talks about a piece,
or lets you know what he's thinking about it," Carolyn told
a visitor in the studio. "And we never know what it's going

to look like, because we don't know what *he's* going to be doing. All the time we were learning *Place*, for example, we weren't even sure he was going to be in it. I had a completely different idea about that dance, and then when we performed it the first time and saw him we all reacted in a completely new way." *Place*, which was added to the repertory just before *Scramble*, is also full of very lively movement, and while the dancers were learning it they came to think of it as a light and high-spirited piece of choreography. In performance, however, the combination of Gordon Mumma's harsh electronic score (entitled *Mesa*), Beverly Emmons' dimly lit stage, and Cunningham's strange wanderings and slitherings produced an atmosphere that was far from cheerful. Cunningham has conceded that his own part—he is onstage through virtually the entire dance —did in fact change the weight and the general tone of *Place* in a way that was unforeseen by him as well as by the dancers. He did not feel that his part in *Scramble* would have this effect, but one could never tell what a Cunningham dance was really going to look like until it had been performed at least once, with costumes, lighting, set, and music all contributing independently to the total effect.

The set and costumes for *Scramble* were being designed by Frank Stella, a young New York painter known for his severe, geometrically striped and shaped canvases. Stella had never designed a stage set before, and when Cunningham suggested the project to him, early in July, there was very little time remaining. By then, Cunningham had definitely committed himself to presenting *Scramble* at the Ravinia festival, so the set would have to be designed and built in two weeks. Stella nevertheless agreed to do it, and came to the studio on July 5 to see a rehearsal. He sat on the floor of the studio, smoking a substantial cigar and watching

the dancers attentively. Afterward he asked some detailed questions. How tall was the tallest dancer when his arms were raised above his head? What were the dimensions of the Ravinia stage, and how high was the ceiling there? Would Cunningham object if part of the stage was blocked off? Cunningham said they would be dancing *Scramble* in the outdoor pavilion at Ravinia, on a stage that was used mainly as an orchestra shell; Beverly Emmons had been trying for three days to get the exact dimensions of the stage, but no one out there seemed to know them. "You understand, nothing about the dance is fixed yet," Cunningham said. "The order of things can be changed, the timing —we can stop and start again at any point. I've kept it that way on purpose."

What Stella had in mind was a set consisting of several broad horizontal bands of colored canvas of varying lengths, each to be mounted at a different height between vertical supports. The dancers would move in and out among these overlapping color bands, which would sometimes conceal parts of their bodies from view; he spoke of the horizontal lines' functioning as a contrast to the rapid lateral movement of the dance. Cunningham asked him if the individual bands, with their supports, could be moved about during the performance, and Stella said he didn't see why not. He said he would work something out and come back in a few days.

Stella came back on July 12 with a scale drawing on lined yellow paper. The drawing showed six colored bands —red, orange, yellow, green, blue, and purple—ranging in length from four to twenty-four feet and mounted from floor level to eighteen feet in the air. Stella said that the vertical supports holding the frames of canvas would be on casters, so they would be easy to move about. He wanted these sup-

ports to be made of the heavy cast-iron pipe used in the
garment district for clothes racks; the homely solidity of
the pipe appealed to him. For the costumes Cunningham
had settled on six ordinary stretch-fabric leotards for the
girls and jump suits for the men dyed the same colors as the
canvas. The other two costumes would be black (Cunning-
ham) and white (Carolyn Brown). Gus Solomons and Lewis
Lloyd, who had been looking on while Stella explained his
ideas to Cunningham, expressed some doubts about the set.
Lloyd felt that the vertical supports would take up too much
floor space and get in the dancers' way. Solomons thought
it was going to look like "a real old-fashioned stage set—
cumbersome." Cunningham said he thought the whole idea
looked very beautiful.

Toshi Ichiyanagi, the composer, whom no one had seen
for several weeks, came to the rehearsal on July 14. Small,
neat, and faultlessly attired (in contrast with Stella, who
rarely appeared in anything but paint-spattered khakis and
an undershirt), the composer sat quietly on a hard chair for
two hours while the dancers rehearsed *Scramble* and also
worked on *Nocturnes*. John Cage had come in that after-
noon to play the Satie piano score for the rehearsal of *Noc-
turnes*, and when he finished, Ichiyanagi opened a large
manila envelope and showed him a page of the score for
Scramble. The score was on white drawing paper, and it
had no notes or clef signs or other conventional musical
marks. Ichiyanagi had invented his own form of notation
for the piece, consisting of exquisitely drawn symbols that
referred to various kinds of sound and sound characteris-
tics. Cage said that it looked difficult and very challenging.
"It's as though one had to be intelligent in order to play
it," he said, beaming.

As the day of the Ravinia première approached, the after-

noon rehearsals lasted longer and longer—sometimes until
six-thirty or seven o'clock. Fortunately, the dancers did not
require a great deal of rehearsing for the other pieces they
would be doing at Ravinia; they were scheduled to perform
for two nights there, and in addition to the new work they
would be dancing *Suite for Five, Place, Nocturnes, Winter-
branch,* and *How to Pass, Kick, Fall, and Run,* all of which
were in the current repertory and fairly fresh in their minds.
Each piece required several rehearsals, though, and *Scram-
ble* was only just beginning to take its final shape. Cun-
ningham went through the entire dance at each rehearsal,
timing each of the four major sections and experimenting,
even now, with different sequences. Not until July 20, just
a few days before the performance, did he settle on the
order that he would use at Ravinia. *Scramble* would begin
with the section that the dancers had learned most recently,
in which they came in very slowly, one by one, from the
wings, each with a different sort of sinuous movement, until
they formed a tight group at the center of the stage. Cun-
ningham then sprang into the quick, complex phrase that
had given Barbara Lloyd trouble earlier, and, one by one,
they followed him until all of them were dancing the phrase
in unison. This was followed by a new Cunningham solo,
which the dancers now saw for the first time. The solo pro-
gressed through odd crouchings and twistings of the body
to a passage in which Cunningham seemed to be making
karate motions with his arms (he had seen an exhibition of
karate and judo at Town Hall in the spring, and it fasci-
nated him), and then he began a loose, loping, circling
movement about the stage. As he was finishing the circling
movement one day, he suddenly shouted—an angry roar
that sounded more animal than human. The dancers
thought for a moment that he had hurt himself. When he

continued to dance, unperturbed, they realized that it must be part of the solo.

Cunningham also added several new and extremely difficult passages for Carolyn Brown in the second section of the dance. "I'm very happy about it," Carolyn said afterward, "and I won't have it right for at least a year." In the third section, Sandra Neel's solo was developing beautifully. Her long, supple body captured the intervals of stillness with a new authority, and she was making the shape of each movement very clear. The fourth section began with the interlocking sextet of dancers, who broke apart to go flying singly and by twos and threes across the stage in waves, and then changed, at the very end, to a stealthy slow movement, with the dancers meeting and making brief contact—knee pressing into partner's hip joint—then sliding past. Cunningham said that the dance was "shaking down," but no one knew whether or not he was pleased with it. As the day of the performance approached, he became increasingly withdrawn and thoughtful.

The Ravinia festival runs from the end of June to the middle of September and is one of the oldest and most distinguished of America's summer music events. Virtually all the great opera stars of the world performed there during the early years of the century, when it was primarily an operatic festival, and since 1936, when concerts began again after a four-year Depression blackout, Ravinia has been the summer home of the Chicago Symphony and has attracted prominent guest artists of all kinds. The festival is held in a pleasant old-fashioned park twenty-five miles from Chicago. Many of its devoted patrons arrive early and picnic on the well-kept lawn under ancient leafy oaks, and if the concert is being given in the open-air pavilion they sometimes do

not bother to buy tickets. The Cunningham company was to give its first performance, on July 24, in Murray Theatre, a traditional theater with a capacity of nine hundred and fifty; the world première of *Scramble* would take place the next night in the outdoor pavilion, which seats four thousand.

The company flew out to Chicago on July 23, a Sunday, arrived around noon, and proceeded in rented cars to the Holiday Inn at Highland Park, about three miles from Ravinia. There were eighteen in the group—nine dancers (including Peter Saul, who would not be performing in *Scramble*), four musicians (Cage, Ichiyanagi, the pianist David Tudor, and the young composer Gordon Mumma), one child (Benjamin Lloyd), a business manager (Lewis Lloyd), an assistant business manager (Theresa Dickinson, who was soon to become the second Mrs. Lloyd), a lighting designer and stage manager (Beverly Emmons), and Gary Zeller, a young off-Broadway set builder, whom Lloyd had engaged to build Frank Stella's set. Although Zeller's firm, the New Century Studios, was charging the company less than it would have had to pay to have the set built by an uptown theatrical contractor, Lloyd said that it and the costumes were still going to cost more than three thousand dollars—enough to wipe out the remaining surplus from the Philip Johnson benefit and put the company in the hole again financially. The set would also necessitate many minor changes and readjustments in the choreography, but none of this bothered Cunningham. "If it works, it could be rather magnificent," he said. "The scale of the thing is immense, you know, and it *is* flexible—at least, I hope it's flexible. We'll know tomorrow, anyway."

Later that afternoon Cunningham, Cage, Tudor, Mumma, and several of the dancers drove over to Ravinia Park for

an orchestral concert in the pavilion. The program, an all-contemporary one, included *Available Forms I*, a work by Earle Brown, Carolyn's husband; Cunningham stayed on after the concert to inspect the stage and the backstage area of the pavilion. The stage itself was large, but because it had been designed for use by a symphony orchestra and not for theatrical performances, its lighting and staging facilities were limited. Cunningham spent a long time in silent contemplation of the space, visualizing how his dancers would fill it. In a large ballet company, the corps de ballet creates guidelines for the eye and focuses attention upon the principal dancers; to fill a stage with eight or nine dancers and to sustain patterns of individual movement that do not lose themselves in isolation or conflict with others going on simultaneously requires not only a different form of choreography but a different concept of the performing space. For Cunningham, the stage is a continuum, an Einsteinian field in which the dancers relate not to fixed points (as even the Balanchine dancers do) but to one another. "Every point on the stage can be interesting, can be used," Cunningham has said. For an hour or more that afternoon, he studied the Ravinia stage, thinking how he would use it for *Scramble*.

The Monday-evening performance in Murray Theatre was sold out. Cunningham started the program with *Suite for Five* (the five were Cunningham himself, Carolyn Brown, Barbara Lloyd, Sandra Neels, and Albert Reid), a dance that he once described as "very sparse, and largely about being still." The dance has an Oriental delicacy of movement, and the music (Cage's *Music for Piano 4–84*) is quiet. The audience, which was predominantly middle-aged and well dressed, applauded with what seemed like a sense of relief, as though, having braced themselves for

uncompromising modernism, they had received a pleasant
surprise. *Place*, which came next, quickly restored the mood
of apprehension. A few couples left the theater soon after
it began, and a larger number covered their ears whenever
Gordon Mumma's electronic score reached a certain vol-
ume. On the dark stage the girls looked naked and defense-
less in transparent plastic costumes; the men, in dark leo-
tards, had a furtive, menacing air. *Place* tends to engulf the
spectators in a grim atmosphere of urban devastation, just
as the dancers in it seem to be engulfed in the harsh
roaring of sound. The ending is somewhat hair-raising. The
girls fall and lie motionless while the men dance over and
around them and finally drag them away; then Cunning-
ham, lying at stage center, climbs into a large plastic bag
and, with violent thrashing motions, propels himself off-
stage. The audience applauded the piece respectfully when
it was over and returned, following the intermission, with
surprisingly few desertions for the final work on the pro-
gram, the Satie *Nocturnes*. They were rewarded by what
is probably the most alluring work in the Cunningham
repertory—a dance that many Cunningham admirers feel
is almost *too* beautiful, in the classic, balletic sense. The
dancers are all in white. Rauschenberg designed their cos-
tumes to resemble "inhabited seashells," and his cool blue-
white lighting and simple set—a white gauze curtain across
half the stage, making a separation between movement seen
clearly and movement seen as though at a distance—create
a dreamlike, moonlit space for the dancers to inhabit. The
dance itself is a sequence of rendezvous. The dancers meet
and part—come together, touch, follow, relinquish contact
—moving sometimes with the delicate Satie piano music
and sometimes independently of it as the music and the
dance hold rendezvous of their own. Throughout the dance

there are moments of unexpected humor and moments of
sudden beauty (as when Carolyn Brown, whirling across
the stage, at each turn sends shards of reflected light flash-
ing from a mirror-glass tiara), and at the end Cunningham,
kneeling behind the gauze curtain, seems to be waving a
spectral, though friendly, farewell. The audience loved it.

As soon as he could manage to do so politely, Cunning-
ham excused himself from the throng of well-wishers back-
stage, changed into street clothes, and hurried over to the
pavilion to see how Gary Zeller was getting along with the
set for *Scramble.* Zeller had started to assemble the various
elements that afternoon, with somewhat grudging assistance
from the Ravinia stagehands. The vertical support pieces
were made of polished aluminum, broken down into lengths
that fitted together ingeniously. (The cast-iron pipe that
Stella originally wanted to use had turned out to be far too
heavy.) The strips of colored canvas, eighteen inches wide,
were each to be attached to two horizontal aluminum sup-
ports with Velcro tape fasteners, and the horizontal sup-
ports were then to be attached to the uprights at the de-
sired heights. Two of the six elements had been assembled
so far—a four-foot red one, standing eighteen feet high, and
a twenty-four-foot purple one, standing at floor level. Cun-
ningham shoved the long purple strip around the stage
with one foot, testing its maneuverability. It moved fairly
easily on its casters. He stood on the stage for nearly an hour,
chin in hand, eyes narrowed, and from time to time he
made notes on a scrap of paper. He also conferred with
Zeller and Beverly Emmons, both of whom planned to work
through the night—Zeller to finish building the set and Miss
Emmons to oversee the installation of a special lighting
boom.

The rest of the company had gone for a late supper (the

dancers do not eat before a performance) at a restaurant
near their motel, and Cunningham joined them there shortly
after eleven. In contrast with their high spirits—the post-
performance euphoria that is one of the few visible rewards
of the dancer—Cunningham seemed, if anything, more with-
drawn and reserved than usual. He had wrenched a knee
quite painfully during the performance of *Place*, but no-
body else knew this at the time. By midnight, the dancers
had all gone to bed.

Most of them were in the motel dining room at nine the
next morning. Over breakfast, they discussed the Detroit
riots, which were front-page news in all the Chicago papers
that day, and read the reviews of the previous night's per-
formance, which were generally favorable (they had "held
the audience rapt throughout some extremely bizarre hap-
penings onstage," according to one reviewer). David Tudor
and Gordon Mumma had already gone over to the pavilion
to see about some rented sound equipment for that eve-
ning's performance. Beverly Emmons and Gary Zeller, who
had worked until 3 A.M., hurried back to work immediately
after breakfast. Cunningham remained in his room. He had
awakened to find his knee swollen and painful, and he
wanted to give it as much rest as possible. It was a perfect
summer day, clear and warm and still, with none of the
humidity that had made the rehearsals in Manhattan par-
ticularly trying.

At the pavilion Beverly Emmons was having her prob-
lems with the stagehands. They were not accustomed to
coping with theatrical demands, for the Chicago Symphony
and its guest artists did not require much in the way of
stagecraft. Miss Emmons, an emphatic young woman
dressed that day in a very short tan miniskirt, was trying to
get the orchestra's equipment removed from several dress-

ing rooms, and she was also trying to get somebody to clean
and, if possible, sand the stage, which was rough and
splintery. She was not having much luck. Mumma and
Tudor, on the other hand, were delighted with the sound
equipment that the festival had provided for them. The
Cunningham company owns very little sound equipment, so
it usually sends a list of its electronic requirements to the
management wherever it is going to perform and hopes for
the best. The Ravinia festival's general manager, Marshall
Turkin, had come through magnificently, with four fifteen-
inch loudspeakers, all the amplification circuitry required,
and two local sound engineers to help in assembling it. The
sound men spent the morning mounting and hooking up
the speakers at either side of the stage, while Mumma and
Tudor built themselves electronic control nests on the stage
itself, one at either edge. Most of the wiring was for
Ichiyanagi's score.

The Ichiyanagi score had turned out, as Cage predicted,
to be extremely difficult. The notation called at certain
points for an instrument to be played by another instru-
ment; Ichiyanagi left it up to the performer to decide just
what the instruction meant and how it was to be carried
out. All morning, Mumma, whenever he had a free mo-
ment, practiced his French-horn part. He is a virtuoso
French-horn player, and he solved the "instrument plays
other instrument" problem by using a bassoon reed and
an oboe reed in place of the horn's regular brass mouth-
piece. The sound he got with the bassoon reed was mourn-
ful and sonorous; with the oboe reed it was wavering and
a trifle shrill.

The dancers arrived at ten-thirty and spent the next hour
warming up onstage, oblivious of the stagehands and of the
sound equipment, which occasionally emitted earsplitting

squeals and buzzes. Each of the dancers had a different
sequence of exercises for stretching and limbering the mus-
cles. They worked in silence, totally absorbed in their indi-
vidual routines. One leg and then the other would swing
back and forth twenty times, lightly brushing the floor as it
swept through its arc; then twenty times out to the side,
then twenty times in a circle. Gus Solomons, who looked
casual and relaxed even when rebounding from a great leap,
took less time to warm up than Albert Reid or Peter Saul,
who would appear in the two works that were to make up
the evening's program along with *Scramble*. Among the
girls, Barbara Lloyd, Valda Setterfield, and Yseult Riopelle
worked for a while, rested, then started again. Carolyn
Brown and Sandra Neels worked more or less steadily,
scarcely pausing for breath, until Cunningham summoned
them at twelve-fifteen to start rehearsing *Scramble*.

Cunningham, whose brief warmup gave no indication
that his knee bothered him, had spent a large part of the
morning experimenting with the set, moving the six ele-
ments in accordance with a group of charts he had drawn
up the night before in his room. The blue canvas, which was
in the middle range in respect to both length and height,
had developed a slight but noticeable sag. Zeller did not
want to add a vertical center brace without consulting
Frank Stella, but nobody seemed to know for certain
whether Stella was coming out for the première.

The fresh, strong colors of the Stella set had an extraor-
dinary effect on the movement of the dance. The set
seemed to change the scale of the piece, containing and
interacting with the dancers and defining the shape of their
movements in unexpected ways. Cunningham wanted the
positions of the various elements to be changed after each of
the major sections of the dance, and the dancers had to adjust

their movements and their cues accordingly. At certain
points they had to step over the bases of the aluminum sup-
ports, which were difficult to see under any circumstances
and would be even more of a hazard under stage lighting.
Entrances and exits had to be reworked. Instead of wings,
the stage had four small doors, one at each side and two at
the rear. A dancer would go out one door and run along a
dark and narrow passageway backstage to get into position
for the next entrance; there were moments of confusion
when a dancer found the exit partly blocked by one of the
vertical supports. When Carolyn Brown first rehearsed her
flying leap off the stage, her head almost grazed the low
lintel of the doorway. She did it four more times, practicing
a lower trajectory, while the other dancers held their breath.
It was nearly two o'clock before Cunningham finished with
Scramble. The dance seemed to have grown enormously in
the Stella set, and it was clear that the strange centrifugal
and centripetal relationships of the dancers as they came
together and separated on the big stage would add up to a
large-scale and infinitely complex work.

While the dancers quickly rehearsed *Winterbranch* and
How to Pass, Kick, Fall, and Run—the two works that
would be performed after *Scramble* on the evening's pro-
gram—Ichiyanagi and Cage held a conference with two
percussionists from the Chicago Symphony who had been
added to the performing ensemble for *Scramble.* The new-
comers stared in some perplexity at the pages of the score,
with their beautifully drawn but totally unfamiliar notation.
Ichiyanagi, whose English is excellent but halting, ex-
plained, with Cage's occasional assistance, the meaning of
each symbol. There was a symbol for pitched sounds, an-
other for noises, and another for sounds electronically pro-
duced; there was a symbol specifying when an instrument

was to be played by another instrument, and a symbol for
when a pitched sound was to "hit" a noise, or vice versa.
The degree of loudness or softness was indicated by the
position of the symbol above or below a horizontal line. Al-
most all the sounds were to be sustained for as long as
possible, and they were to be produced without emphasis
or stress, so that the effect would be of sounds with no be-
ginning or end. Each performer had a wide range of choices
both in the instruments he could use and in methods of
sound production, and for a while the two Chicago Sym-
phony men could not quite grasp what was expected of
them. They wondered how a pitched sound could "hit" a
noise. By letting a triangle strike against the back of a
chair? Ichiyanagi nodded. Gradually, with Ichiyanagi's and
Cage's encouragement, the idea that these sound problems
were theirs to solve began to appeal to the two men. They
became visibly enthusiastic.

Cunningham finished rehearsing *Winterbranch* and *How
to* at two-thirty. The dancers collapsed on the stage, ex-
hausted and dirty after four hours' work, and watched the
musicians setting up their percussion instruments in the
space between the stage and the front row of seats. Mum-
ma and Tudor were still wiring their apparatus together,
and the loud crackle of electronic feedback periodically
shut off conversation.

"Are we going to hear any of the music before we dance?"
Carolyn Brown asked Ichiyanagi.

Ichiyanagi said he hoped there would be time for a music
rehearsal that afternoon.

"Is it very loud?" Sandra Neels inquired.

Mumma said that the speakers were mounted outside
the stage area, one on either side, and therefore the sound

would not be loud at all for those onstage. "It's going to be a mixture of live and electronic sound," he added.

"We know," Sandra murmured a trifle glumly.

The company had a late lunch at the motel and rested for an hour or so, and then, at five-thirty, Cunningham and several of the dancers drove back to Ravinia. The others followed half an hour later. In the car going over, Cunningham seemed surprisingly relaxed and peaceful; the withdrawn, preoccupied manner of the preceding days had largely disappeared, and he chatted amiably with the dancers about inconsequential matters that had nothing to do with the new dance or the performance. The evening was clear and cool, and the setting sun, slanting through the oaks in Ravinia Park, bathed the lawn in pools of light and shade. The dancers went backstage to put on their makeup. For the next forty minutes, the only sign of activity was a teen-age boy methodically dusting every seat in the pavilion while totally absorbed in a transistor radio that was belted to his waist and plugged into his left ear.

Shortly before six-thirty Cunningham, wearing an ancient striped dressing gown and slippers, emerged from his dressing room and began once more to shift and rearrange the elements of the set. In the fading light onstage, his theatrical makeup gave him an unearthly look: huge, shrouded eyes and livid cheeks. He consulted his charts, moved the blue canvas, studied it for a while, moved another. After a few minutes he went back into his dressing room and closed the door. One after another, the dancers came out and began to warm up. Yseult Riopelle was first, and then came Sandra Neels (face chalk-white, eyes dark), then Gus Solomons (crouching and stretching like some giant mantis). Two teen-age girls, early arrivals, came to stand by the

stage and stare in wonder at Solomons, who took no notice of them. The dancers wore practice clothes; they would not put on their costumes until the last moment.

By seven-thirty the space on the lawn outside the pavilion proper was beginning to fill up with non-paying members of the audience. Families with young children staked out choice spots, spread their picnics, and trained binoculars on the practicing dancers. A diminishing patch of sunlight fell across the middle rows of seats inside the pavilion. Backstage it was getting dark. In the passageway Sandra Neels stood holding on to a pipe while she did slow knee bends. "I always feel as though I'm about to fall apart when we're doing a piece for the first time," she confided to Barbara Lloyd. "I only wish the stage were more friendly." The floor of the stage was even worse than it looked. During rehearsal the dancers had worn ballet slippers to guard against splinters, but during the performance itself they would be barefoot.

Just before eight o'clock Frank Stella appeared backstage. He had on his customary undershirt and khakis and, as usual, was smoking a cigar. "I wasn't going to come," he explained, "but then I decided I'd hate myself too much if I didn't, so I just dropped what I was doing and went out to La Guardia." He needed two dollars to pay the taxi-driver who had brought him over from O'Hare Airport. Stella and Gary Zeller went out onstage to look at the set. The artist seemed pleased. "The green one sags a little, but it's not too bad," he observed. "The little red one looks great up there." Zeller had put an aluminum strut in the blue canvas to remove most of its sag. Stella approved, but soon he and Zeller were deep in a discussion of how the set could be improved technically and made less cumbersome; Stella thought it might be possible to devise a system of overhead

cables. Lewis Lloyd, who had joined them, went away shaking his head.

Cage and Ichiyanagi were checking the equipment that the men from the Chicago Symphony had procured for them. Each of the four percussion players (Cage, Ichiyanagi, and the two newcomers) had his own ensemble of instruments. The Chicago Symphony men were stationed just to the right of the stage, where they had surrounded themselves with drums, triangles, gongs, a vibraphone, marimbas, and various other conventional or improvised instruments. Ichiyanagi, in the center, would perform mainly on the piano and the celesta. Cage was off by himself at the left, with more drums, a glockenspiel, wood blocks, and a battery of electronic sound-making devices. David Tudor and Gordon Mumma were up on the stage itself—Mumma at the far left, with his French horn and his electronics, and Tudor at the far right, with an all-electronic console, which he would use to modify and mix the sounds that the others were making. Mumma was very excited about the score, which he said was by far the most difficult he had ever had to perform for a dance concert. When the Chicago Symphony men tried to explain their parts to three of their colleagues who had dropped by, one of the visitors remarked that Ichiyanagi's score would make the previous Sunday's avant-garde program sound like Mozart. (After the performance many people remarked how surprisingly gentle and "musical" the score had been, and how Japanese.)

It was almost completely dark backstage now, and very quiet. The dancers were putting on their costumes. The paying audience started to file in at about eight-fifteen. It looked to be the same sort of audience as the previous night's, but considerably larger; two-thirds of the four thousand seats were occupied by eight-thirty. A bell rang back-

stage, and the dancers assembled quietly in the dark
passageway. The five girls stood very still in their new skin-
tight leotards (Carolyn Brown in pure white, the others in
yellow, green, orange, and purple); Albert Reid and Gus
Solomons (Reid in a red jump suit, Solomons in a blue one)
seemed to be barely suppressing an urge to be in motion.
Cunningham joined them; it was the first time anyone had
seen him in nearly an hour. He wore a black jump suit. His
manner was calm and gently paternal, and for the last few
moments, as they whispered and joked in the dark passage-
way, the company seemed like an affectionate family on the
eve of some pleasant celebration. Beverly Emmons came
up and said that the music was going to start very soon.
"They'll play for two minutes while I dim the house lights,"
she said. "When I put the stage lights up, you begin.
Okay?" There was a last-minute question about curtain
calls—should they go offstage and then come back, or just
stay onstage at the end? Cunningham said to go off and then
come back. The music started quietly, with some long, iso-
lated sounds from the celesta and the glockenspiel, and the
house lights began to dim. The dancers all cupped their
hands and blew kisses to one another. "Have a good time,"
Cunningham whispered as they scattered to their various
entrance points. The stage lights came up, and the dance
began.

INDEX

FOR THE BEST IN PAPERBACKS, LOOK FOR THE

Other Art, Architecture, and Design books available from Penguin:

□ **WAYS OF SEEING**
John Berger

"Seeing comes before words. The child looks and recognizes before it can speak." This collection of verbal and pictorial essays questions how we view the things around us, and how our viewing may be altered by what we hear, know, and believe.

166 pages ISBN: 0-14-021631-6

□ **HOME**
A Short History of an Idea
Witold Rybczynski

Walk through five centuries of homes both great and small—from Medieval manor halls to Ralph Lauren-designed modern environments—on a house tour like no other, one that delightfully explores the very idea of "home."

256 pages ISBN: 0-14-010231-0

□ **HOW TO DRAW THE HUMAN FIGURE**
An Anatomical Approach
Louise Gordon

Because knowledge of bone structure and musculature often enables an artist to produce more professional drawings of the human figure, Louise Gordon's analysis and clear, accurate drawings are ideal for the student or the professional.

144 pages ISBN: 0-14-046477-8

FOR THE BEST IN PAPERBACKS, LOOK FOR THE